RENDERING IN PEN AND INK

RENDERING IN PEN AND INK

BY ARTHUR L. GUPTILL
Edited by Susan E. Meyer

WATSON-GUPTILL PUBLICATIONS, NEW YORK

First published in 1976 in the United States and Canada
by Watson-Guptill Publications a division of Billboard Publications, Inc.
1515 Broadway, New York, N.Y. 10036

Library of Congress Cataloging in Publication Data
Guptill, Arthur Leighton, 1891-1956.
 Rendering in pen and ink. Pbk. Ed.
 Includes index.
1. Architectural rendering. I. Title.
NA2780 G86 1976 720'.28 76-18759
ISBN 0-8230-4529-3

Manufactured in U.S.A.
Paperback edition, first printed in 1997

3 4 5 6 7 8 9 10/06 05 04 03 02 01 00

Editor's Note

Arthur L. Guptill's book on pen and ink has become a classic in its field. No other book has ever provided such an exhaustive treatment of pen and ink and no other artist was so uniquely qualified for the task.

Entitled *Drawing with Pen and Ink* when it was published in 1930, the early editions of this book have become collector's items, widely sought by architectural renderers, architects, and designers. In recent times, there has been a resurgence of popularity for pen and ink among all groups of artists and designers, a trend that has made it possible, *imperative*, in fact, to reissue this classic volume by Arthur L. Guptill.

Nearly all of the original book has been retained in this new edition. In particular, virtually all of the drawings—those by Mr. Guptill as well as those by other artists—have been included in this volume. Although edited for readability, the text has been fairly well preserved in an attempt to remain faithful to the original. Only those portions of the text were eliminated that referred to materials or procedures no longer made or employed. With this exception, however, no information has been altered or updated. No reference is made here to developments of felt tip pens or ballpoints, for example, items that have developed only after Mr. Guptill's writing.

As an artist and architectural renderer, as an architect, as a teacher, and as a writer, Arthur L. Guptill possessed unique talents for creating art instruction books.

Without being stodgy, he was a systematic thinker, capable of isolating complex principles and investigating them practically and simply so that any art student could comprehend and execute the most difficult problems. Mr. Guptill wrote books on oil painting, watercolor, and pencil—as well as pen and ink—and illustrated his instruction equally well in all of these media. Yet his favorite medium was pen and ink, perhaps because it was the most difficult—therefore the most challenging. His affection for this medium inspired thousands of students in his book, and I am quite certain that this new edition will continue to follow that distinguished tradition for many years to come.

<div align="right">SUSAN E. MEYER</div>

Contents

List of Artists Represented

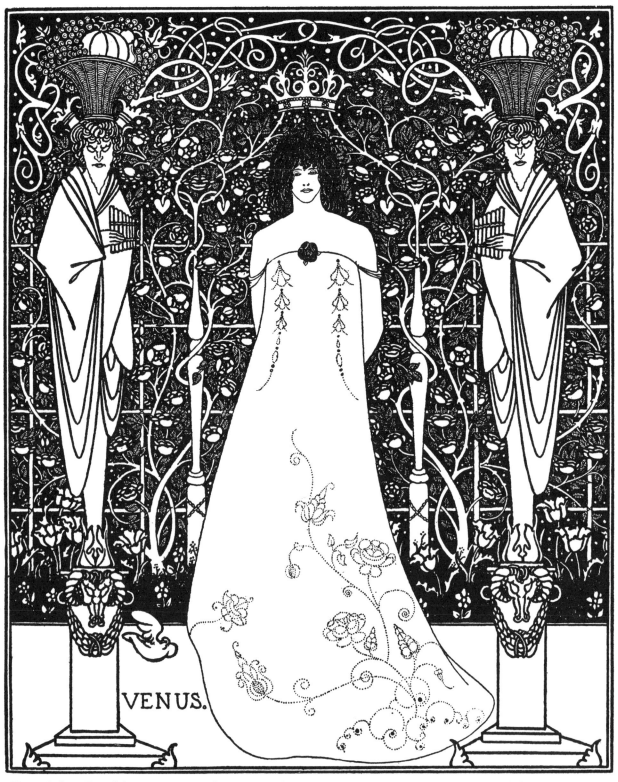

Fig. 1. Aubrey Beardsley: Frontispiece for Venus and Tannhauser. Beardsley was a giant in his ability to use highly stylized or decorative treatment to good advantage.

1. Some Introductory Considerations

Rockwell Kent

Pen drawing, as a separate and complete form of pictorial representation, is a phenomenon of comparatively recent date, its greatest development having taken place since the beginning of the last quarter of the 19th century.

This of course does not mean that pen drawing was unknown prior to that time, for such is far from the case. You have only to recall the illuminated manuscripts of the Middle Ages to realize with what skill pen lettering and certain types of decorative design were then done. But in this work the drawing was subordinated in nearly every instance to the lettering itself, or the pen lines in the illuminations were merely outlines or framework for the colored embellishments.

Again, remembering the many pen sketches and studies made centuries ago by some of the most famous of our old masters, you will soon realize that the pen was turned to with great frequency even in their day. Analysis of their pen drawings makes plain, however, that this early work was usually in the form of preliminary studies for paintings or parts of paintings, or was much in the nature of a sort of pictorial shorthand, by means of which facts of interest were vigorously and sometimes, it must be admitted, rather crudely recorded. Apparently no attempt was then made to develop pen drawing as an art by itself; only during the last few decades was this done. Today pen drawings are made not simply as adjuncts of another art or as means to certain ends, but as finished and complete things in themselves (see, for example, Fig. 1).

Popularity of Pen Drawing

Undoubtedly the invention and gradual improvement of the various processes of photomechanical reproduction, which have provided comparatively cheap and faithful methods for reproducing pen work, have given great impetus to this development. Publishers have been quick to take advantage of these processes and thus have created a demand for drawings in this medium, which artists in turn have hastened to meet.

Pen drawing has received encouragement, too, through the gradual perfection and standardization of the materials used —pens, inks, and papers—of all of which an infinite variety may now be obtained easily at reasonable cost, permitting selections suitable for any purpose.

Even with these encouragements, it is doubtful if pen drawing as an art would have advanced so rapidly had some artists not realized that the pen, because of its peculiar qualities, was a medium demanding a far different treatment from that accorded any other.

It may be well to pause here to consider certain fundamental principles which bear on all art work — principles with which these artists were undoubtedly familiar—and to see in what way they are applicable to pen drawing.

Limitations of Other Media

First, remember that each of the fine arts has certain restrictions as a result of which characteristic conventions have been developed. (This thought will be amplified in a moment.) Then too recognize that unless the artist accepts these restrictions and their accompanying conventions, he will be heavily handicapped as far as artistic accomplishment is concerned.

To illustrate the first thought: the sculptor, using plastic materials, is able to correctly copy many of the forms of nature, but is forced by his medium largely to disregard their color. The painter, on the other hand, can show their color, but, unlike the worker in plastic materials, he is limited by his canvas to only two dimensions, being forced to resort to conventionalities for the representation of the third. The worker in brush and wash of gray is forced still further to employment of convention, for he must interpret color in terms of various tones of gray, ranging from light to very dark. Such media as charcoal and crayon are frequently used in much the same way as wash, adopting similar conventions. Yet these media may be employed in a linear manner, too, in which case new conventions come into play, particularly the use of outline and the suggestion of color and light and dark by means of various combinations of openly spaced lines. The pencil, though capable of being handled much like wash or charcoal or crayon, has also certain distinctive characteristics, notably its ability to hold a fairly sharp point. Each medium demands equally distinctive conventionalized treatment.

Limitations of the Pen

And now we come to the pen and its own limitations and conventionalities. There are many, perhaps more than for any other medium. It might seem that this would put the pen at a distinct disadvantage, yet the contrary is true. The pen is a linear tool, but unlike the crayon or charcoal or pencil, it gives off no color or tone itself. Instead it serves as a vehicle to transmit ink from bottle to paper, acting in this sense much like the brush. Unlike the brush, however, it has a rather fine and stiff point, capable of holding only a very small amount of ink, which makes it an impractical instrument for covering large areas of paper surface.

This limitation acts in two direct ways. It tends to keep pen drawings somewhat

small in size, and makes the use of a large variation of tonal values, as well as big areas of them, extremely difficult. You must remember that every line made with a pen is absolutely black (colored inks being a rare exception) against a background of paper which is usually white. This means that color must necessarily be disregarded altogether or suggested by the white of the paper or by various combinations of jet black lines. Tones of light and dark, too, must be ignored or suggested in similar manner. In order to build a value of gray it is necessary to dot the surface with stippling — a little-used treatment — or to lay individual black lines side by side, or crossed in series. If the artist wishes subsequently to darken a tone obtained in one of these ways, he must painstakingly enlarge each existing line or dot or must put more lines or dots into the area. (Compare this with wash, where it is possible to produce almost any given value quickly and easily, or to wash over and still further darken a tone.) To lighten a tone and still keep it in good character is practically impossible; if it is too dark there is nothing to do but erase (and in pen work this is far from easy) or put a patch on the paper and begin again.

It is because of these various technical difficulties of working with a fine point in black ink on white paper that it is so extremely hard, if not impossible, to build up values corresponding with all those in nature. For this reason the less positive values must be disregarded, and the others simplified or merely suggested.

If color or tone is disregarded we must substitute something for it, unless the forms are to be lost. So here we resort to the conventionality of using outline, particularly where we wish one light object to stand out against another. The pen is an especially fine instrument for this outline work: not only is it unexcelled for the sharp delineation of shape and for precision of draftsmanship, but its lines, even though jet black, may be made very expressive of all sorts of irregularities of form and texture.

This use of outline, together with the method of tone building by means of lines or dots, as touched upon above, are two of the most distinctive characteristics of pen drawing. There are many minor conventions in use to which we are so accustomed that we hardly think of them at all: methods of suggesting shadow tones, for instance, and trees and clouds and the textures of building materials, and so on.

So these are the important restrictions and limitations and the resulting conventionalities of pen drawing recognized by artists who made the art what it is, and which must still be recognized by those who would emulate them. If you try to make a pen drawing larger than the instrument warrants, or attempt to carry gray tones all over your paper, or in any way disregard the peculiar properties of the medium, you will be forcing it to do that which it is not best adapted to do, and whatever success results from such methods is almost sure to be technical, rather than truly artistic.

Developing a Personal Technique

This does not mean that you are so bound down that individuality is impossible; quite the contrary is the case, for it is often true that the more conventional the art, the greater the opportunities for originality. We might go so far as to say that there is perhaps no medium offering one a better chance for the development of a personal technique than the pen, for pen drawing is akin to handwriting, and just as no two people write alike, so no two people draw alike.

Commercial Applications

We have already mentioned the popularity of pen work. Part of this is undoubtedly due to the methods of reproduction to which we have previously referred. Part of it, as we have said, is due to the ease and low cost with which the necessary materials may be secured. Yet aside from all such reasons, pen drawing has made a lasting place for itself among the fine and applied arts through its intrinsic merits alone. Pen drawings, in their simple black against white, have a crispness and directness that are appealing; they are full of life and light. Many of them are only suggestive, leaving much to the imagination, and we take pleasure in this. A few lines here, and a few touches there, and sometimes that is all; yet there is a power to this suggestion which often makes photographs, telling everything, seem stupid by comparison.

This virtue of line drawing over photography is realized even by "cold-blooded" businessmen, or by the advertising experts representing them, as is evidenced by the great use of pen work for advertisements, even in a day when commercial photographers are existing on every hand.

Perhaps this popularity of pen work for advertising purposes has come about partly because reproductions of pen work harmonize so beautifully with the type matter of the printed page — largely because of their scale, their linear quality, and their being printed on the same paper with the same ink. And this harmonious quality is undoubtedly one of the main reasons why pen illustrations for books and magazines and all sorts of similar press work are in such great demand.

Other Observations

It might seem that the strong contrasts of black and white in pen work would prevent such subtleties of representation as many subjects require. Yet there is ample evidence in the form of drawings that this is not the case. In fact, there is a delicacy to much pen work which is lacking in the work of other media.

Another point in the favor of drawings done with pen and ink, and one which should not be forgotten, is their cleanliness. Many media rub or soil easily, but pen drawings not only keep clean themselves, but do not soil other drawings with which they come in contact — and they do not fade.

Here, then, are some of the leading characteristics of pen drawing, some of the principles on which it is based, an outline of its history, and certain uses to which it is put. It is enough to show the importance of the subject, to suggest with what seriousness it should be regarded. If, however, what has been written here makes the subject seem too deep and complex, we can offer a word of encouragement to the student. This is, that pen technique itself, being so highly conventional, is more or less a matter of tricks. Just as some learn to write well with ease, so some, already grounded in a knowledge of drawing (for, as we have previously said, there are no easy tricks about that), learn these tricks of technique and thereby get the knack of pen work almost without trying. This is, of course, exceptional. It must be admitted that most of us need much practice to gain the same results, while some of us, with the best of effort, will never acquire more than an ordinary technique. Even famous workers in other media have sometimes failed miserably with the pen, much to their own discouragement undoubtedly, but to the encouragement of lesser artists who have also found the road a difficult one.

2. Materials and Tools

Harrie Wood

The materials needed for pen drawing are few in number, simple, inexpensive, and easily obtained. It takes little to begin: two or three good pens and penholders; a bottle of ink and a penwiper; a few sheets of paper having a smooth, firm surface; a drawing board or some such support on which to place the paper, and a half-dozen thumbtacks to hold it there; a fairly soft pencil for constructing the drawing and a soft eraser for the later removal of the pencil lines and the cleaning of the sheet; and a rather hard eraser or knife for the correction of pen lines.

The market is flooded with such a variety of these things that it is necessary to offer some advice so you can make your selection more easily. The beginner, lacking guidance, is almost sure to purchase things of more diverse types and in larger quantities than is essential. You surely cannot become an artist by the simple expedient of collecting art supplies. If you buy but few things instead, and learn to master them well, trying others only after this mastery has been attained, you will eventually become partial to certain things especially suited to your own individuality. You should not, however, be too hasty or overconfident in condemning or rejecting materials. You cannot heap blame upon a musical instrument simply because you found yourself unable to play it at the first attempt. Like such instruments, materials often have hidden qualities that take long practice to bring into evidence.

You can only do good work with the best materials. These recommended are by no means the only excellent ones, but as they have stood the test of time and have been held in favor by many leading artists, they are listed here without hesitation. If not available, others can be found that will give equal, and possibly even greater, satisfaction. A few special things

are described in later chapters, where their uses are also explained in some detail.

The choice of pens is a matter of great importance, yet artists are in so much variance that it is small wonder the student is at a loss to know where to turn.

Quill and Reed Pens

In earlier times there was no such bewildering variety as we have now. The word "pen" seems to have come down to us through the Latin *penna*, meaning a feather or plume, and so originally referred to pens fashioned from feathers (Fig. 2). These quill pens, and pens made from reeds, were used for many centuries, still being in common use even after the middle of the 19th century. Today, however, they are rare indeed. In the late 1920's a noted British artist, Walter Crane, in his book entitled *Line and Form*, said, "but though one occasionally meets with a good steel pen, I have found it too often fails one just when it is sufficiently worn to the right degree of flexibility. One returns to the quill, which can be cut to suit the particular requirements of one's work (Fig. 3). For large, bold drawing the reed pen has advantages, and a pleasant rich quality of line."

In *Line*, another English book of the same period, Edmund J. Sullivan said, "Reed pens, like the quill, have been almost entirely supplanted by the steel nib. The writer has small experience of them, but well remembers J. Pennell, that most expert technician, getting excited about them; and if an artist can become pleasurably excited about the handling of a tool, that tool is for the time being the best possible. That it is the calamus of the ancients lends it a special charm. A set of them as used by the Egyptians can be seen

in a case at the British Museum. . . ." This gives us some idea of their antiquity.

And Maginnis, in *Pen Drawing*, written in the same period, had this to say: "Though somewhat out of fashion for general use, the quill of our fathers is favored by many illustrators. It is splendidly adapted for broad, vigorous rendering of foreground effects, and is almost dangerously easy to handle. Reed pens, which have somewhat similar virtues, are now little employed, and cannot be bought."

Whatever their value, both reed and quill pens are now so scarce that a recent canvass of a number of leading supply houses failed to show any available.

Metal Pens

But there is no shortage of metal pens. These, too, are of early origin. Bronze pens were excavated at Pompeii, and we have other instances of their Roman use. These early pens copied the quill form (Fig. 4), a form which we now find definitely suggested in our small "crow quills" of steel, of which more will be said in a moment.

Attempts were made to manufacture steel pens towards the close of the 18th century, but it was not until 1825, in England, that Joseph Gillott made them practical, greatly improving their form and, by the introduction of machinery, cheapening their price. Even today Gillott pens still hold their place among the best made, and their fine and medium points seem to be in such general use among artists that we describe them first.

One of the smallest of these is the "crow quill" (659) (Fig. 5). The crow quill has a most delicate point, making an extremely fine line unless pressure is applied, when it will yield a line of astonishing width for so small a pen. Also

Fig. 2. The word "pen" comes from the Latin "penna," meaning feather.

Fig. 3. The pen knife was so named because it was used for sharpening quill and reed pens.

Fig. 4. Crow quills were originally made from crow feathers.

Fig. 5. This is a modern steel crow quill.

very fine is the Gillott lithographic pen (290)—made for drawing on lithographic stone but popular for use on paper—and the Gillott mapping pen (291). This latter instrument is particularly facile for one so small, and is perhaps as well-liked generally as any of the extremely fine ones.

These three pens are relatively expensive, but if they are not abused they will give a very fair length of service. If repeatedly called into use for lines beyond their natural capacities, they will soon fail. For the beginner such points are often dangerous, leading him into finicky ways. They are naturally better suited to small rather than to large work, and are at their best on smooth papers.

For larger drawings, or for rougher surfaces, or for any lines but the finest, turn to points such as the Gillott 170, 303, or 404. These are not only good for all-around work, particularly for the beginner, but they are cheaper than the fine-pointed pens. The 170 is fine enough for almost any purpose; the 303 is a very good medium size, while the 404 will give as coarse a line as is usually needed.

When pens larger than the 404 are required, turn to any of the makes commonly on sale. For lettering of the type shown on most of the accompanying illustrations, a ball, oval, or dome-pointed pen is good; the same pen will also make rather coarse lines of uniform width. For many types of decorative drawing, wide stubs such as those frequently used for lettering are practical. These may be found in many sizes. Then there are the round or "spoon-bill" points (Speedball is the most familiar manufacturer of these pens). Although used primarily for lettering, these nibs, pictured in Fig. 6, are also suitable for some types of pen drawing, particularly work of a very large or bold nature where lines uniform throughout their length are needed.

These, then, are the pens most often used for drawing. There are special pens, to be sure, such as the "double line" pen (Fig. 7), sometimes employed by bookkeepers for the ruling of two parallel lines with one stroke, and occasionally turned to by artists for novel effects (Fig. 8). The fountain pen, too, has become popular as a drawing instrument, though most of the waterproof inks do not work in it to advantage. The fountain pen is especially of value in sketch work, where ink in bottle form is inconvenient.

Penholders

As it is not uncommon for several pens to be employed on a single drawing, it is convenient to have several penholders, one for each of them. The crow quill pens, and some of the other tiny points, require special holders, which may be purchased with them. One type is illustrated at E, (Fig. 10). In this type, the round barrel of the pen is pushed onto a stock of approximately the same diameter (2). A member (3) slides down tightly to a convenient position, covering a bit of the upper end of the metal barrel. When the pen is not in

Fig. 6. Both wide stubs (left) and spoonbill pens (right) can be useful for some purposes.

Fig. 7. This is a double line pen.

Fig. 8. Strokes made from a double line pen look like this.

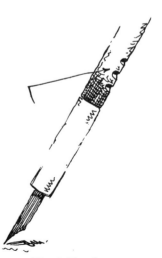

Fig. 9. Notch your pen holder for identification as shown, or use different colored holders.

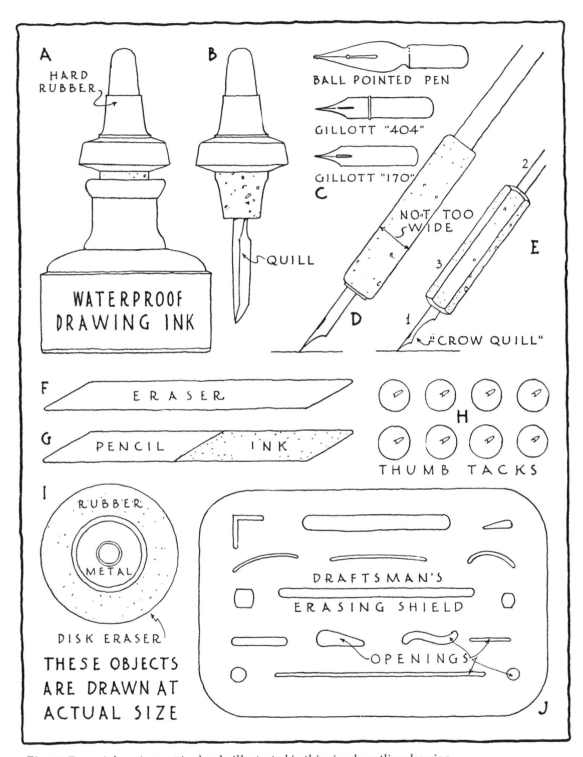

Fig. 10. Essential equipment is clearly illustrated in this simple outline drawing.

use this member is pushed still further down to completely cover and protect the delicate point.

For other pens, holders in general use for writing are satisfactory. In purchasing these, be sure that they are sufficiently small in diameter to enter the neck of a bottle without becoming soiled with ink.

It is generally preferable to vary the colors of your penholders, or to mark them individually with notches, or in some similar method (Fig. 9). This way each may be easily identified at a glance. A red holder might always contain a Gillott 303 pen, a brown one a 404, etc. You will soon become accustomed to this arrangement and save time when changing from one pen to another.

Penwiper

You should have a small chamois or felt, or some practical sort of wiper for your pens, and keep them clean. Avoid using one that is linty with loose particles to catch in the nibs, causing blots.

Ink

Ink, like pens, is of early origin. Evidence of its use is found on papyri and manuscripts dating back more than 4000 years. A large part of this early ink was colored. Today most of the ink used for drawing is black, and much of it is waterproof. Practically all is bottled in liquid form, though for many years artists purchased it in stick form (Fig. 11), grinding it in water on a slate slab (Fig. 12) or similar rough surface until a sufficiently dark liquid was obtained. There are now many kinds on the market which are satisfactory. Of American inks, Higgins' is one of the standards. Of those made in Germany, Pelikan is good. Most of the American inks, including Higgins', are put up in conveniently shaped bottles, not easily tipped over (Fig. 13) with very practical stoppers fitted with quills to aid in filling ruling pens. (See illustrations at A and B, Fig. 10.) Waterproof ink is essential when drawings are to be tinted with color or wet in any way. For other purposes, where they are not to be exposed to moisture, the ordinary black drawing ink is considered by many to flow better than the waterproof.

Use ink from only one bottle on any single drawing, because some inks dry more shiny than others. (We will discuss the many colored inks on the market further in Chapter 20.) Whether the ink is black or colored, each bottle should be kept closed when not in use, to prevent thickening due to evaporation. At best, the ink in a bottle is almost sure to become a bit gummy before it is gone. If it does, dilute it a little according to the manufacturers' directions, though it is generally preferable to buy a new bottle for the finer lines, saving the old for work with a brush or larger pens. When two or more bottles of ink are in use, mark the date of purchase on the label so that the bottles will not be confused.

Papers

Bristol board is one of the most commonly used surfaces for pen drawing, and the better grades offer many advantages for this work. First of all because bristol board is smooth, it allows the pen to move over it in any direction without danger of the points stubbing in rough places. Again, it will stand a fair amount of erasing without serious injury (though erasing does frequently make it somewhat unsightly, destroying the gloss). Bristol board is firm enough to prevent minor irregularities of the surface under it — such as thumbtack holes in the drawing board beneath — from affecting it to any considerable degree. This is a great advantage over some thin papers, which can hardly be worked upon unless bristol or other smooth board is placed under them. Bristol board stays quite flat, too, unless a great amount of ink is used, when it sometimes shows a tendency to buckle. It is stiff enough so the finished drawings may be easily handled. As a rule, both sides of the bristol board are alike, so if one side is ruined the entire sheet is not wasted.

Bristol board is produced in various weights, two or three ply being those customarily employed. Two ply is rather thin but does well for most work; the three ply is an excellent thickness for almost any purpose.

Bristol board also comes in a variety of surfaces, some very glossy, some smooth but only slightly shiny (and this is best for most problems), and some dull. Some bristol boards (called kid-finished) are rather rough. This finish is not as good for most pen work as the smoother grades.

Eraser marks are rather apparent on the smoother grades. Likewise, water makes dull spots of an unpleasant contrasting nature. The board also tends to bend, forming unsightly places if it is rolled and pressed or otherwise misused. Therefore, if the appearance of the finished drawing is important, protect the surface as much as is possible. When you buy bristol board, ask for a good brand — one which is not too soft or absorbent — and then be sure that the sheets have not been bent or dented or otherwise damaged. Never allow bristol board to be rolled tightly, if at all. If you carry it rolled under your arm, protect it from crushing in order to keep its smooth appearance.

If you would prefer something which damages less easily, which stands erasing to better advantage, and which has a surface of a more interesting nature, try some of the smooth-surface (hot-pressed) drawing papers. These can be purchased already mounted or can be bought in sheets at less expense. These sheets may be used just as they are, or, as they have a tendency to wrinkle more easily than bristol board, they may be stretched onto a drawing board.

One method of stretching paper is as follows. Choose a board at least an inch or two larger all around than the paper, and lay the paper loosely on this. With a sponge, wet the paper thoroughly on the

Fig. 11. Stick ink is now almost impossible to find.

Fig. 12. A slate slab for grinding ink is also rare.

Fig. 13. This type of bottled ink does not tip over easily.

Fig. 14. Keep a brush nearby for dusting the paper.

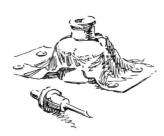

Fig. 15. A bottle holder made of cloth and thumbtacked to the drawing board is easy to make.

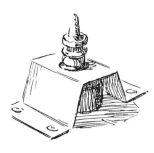

Fig. 16. A paper bottle holder tacked to the board also serves the purpose.

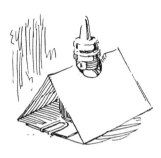

Fig. 17. This bottle holder is made of heavy paper or thin cardboard, joined together with a paper clip.

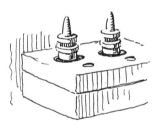

Fig. 18. Here is a holder for two bottles made from a box. Extra holes in the cover are for bottle stoppers.

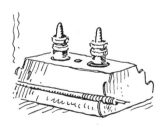

Fig. 19. A cardboard ink stand, holding two bottles and several pen holders is another alternative.

upper side, leaving about an inch of dry edge or margin all around. Allow the water to stand several minutes until the paper has swollen and buckled into a hilly surface. Then sponge off the superfluous water, leaving the paper just damp. As you complete this operation, slightly dampen the previously dry margins. Apply strong mucilage or glue to these margins at once. By the time this is on, the paper will have become fairly flat again, though still hilly. Next turn the paper upside down (it is best to have help with this), being careful not to get glue on the board anywhere under the sheet, and press the glued margins tightly to the board until they adhere all the way around. The paper will still be full of humps. As the edges are pressed down you can draw it a bit smoother, and shrinkage as it dries will do the rest. (Do not pull it too hard, because it will break when dry if the paper is too tight.) If you make sure that the glued edges are kept fast by rubbing them down once or twice with your knife handle or some other convenient object, you will have — in a half hour or less — a splendid surface of great strength: a surface showing injury or marks of erasing far less than bristol board. Of course, you must not extend your drawing onto the glued margins, as it is almost impossible to remove them whole when the rest of the sheet is cut from the board. Usually they are allowed to remain until later, when they are taken off at leisure by soaking thoroughly with water until they are soft, and may be washed or scraped off without trouble.

In addition to this hot-pressed paper, there is another grade known as "cold-pressed." Somewhat rougher, this is really a watercolor surface. Its roughness prevents pen work of the most perfect kind, yet permits certain interesting effects, as all lines drawn upon it have a tendency to be irregular or broken. If you intend to tint your pen drawings with color, this is an especially good paper, though the hot-pressed paper stands washes well too. In respect to wash application both hot-pressed and cold-pressed papers have an advantage over bristol board, which — with the exception of the kid-finished grade — is not well suited to such work.

Besides bristol boards and drawing paper, there are, of course, many other surfaces available which will take the pen well. Generally speaking, the surfaces that are good for writing with a pen will do for drawing. The essential qualities you need are a fair degree of smoothness, coupled with sufficient firmness to prevent stubbing the pen or blotting the ink. You also want the paper to permit the use of an eraser or knife for correction, without becoming absorbent or too unsightly in appearance. Some of the ordinary bond papers meet these specifications satisfactorily, especially those of the heavier weights and better grades.

The architect frequently uses tracing cloth for making pen drawings, first dusting it with prepared powder and then drawing on the dull side. The finished results may then be blueprinted. Prints in black and white, or brown and white, or red and white, also may be obtained. Another advantage of tracing cloth is that its translucency allows it to be used over a previously constructed layout on which the draftsman may work as long as he wishes. The tracing cloth drawing may then be simplified in the final stage to a representation of the essentials.

Tracing papers of stiffer grades are sometimes used in the same way. However, while tracing cloth is strong and will stand almost any amount of erasing, tracing paper is easily torn or pricked through by the pen and can scarcely stand rubbing at all.

Drawing Board

Almost any smooth drawing board of convenient size will do. It is best to have one large enough to support the hand as well as the paper, as you cannot do your best work in cramped space. If the board is at all rough, putting a few extra sheets of paper beneath the drawing paper will make a smoother surface. If paper is to be stretched, it is just as well not to use a new board if an older one is available. The stretching process, with its water and glue, may cause warping, a slight raising of the grain of the wood, and a somewhat unsightly general appearance. However, whether a board is old or new, that part of it beneath the "stretch" (as the stretched paper is called) should be washed beforehand to make sure it is clean; otherwise stains may come through the paper while it is damp, and show on the surface.

Thumbtacks

If paper is not stretched, it is usually thumbtacked to the board. A dozen or so medium-sized thumbtacks may be kept for this purpose, pressed into a convenient part of the drawing board when not in use.

Pencils

Since most drawings are laid out in pencil before they are inked, a few pencils are needed. On smooth bristols, medium or rather soft grades are good, such as HB, B, or 2B. For rougher paper, harder points like the F, H, or 2H are better.

Ruler

Whether or not a scale rule or such instruments as a T-square and triangles are needed depends on the nature of the work.

Erasers

You should have some kind of a soft or medium eraser for removing the pencil construction lines and for cleaning the entire sheet after the pen work is done. Art gum is excellent for this purpose, and is one of the few erasers which can be

used on smooth bristols without destroying the gloss. If employed for the final cleaning of the sheet, the gum eraser will not lighten or gray the pen lines to the extent that many erasers do.

A harder eraser, perhaps one of the red or green ones, as shown at F (Fig. 10), is good for the more stubborn pencil lines and, if employed patiently, will remove ink lines as well. The usual ink erasers such as pictured at G and I (Fig. 10), are too hard and gritty for most paper surfaces, and should be used only with the greatest caution, if at all. Chemical ink eradicators will not remove most of the drawing inks.

Knife

Many artists prefer a good sharp knife or razor blade when it comes to making corrections. A knife is also a great convenience for many other purposes in connection with work of this kind.

Erasing Shield

We illustrate at J (Fig. 10) a thin metal erasing shield of the type draftsmen use. A shield is often almost indispensable when erasures are necessary, as it may be placed on a drawing in a way that exposes to the action of the eraser only those portions of lines that are to be removed.

Brush or Cloth

The habit of dusting your paper every few minutes is excellent because it prevents the accumulation of bits of lint which might get into the pen and cause blots. A soft brush or non-linty cloth will do a good job (Fig. 14).

Blotting Paper

Some accidents are sure to happen. Occasionally a bottle of ink is splashed or spilled, or a pen drips. Keep a few blotters on hand for such an emergency.

Bottle Holders

The danger from spilled ink is so real that some artists, in order to lessen it, use rubber bottle holders which are on the market. Most of these holders are simply containers of sufficient weight and balance to prevent easy overturning of the enclosed bottle (or bottles, as some take care of two or more). Though such a holder is by no means essential, the student, especially if inclined to be careless, will find himself relieved of considerable anxiety if his bottle is secured by something of the sort. Students in school, particularly when working in limited space, really need to take such precautions. It is not necessary to go to the expense of buying holders, as homemade ink stands such as those pictured in Figs. 15 to 19 are also sufficient.

To make a holder, slit the pen wiper (or any cloth of similar size) in the center, creating an opening large enough to permit it to be forced down over the neck of the bottle. Then place a thumbtack through each corner to hold the whole thing tight to the board, as shown in Fig. 15. If thumbtack holes in the board are for any reason objectionable, thumbtack it into a block of wood large enough to prevent easy overturning.

Paper may be substituted for the cloth (Figs. 16 and 17), either thumbtacked down or folded to form a bearing surface of liberal size, and then glued or clipped rigidly. A cardboard box may also be substituted, with an opening through the cover for the bottle neck (Fig. 18). Since the stopper, rolling ink across the paper, is sometimes a nuisance, it is practical to provide an extra hole in which it may be kept out of the way, yet handy when needed. It is sometimes desirable to make provision for two bottles (Figs. 18 and 19), which also makes the holder of sufficient length to include a little rack suitable for supporting a pen or two (Fig. 19), thus adding to its value.

So much, then, for the selection and arrangement of the materials. We must now learn how to begin drawing with them.

3. First Exercises in Pen Handling

Bertram G. Goodhue

Now we will begin the first actual work in pen drawing; work of the very simplest sort, designed to acquaint the beginner with his instruments and provide a logical starting point from which to advance gradually and consistently, as broader perception and increased manual dexterity are gained.

Take Your Time

The beginner must not try to rush ahead too fast. Just be content to master each step, one at a time. Just as the student of the piano would find it impossible to render even the simplest composition completely and correctly until thoroughly drilled in the proper preliminary steps, so the student of drawing will find obstacles equally great if, in his impatience, he attempts a finished drawing of any but the simplest of subjects before mastering the rudimentary exercises provided here.

You must first learn to manipulate the pen itself. It is easier for most of us to handle a pen than a brush or a stick of charcoal or crayon, mainly because we are accustomed to using it in writing. Drawing, however, requires far greater freedom of movement than writing. In writing, the pen is held in very much the same position; in drawing, the position is frequently varied. In writing, a comparatively small number of standardized curves and straight lines are combined in a methodical and frequently repeated manner. In drawing, there is almost no end to the variety in length, direction, and character of the lines used or to the methods of combining them. The penman, then, seeks a certain monotonous perfection of stroke; the artist, on the other hand, must acquire the greatest possible versatility in the command of his instrument. The artist must be able to draw long, sweeping strokes, bold vigorous lines, crisp dashes, and delicate dots. He must be able to draw reasonably straight lines and pleasingly curved lines, singly or in combination. And he must have the skill to draw all of these when and where he pleases on his paper, vertically, horizontally, or slantwise. This must be accomplished, however, with little conscious effort, so that attention is freed for the development of the composition as a whole.

This does not mean you should never attempt finished pen drawings until you have absolute control of your pen — a stage which you will probably never reach anyway. But after what seems a reasonable amount of practice in drawing individual lines and in building simple ones (depending on your natural aptitude and previous experience), you should progress directly to making drawings.

Continue your pen practice in these finished drawings by varying its handling from time to time. Also experiment with different pens and different papers, and with drawings of various sizes. Meanwhile keep up additional pen exercises in your spare moments, scratching a few lines or building tones whenever opportunity offers, until you have arrived at a really worthwhile degree of proficiency. And don't forget: just as trained musicians run their scales and otherwise work to keep in practice, many experienced artists spend their leisure hours sketching in order to retain the skill that is already theirs.

Tools for Your Practice

Now just a word as to the materials for this first work. Not all of those described in the previous chapter are needed. The following, however, are really essential:

1. Several sheets of smooth white paper or bristol board of convenient size.

2. A medium pen or two, such as the Gillott 303 and 404.

3. A penholder and a wiper.

4. A bottle of black drawing ink.

5. A drawing board or other suitable support.

6. A few pencils, thumbtacks, and one or two erasers.

Most of the drawing bristols are sold in sheets of 22 x 30, 22 x 28, and 23 x 29 inches, or 50 x 70 and 51 x 71 cm. Each sheet, cut in quarters, gives four sheets of about 11 x 14 or 15 inches/20x30 cm, a good size and proportion for most work of a preliminary character.

Cut all paper used to a uniform size, so far as possible, so that you will gradually form a collection of drawings which will fit well together either in exhibition or in a folio used for their protection. Above all, don't try to economize by using too cheap a paper.

Setting Up

Thumbtack a sheet of your paper to a drawing board or, as a substitute, lay it on a stiff, firm book or similar support; the board is preferable. Sometimes the paper, especially if it is a stiff bristol, may be laid on a smooth table top with nothing else under it. The size of the drawing board is optional, though don't use one smaller than 16 x 23 inches/40 x 51 cm. A large enough board should accommodate a half sheet of bristol (about 15 x 22 inches /31 x 50 cm) and permit you to work on the quarter sheet without cramping.

When you are ready to draw, sit in a natural position. It is usually best to sit facing a table with the drawing board on top of it or resting against the edge, and tipped in such a way that the eye can

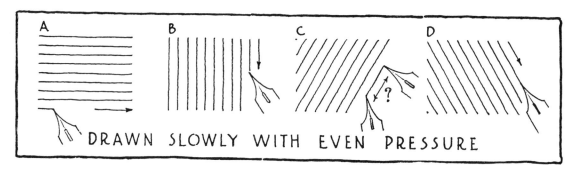

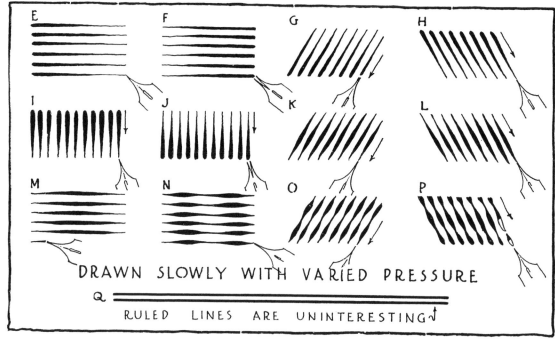

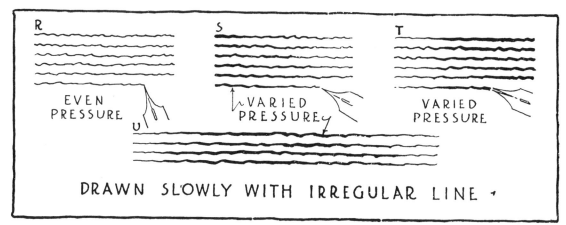

Fig. 20. Here are some elementary straight-line practice strokes. Try many kinds of strokes to gain facility.

Fig. 21. Draw vertical guidelines in pencil.

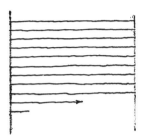

Fig. 22. Start and stop your ink lines exactly at the pencil guides.

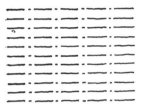

Fig. 23. Practice dot and dash lines, keeping them in an even line.

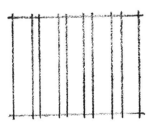

Fig. 24. Draw pencil guidelines if necessary.

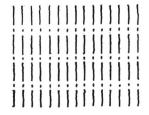

Fig. 25. Try some lines vertically.

view the entire paper easily. Be sure the sheet is will lighted, with the light falling from the left if possible. If the paper surface is shiny, be sure that no harmful and disturbing reflection of light is thrown back into your eyes. Place the ink bottle in a convenient position, usually to the right so you have it within easy reach, but not too near the edge of the table where it might be pushed off onto the floor. Next place a pencil or two and the pens and erasers nearby (and also keep a blotter or rag handy for emergency), and you are ready to begin.

Holding the Pen

Try to hold the pen naturally, much the same as for writing. (We have already said, however, that it will be necessary to vary its position to some extent for different types and directions of line, having it sometimes twisted or turned, sometimes almost vertical, and again more nearly horizontal.) Keep your fingers far enough back from the point to prevent them from becoming daubed with ink, and above all, don't cramp your fingers tightly onto the penholder.

Before starting the first lines, place an extra paper (any clean sheet will do) under your hand to protect the surface of the drawing paper from dirt and moisture. Get the habit of working in this way from the start, seldom allowing your hand to touch the surface of the drawing.

The First Even Lines

Now dip your pen in ink and confidently begin practicing the simplest types of lines. Don't work hastily or carelessly; try to make each line a thing of real feeling and beauty. Too often the beginner is misled into copying what seem to be carelessly drawn lines made by well-known artists. Lines of this sort are often the result of years of practice and usually very hard to imitate successfully. And remember that some well-known artists are famous *in spite* of their technique rather than *because* of it.

Straight lines offer a natural starting point for this practice. Fig. 20 shows a few practical straight-line exercises. Because this illustration and those immediately following it have been reproduced at the size of the original drawings and have not been corrected or touched up in any way, each stroke appears almost exactly as drawn.

Copy these exercises, starting with the horizontal strokes shown at A. The arrows indicate the directions in which the original strokes were drawn, and the pen points show the approximate angles at which the pen was held. It is possible and proper to draw strokes like those at C in either of the directions indicated.

If you are left-handed you will naturally reverse the exercises, not only on this page, but throughout the whole book. Left-handedness, by the way, is seldom a handicap in freehand drawing; some of our best artists have been left-handed. At least one of our masters of the pen—

Fig. 26. Do some slanting lines—with or without pencil guidelines.

Fig. 27. Measure off even spaces and mark them in pencil with a dot. Connect these dots by eye with your pen.

Fig. 28. Try a variety of lines.

Fig. 29. Avoid any mechanical effects in this practice work.

Fig. 30. Invent exercises of your own.

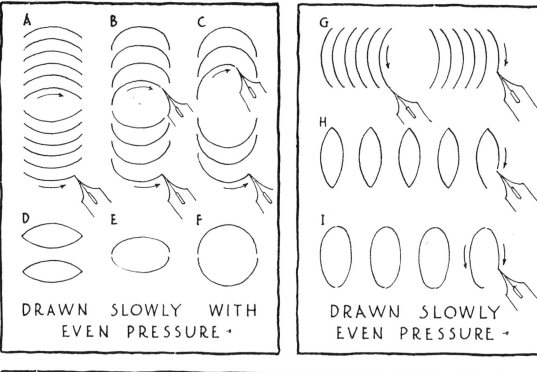

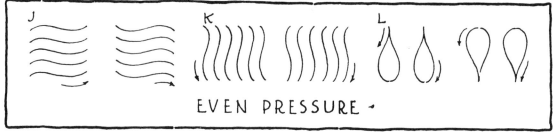

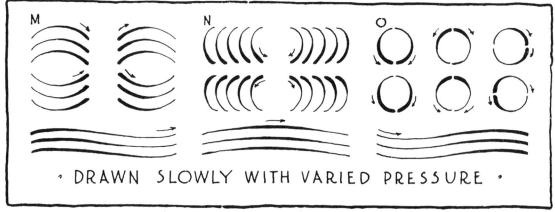

Fig. 31. Here are some typical curved-line practice strokes. Study carefully and invent your own exercises.

Daniel Vierge — was forced (because of a stroke) to change from his right hand to his left rather late in life, and did so with little detriment to his style, once the adjustment was made.

Draw many strokes similar to those at A, B, C, and D. Vary their length and direction. Draw some slowly; some swiftly. Fill several sheets with them. Try different ways of holding the pen. Try different pens if you wish.

Helpful Exercises

As you draw, you will probably be able to discover some of your own weaknesses. You may have a tendency to run the lines which are intended to be horizontal up or down hill, or to tip your verticals. You may find it hard to start and stop your strokes just where you wish, or to keep them parallel. If these problems are yours, perhaps your paper is not directly in front of you, a situation that inevitably causes difficulties. Get it right and then try again. If you find yourself unable to start and stop your strokes where you wish, try the exercises shown in Figs. 21 to 30

Suppose, for instance, you are practicing horizontal lines. First rule with your pencil two vertical lines, as in Fig. 21, as guides for the ends of the horizontal lines. Next practice doing the horizontals, starting and stopping them exactly on the penciled verticals, as in Fig. 22. Try some longer ones and some shorter ones in the same way and then do likewise with vertical and slanted strokes. As a further ex-

ercise of advantage at this time, practice dot and dash lines of the type shown in Fig. 23, trying to space the dashes in even vertical rows, one above the other. Draw pencil guide lines, if necessary, as in Fig. 24. Try also some dot and dash lines drawn vertically and in tipped positions as in Fig. 25 and 26. Here again, if you have trouble getting your lines parallel or evenly spaced, there is no harm at first in laying out some pencil guide lines with your ruler, one for each line if necessary, later going over them freehand in ink. Try not to do much measuring or ruling, however; try instead to train your eye and hand.

A good exercise for teaching you to draw in any desired direction is shown in Fig. 27. Here pencil dots were carefully spaced for the beginning and ending of each line; then the lines were drawn. Those in this sketch are rather short; try drawing similar dots 5 or 6 inches/12 or 15 cm apart so it becomes necessary for you to draw very long lines. If you practice this you will soon find yourself able to carry a line way across a sheet of paper to any desired spot with only slight variations in direction.

Now Vary the Pressure

After you have practiced all of these exercises, done with comparatively even pressure of the pen, turn back to Fig. 20. Make strokes such as those shown from E to P, tapering or shading each from dark to light or from light to dark. Work with

care but don't expect too much mechanical perfection; notice that the ruled lines at Q are too straight and perfect to be interesting. Exercises like these will teach you some of the real capabilities of your pen, so they are most important.

Sometimes an evident shake or tremor to a line is highly desirable, so also practice making irregular lines, such as those at R, S, T, and U. Draw them straight in general direction, some long and some short, some with even and some with varied pressure, and show them at different slants as well as vertical and horizontal. Figs. 28, 29, and 30 offer additional suggestions of a similar nature.

Curved Lines

Now turn to Fig. 31, which shows a variety of curved lines. This illustration speaks for itself. Here again, copy these exercises and then devise others of your own. These were drawn slowly; draw some similar strokes quickly. Copy other strokes from pen reproductions, too; hunt and see how many types you can find.

When you have made many kinds of individual lines over and over again, and think you are getting the "feel" of your pen, you are ready to turn to the next chapter, and work with combining strokes into tones.

In leaving this chapter, however, keep the thought in mind that whenever you get the opportunity you should come back to practice the sort of thing suggested here.

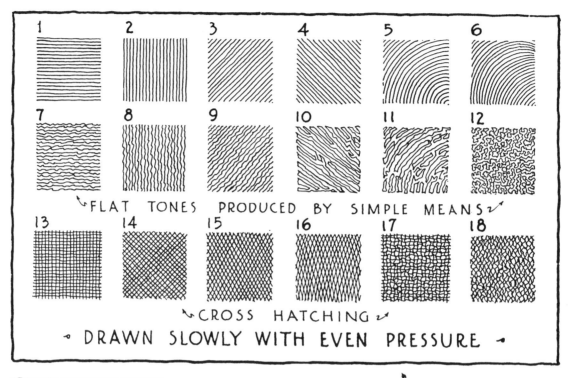

1 2 3 4 5 6

7 8 9 10 11 12

FLAT TONES PRODUCED BY SIMPLE MEANS

13 14 15 16 17 18

CROSS HATCHING

• DRAWN SLOWLY WITH EVEN PRESSURE •

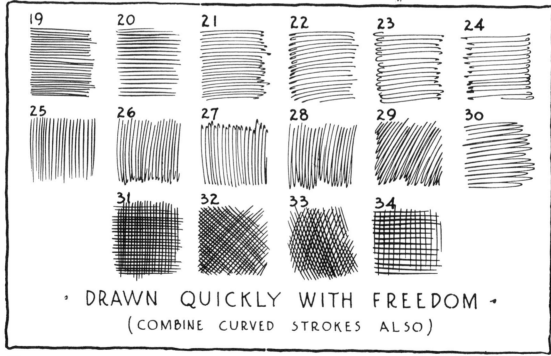

19 20 21 22 23 24

25 26 27 28 29 30

31 32 33 34

• DRAWN QUICKLY WITH FREEDOM •
(COMBINE CURVED STROKES ALSO)

Fig. 32. Here are various methods of combining straight and curved strokes into areas of tone. Practice this kind of exercise whenever you can.

4. Practice in Tone Building

W. D. Teague

Many pen drawings are done in outline alone, but a far larger number of drawings make use of varying tones of gray, often in conjunction with areas of pure black. Because of this, it is important to study methods of tone building at the outset, to provide a preliminary foundation for later work.

We pointed out in Chapter 1 that in pen work each line or dot made is pure black, and usually on white paper. But the effect of either light or dark gray is obtained only by placing dots or lines of pure black close together so as to produce a result which *appears* gray. The process of learning to suggest grays of different tone, and at the same time to indicate textures of numerous sorts, is very fascinating. Innumerable combinations of many kinds of dots and lines are possible. Start with some of the simpler ones such as are shown in Figs. 32 and 33, and later you can experiment with other methods.

First Study These Examples

Before you begin, turn to the illustrations for a moment. In Fig. 34 lines have been drawn with a medium pen (Gillott 303) 1/8 inch/3.2 mm apart in a space 1 inch/ 0.025 mm square. In Fig. 35 the same pen has been used, but the lines have been drawn 1/16 inch/1.6 mm inch apart; in Fig. 36 twice as many lines 1/32 inch /0.8 mm apart occupy an equal area, and these, too, were drawn with the same pen. Figs. 37, 38, and 39 have a disposition of lines similar to Figs. 34, 35, and 36 respectively, and seem darker only because drawn with a considerably heavier pen.

The lines in Figs. 34 and 37 are all at the 1/8 inch/3.2 mm spacing. Arranged in this way, and with the book held two feet or more from the eye, they count as individual lines rather than subordinate parts of a tone. This is especially true of the darker ones in Fig. 37. If spaced closer, as

in Figs. 35 and 38, we become less conscious of the separate strokes and more conscious of each tone as a unit, yet the lines are still rather prominent. At Figs. 36 and 39 tone has taken definite precedent over line. The areas in Figs. 36 and 39 have grown much darker than in Figs. 34 and 37 because of the larger proportion of white paper covered.

For a second and similar example, compare Fig. 32 with Fig. 20. It will be seen that Tones 1, 2, 3, and 4 of Fig. 32 are practically the same in formation as Lines A, B, C, and D of Fig. 20. Here, again, the main point of difference is that in Fig. 32 the various parallel lines in each group are kept so close together that they tend to merge into a unified whole.

Building Tones with Straight Lines

Tones such as these—built up of straight lines—are among the most common used in pen work, and, being the easiest to do, afford a good starting point for the beginner. Begin by copying the examples at the top of Fig. 32. Just as a general rule, make the strokes approximately 1/32 inch/0.8 mm apart, the same spacing as used in Figs. 36 and 39. Don't measure, however; there should be nothing mechanical about such exercises. As in actual pen drawing, the spacing depends on many things and is usually variable. It is generally worse to get lines too close together than too far apart, for unless a reasonable distance is left between them, they may blot or run together in places, which is often objectionable. Particularly when the work is made for reproduction, the lines must be quite openly spaced, as most drawings are reduced, which means the spaces between the lines will be diminished. If the work is not sufficiently "open," the lines may fill in.

Practice drawing many of these small areas of tone, keeping the lines evenly

spaced so as to give a uniform grayness or flatness to each. Draw them with lines slanting in various directions, and with curves like Tones 5 and 6, Fig. 32. Try different pens and papers.

Once you have gained a fair facility in making these even lines, practice with a greater variety of lines. Aside from indicating different tones you must learn to suggest various textures, and this demands an acquaintance with the greatest possible variety of lines and tones. The squares from 7 to 11, in Fig. 32, are much like those from 1 to 5, except for the wavering or wandering quality of the lines. At 12 is an extreme example of the type of line which wanders, changing direction to such an extent that the tone scarcely seems made up of lines at all. It is worth observing that in this tone variable areas of white, about 1/32 inch/0.8 mm wide, do actually separate all parts of the wandering lines.

Practice all these exercises, hunt for other examples of tones, and invent some of your own. But remember when copying reproductions, that the apparent fineness and close spacing of lines is often the result of great reduction from the sizes of the originals.

The work we have suggested will soon give you a reasonable dexterity in filling small areas with simple tone. You will find that you are able to control the degree of darkness of each area in two ways: first by varying the distances between the lines, and second by differing the widths of the lines themselves. You will need this knowledge constantly; if you build a tone of gray and find it too light, you may darken it by adding more lines between those already drawn or by widening the existing ones. In the first instance the tone becomes more homogeneous; in the second the lines themselves grow somewhat more prominent. This is sometimes an advantage, especially when the lines

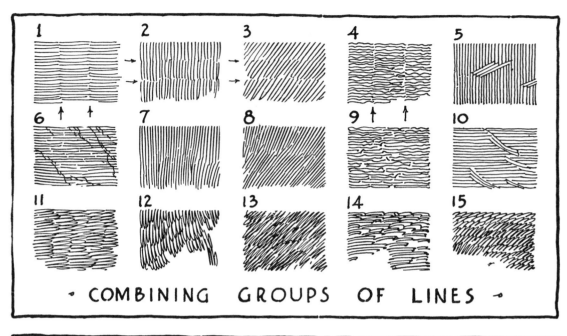

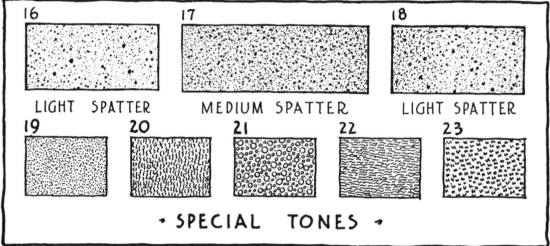

Fig. 33. Here are more examples of areas of tone built up using a variety of methods. Analyze other examples of pen work in this book to determine their tone formation.

Fig. 34. This is 1/8 inch/3.2 mm spacing with a medium pen.

Fig. 35. This is 1/16 inch/1.6 mm spacing with a medium pen.

Fig. 36. This is 1/32 inch/0.8 mm spacing with a medium pen.

Fig. 37. This is 1/8 inch/3.2 mm spacing with a coarse pen.

Fig. 38. This is 1/16 inch/1.6 mm spacing with a coarse pen.

Fig. 39. This is 1/32 inch/0.8 mm spacing with a coarse pen.

suggest some particular texture. On the other hand, it is often of equal disadvantage when they do not.

The tones to which we have so far referred might be called "open"; each stroke is a fairly definite and complete thing. For many kinds of work such tones are eminently satisfactory. There are some purposes better served by other types, however, as you will see in later chapters. Among these, tones made up by crossing lines (or "crosshatching" as it is called) have their occasional place and, although they are not recommended for too frequent use, they are worth practicing. From Tones 13 to 18, Fig. 32, we have shown several examples of crosshatching which explain themselves.

Drawing Tones Freely

In the lower half of the page you can see tones built up with far greater freedom. These are probably more typical of most of those used in pen work than are the others above, yet all kinds are important. These tones were formed very quickly, and in copying them do not expect to duplicate them exactly. Instead try to work for their general effect. Try others of your own, too, using curved lines, as well as straighter ones. Vary the weight and length of lines and try tones consisting of tapered strokes, like those discussed in describing Figs. 20 and 31.

Notice in particular the "hooked" strokes shown in several of the examples. There are many uses for these, some of which will be pointed out or discussed in subsequent chapters.

Combining Lines

At this stage you should be able to draw a large variety of individual strokes, and combine them into small areas of tone. It is easier and more satisfactory to do this than to cover the larger and somewhat irregular areas as are necessary in most drawings. Therefore, the next move is to attempt this very thing.

The upper half of Fig. 33 is designed to show a few of many practical combinations of lines. The first four tones require little explanation. The arrows are directed to the lines (or, more properly, spaces) of junction between the various groups of strokes. In grouping lines in this way, be sure to make these points of junction as inconspicuous as possible. Avoid the patchy effects shown in Fig. 40. If tones are built of patches it is customary and better to join them as in Fig. 41 in order to obtain homogeneous effects. Tones 6, 7, 8, and 9, Fig. 33, should be compared with Tones 1, 2, 3, and 4, as they are very similar. These largely disguise or do away with the junction lines just mentioned, through the use of greater variety in length and direction of stroke. Tones 5 and 10 show interesting slanting interruptions to the straight vertical and horizontal lines. This sort of thing is very useful for some purposes, especially where a large area of tone has a tendency

Fig. 40. Avoid patchy effects like this.

Fig. 41. If tones are built of patches, be sure to join the patches like this.

Fig. 42. Ink may be spattered with a safety match and brush.

Fig. 43. You may also spatter ink with a screen and brush.

to become monotonous in character. The lines dragged across Tone 6 serve a similar purpose. Tones 11 to 15 were drawn with great freedom; these would be particularly useful in representing rough-textured objects of many kinds.

As with previous examples, practice these tones and seek out others, from available pen drawings and reproductions, and copy them over and over, besides carrying on your own experiments.

Creating Special Tones

In drawings of a highly conventional nature or decorative quality, tones such as those at the lower half of Fig. 33 are often seen. These tones not only give the desired value of light and dark, but also show some special texture or pattern. Though interesting, they are of less importance at this time than are those shown previously, with the exception, perhaps, of the spatter tones shown in squares 16, 17, and 18, and the stippled tone at 19.

The stippled tone was made by dotting the entire surface with fine dots of the pen, care being taken to avoid the stiff effect that might follow if they were arranged in straight lines. Such a tone is often most useful; distant hills or mountains may be expressed by it, as well as such rough surfaces as stone or stucco walls.

For similar purposes, the spatter tones are good, too. These may be done in several ways. In all of them it is necessary to cover the portions of the paper that are to be kept free from spatter.

If the areas to be spattered are simple in shape, even, and true, the rest of the paper can be easily protected by strips of heavy paper or cardboard; stencil board is excellent. When the shapes to be hidden are irregular in shape—and consequently harder to cover with paper—pure artists' rubber cement is sometimes painted directly onto the parts to be protected. After the inking is done (this will be explained in a moment) the cement is rolled off by the fingers without injury to the paper. Impure cements must be avoided, as they stain paper.

For covering drawings during spraying operations, some artists use what is known as *frisket paper*. This is a somewhat transparent or, more properly, translucent paper, which is coated with rubber cement. The paper is pressed down over the entire drawing, and the frisket is cut with a sharp knife or razor blade to the exact outline of the parts to be spattered. The unwanted portions are stripped off, and the finger is next rubbed over the exposed portion of the drawing surface in order to remove any remaining cement. After this, the spattering is done.

Heavy tracing paper is often used as a substitute for the frisket. This is cut out with the razor blade in the same way, and then held down by rubber cement, pins, or small weights placed along the edges. Because the tracing paper may wrinkle from the dampness of the ink, care must be taken that the spray is not spattered under it.

When the paper has been properly prepared using one of the methods described, a scheme for the spattering must be determined and carried out. There are several practical methods. In one of them a toothbrush is dipped in the black ink so that each bristle is inked for 1/8 inch/3.2 mm or so. Some prefer to ink the brush by rubbing the bristles with the quill of the ink bottle stopper. Then, with the brush held nearly horizontally in the left hand, bristles up, as in Fig. 42, stroke the bristles toward you with a wooden match or toothpick, causing them when released to snap or catapult tiny drops of ink onto the exposed paper until it has been sufficiently darkened. Too much ink in the brush will naturally cause blots, so it is best to try the process on waste paper before risking the drawing. Another method is to rub the ink-charged brush, bristles down, over a piece of screening held a couple of inches or millimeters above the flat or nearly flat drawing (Fig. 43). This method probably offers the artist somewhat better control over the medium. Still another method is to blow a spray of ink onto the drawing with a small atomizer or fixative blower.

These somewhat lengthy explanations of methods of stippling and spattering tones are enough to show that such work is not easily done. Stippling is the simpler of the two methods if the areas to be covered are small. By varying the sizes of pens it is possible to vary the stippled effects in very interesting ways. You also have better control over the stipple; the more dots the darker the tone, of course, and graded effects are easy to obtain.

There are several dangers from spattering. First, it is hard to judge the value of the tone correctly, and easy to get it too dark. Second, it is difficult to keep from getting some of the tiny drops of ink under the frisket or protecting paper. It is easy, if you become impatient, to blow or spatter so many small drops onto the drawing that they run together and form blots before they have time to dry. It is preferable to stop for a few moments now and then to give the ink a chance to dry. In spite of these difficulties (which a little experience will overcome), spattering is much quicker than stippling for large surfaces, even though more preliminary work is necessary. Once the spattering itself is begun it progresses very rapidly.

The samples of spatter work which we have shown in Fig. 33 are rather light, especially Tone 16. Tone 17 is darker and Tone 18 grades from the medium to the lighter tone. Many spatter tones are much darker than these. Both the spatter work and the stipple work reproduce so well that various mechanical stipples have been invented which are sometimes substituted — as a means of saving time — when drawing for reproduction. Both stipple and spatter are often employed in conjunction with line, the dots being made in some cases in areas which are free from line or simply bounded by outline, and sometimes on top of tone built up of strokes. In Chapter 20 further discussion of both stipple and spatter will be found.

Before leaving this subject it seems best to issue a word of warning, particularly to the beginner: these expedients, stippling and spattering, are not truly pen drawing. They produce results so different in character from the customary forms of pen work that if used injudiciously or to excess, they are almost sure to cause trouble. Keep them in mind, however, and try them occasionally. In the meantime, gain the greatest possible proficiency combining true pen strokes.

5. Elementary Steps in Value Study

Herbert S. Kates

In the previous pages we have used the word "value" a number of times. Let us see what this word really means. In its customary significance outside of the realm of art, the word relates, as we know, to the desirability or worth of a thing, sometimes to its utility or its market price. In the world of music value refers to the relative length of a tone as signified by a note. Its use in art is similar to its use in music, except that instead of referring to the relative length of a tone, value refers to the relative amount of light or dark in some given area. If an object is light in color or tone, for instance, we say that it is light in value; if dark in color or tone we call it dark in value; if of medium tone we pronounce it of middle value.

Obtaining Values in Pen Drawing

In pen drawing if we wish to represent an object which is light in value we usually do so—though there are exceptions—by employing tones which are also light in value. If we wish to picture some very dark object in a natural way we use values which are dark. If our desire is to show the appearance of a dark red apple against a light yellow background we use values of dark and light closely approximating the amount of dark and light in the objects themselves. Because of the technical limitations of the pen, however—which make it difficult to show all the possible range of values from the white of the paper to the black of the ink—we frequently simplify actual values in their representation, as was mentioned in Chapter 1. Light objects, for example, are often shown as white, and dark ones as black, and if objects have a larger number of slightly varying tones which do not seem wholly necessary to the satisfactory pictorial expression of the objects, these tones are simplified in the representation, only the general values of each mass being expressed.

Notice the delightful sketch by Herbert S. Kates, heading this chapter, for instance: very few values have been used. There is the white of the paper, also a gray middle value, and finally a few black touches — that is all — yet the whole is most effective. The simplicity of the handling is consistent with the plainness of the architecture.

In making a pen drawing — or any sort of picture, for that matter — it is not the absolute correctness of each individual tone that is most important (though no one can doubt the usual advantage of a reasonable degree of accuracy), but it is the right arrangement or disposition of the various values of light and dark that is particularly essential. It is easy to get objects "out of value" with their surroundings even though they seem good individually. But it is too early to discuss this relationship of one value to another, Chapter 10 on composition being partly devoted to this very thing.

What we do wish to impress on you is that if you learn to express individual values at the outset, in various techniques indicative of many materials or surfaces, later you will make use of this knowledge almost unconsciously, keeping your mind free to cope with other difficulties of drawing and composition.

Making Value Scales

To start value practice, make several scales somewhat similar to that shown in the value scale (A) at 1, Fig. 44 or in Figs. 45, 46, and 47. In Fig. 44 the upper rectangular space indicates the white. The black was drawn next. In the middle gray notice that the black lines are approximately the same widths as the white spaces left between them: this middle value is truly halfway between the black and the white. The light gray is intended to be halfway between the white and the middle gray, and the dark gray halfway

between the middle gray and the black, so the whole scale gives a natural gradation from the white to the black. Unfortunately, the light gray in this value scale (A) seems to show too sudden a change from the white. This is largely an optical effect due to the exaggerated emphasis given to the white by the strong contrast of the margin lines around it, and to the darkening tendency that the black margins have on the light gray tone. Fig. 45 is better in this respect. Copy this scale, then, allowing the tones to be adjacently disposed as indicated. In this sketch we show no pure white or black, but a graded adjustment of five values from very light to very dark gray. The change in value is brought about by adding to the number of lines in each unit of tone, from the light to the dark, and by slightly widening the lines by increased pen pressure as the dark is approached. In Fig. 46 cross-hatching has been used to produce similar tonal results. Fig. 47 shows a somewhat freer type of technique employed in much the same way. To turn back to Fig. 44, at 3 of the value scale (B), we see that it is possible to form areas of almost any desired tone even when definite patterns of decorative effects are the means.

Building Gray Values

Once you have made a number of these scales (you may add tones showing a wider range of values if you wish, a common number being nine, or one between each pair which we have shown in Fig. 44) you should try the interesting experiment of attempting to represent portions of objects of neutral color in the correct value of pen tone. Take a bit of gray paper, for instance, and try to produce in ink on your white drawing paper an approximately correct effect of the value of the gray. Or take a white cardboard box and attempt to build a gray corresponding to the white of some portion of the box as it

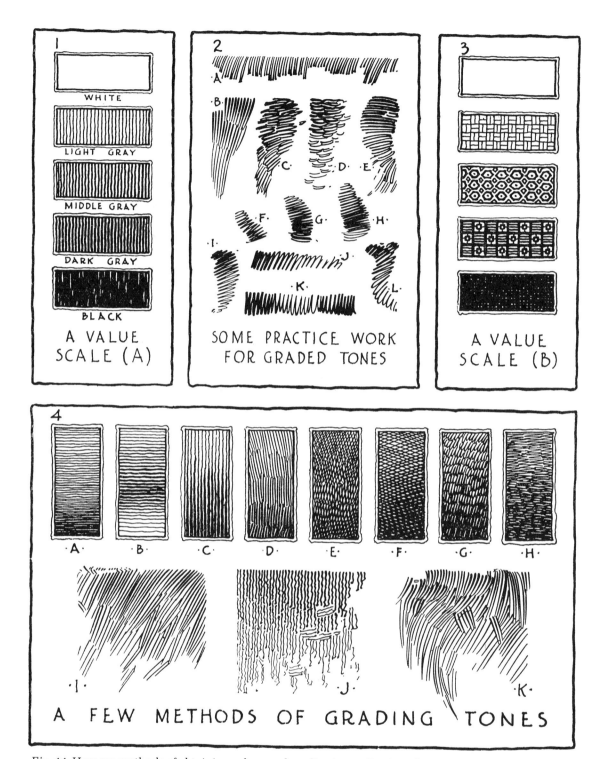

Fig. 44. Here are methods of obtaining values and grading tones. Don't underestimate the importance of this practice.

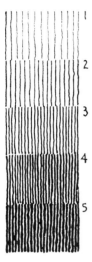

Fig. 45. Copy this value scale, placing one tone directly against the next. Notice that neither pure white nor any solid black appears at either extreme of the scale.

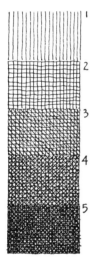

Fig. 46. A value scale may be indicated with cross-hatch.

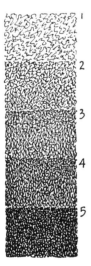

Fig. 47. This value scale is even freer in treatment, yet no less effective.

appears grayed by shade or shadow. (The intent should not be to draw the box, but merely to indicate a small area of its tone.)

By dealing with grays, whose relative values are *perceived* without great difficulty, the problem is mainly one of *representing* those values. When objects are in color, however, it takes some skill for the artist to perceive them correctly, as well as to translate or interpret them in terms of gray. As an aid in determining the correct value of any surface—whether neutral or in color—it is helpful to compare the surface with some white object (a sheet of white paper will do nicely) which is turned to receive the maximum available light. You will find that many objects of different colors may have the same value, while objects actually the same in both color and value may vary greatly in apparent value, due to differences in their lighting.

Grading Tones

Up to this point in our pen practice, we have considered mainly units of tone that are comparatively flat, or uniformly gray, throughout. These are the ones which you should practice first. But since many objects show gradations of tone, you are hardly qualified to attempt to render them until you have become somewhat proficient in grading areas of your paper surface with pen tone. Try building graded tones as soon as you have acquired reasonable skill in handling the flat ones.

The group of flat tones in Fig. 45 gives something of a graded effect — if arranged as they are here—but the gradation is lacking in smoothness. It is only a step from this, however, to the making of similar graded tones such as Figs. 48, 49, 50, and 51. Practice the formation of tones of this kind. Fig. 44 shows other methods of grading work. In Section 2 there are a number of free stroke combinations running from light to dark or from dark to light, and you should try many arrangements of this sort. In Section 4 we have from A to H a group of more carefully constructed tones, each of which is graded to some extent. In that at A, lines of uniform width have been used but have been more closely spaced towards the bottom, until finally they touch and merge into practically solid black. At B the pen pressure has been varied so that it has gradually increased and then decreased the weight of the strokes — shading the tone from light to dark and back again. At C we have an example of the sort of tone which is produced when tapering lines of the kind shown at J, Fig. 20, are used in juxtaposition. Tones D, E, F, G, and H, speak for themselves. At I, J, and K, are larger areas, graded with somewhat more freedom.

Innumerable combinations similar to these are possible. Try some of them so that after this practice, you will have sufficient dexterity to allow you to proceed rapidly with the more interesting problems to follow.

Fig. 48. It is not necessary to separate tonal areas completely in order to suggest change.

Fig. 49. A variety of strokes may be used to obtain similar effects.

Fig. 50. Graded tones have been indicated here with free strokes.

Fig. 51. Here values are indicated by increasing the width of the horizontal strokes.

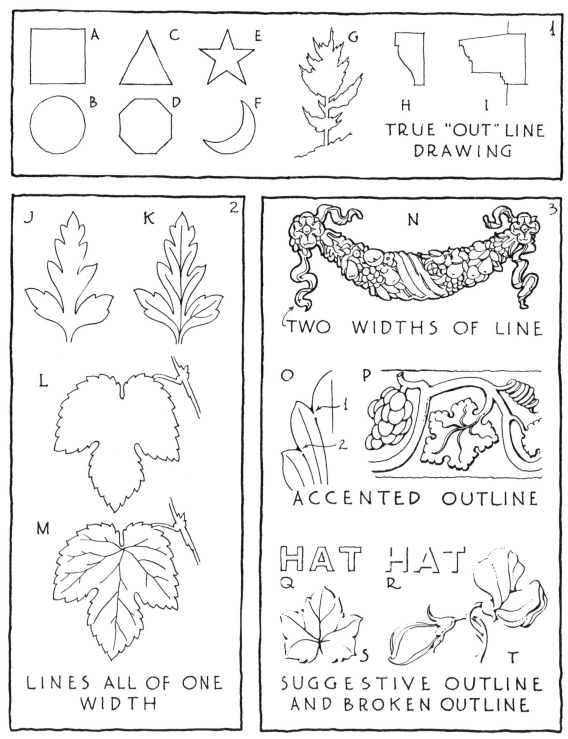

In the image, the panels contain the following labels:

Panel 1: A, B, C, D, E, F, G, H, I — TRUE "OUT" LINE DRAWING

Panel 2: J, K, L, M — LINES ALL OF ONE WIDTH

Panel 3: N — TWO WIDTHS OF LINE; O, P — ACCENTED OUTLINE; Q, R, S, T — SUGGESTIVE OUTLINE AND BROKEN OUTLINE; HAT HAT

Fig. 52. Here are some examples of the most common types of simple outline drawing.

6. Kinds of Outline and Their Uses

Bob Fink

In Chapter 1 we mentioned that actual objects have no true outlines, no definite edges or profiles bounding them that appear as lines. We see one object as distinct from others only because it is lighter or darker, or of a different color, or has shade or shadow tones upon it or about it, or other effects of illumination that define it or detach it from its surroundings. If you doubt the truth of this, just examine objects with an unprejudiced eye. In some instances you will find what at first glance may appear to be outlines, but analysis will prove them to be nothing but extremely narrow areas of tone either light, shade, shadow, or perhaps color.

Despite this, it is very hard for us to think of objects as not bounded by definite lines. Stated conversely, it is remarkably easy for us to think of objects as though they were actually bounded by definite lines.

If you draw these imaginary boundary lines of some object, and add similar lines showing the separation of one part (or tone or color) of the object from another, you have an outline drawing of the object. As this is a comparatively simple and natural process, it is fair to say that the outline offers the easiest and most natural form of pictorial delineation. If proof of this is needed, study the drawings of children. Even very young children express themselves naturally in outline, as have primitive people in widely scattered portions of the world. The sketches in Fig. 53 further exemplify this. They were drawn by a child of four.

Pen and ink, because of its ready adaptability to linear representation, is the most logical medium for outline drawing. Nothing excels it for the sharp delineation of form and precision of draftsmanship.

When the very young child employs outline he gives little thought to the nature of the line itself. For obvious reasons he seldom finds the opportunity to use ink, but hand him a pencil and he will at once hunt for some surface on which it will mark plainly. He will then draw until the point is worn away or until he loses interest. If the point happens to be wide he will be satisfied with the broad strokes; if fine and sharp, he will generally take equal pleasure in his work, unless the lines seem too indistinct. Hand him a piece of white crayon, and he will hunt for a dark surface on which the lines will show well. Again the size and characteristics of the lines will interest him little, if at all, if they are of sufficient strength to satisfy his vanity.

Types of Outline Drawing

The artist, on the contrary, knows that if he is to express everything he desires, and express it well, he must learn to use many kinds of outline, ranging from the most direct to the most subtle. He realizes that there must be a definite relationship between the type of line drawn and the size and characater of the subject pictured, as well as the size and purpose of the drawing itself. He works to master these many kinds of lines and to improve his knowledge of their natural and proper uses.

The simplest of the outlines which we have in pen work is that employed in Section 1, Fig. 52. This is a line of approximately uniform thickness throughout, entirely bounding each object depicted. This is, therefore, a true "out" line or outer line — a profile. Other examples are shown in Section 2 (J and L) in Fig. 52. Such a line is sometimes quite satisfactory for representing extremely simple objects of expressive contour, or those which are flat or low in relief, or even solid or rounded forms whose characteristics are already well known to us. It

Fig. 53. These drawings were done by a four-year-old child.

Fig. 54. Notice how accented outline can be used to treat a variety of subjects.

makes little diffence whether the forms are geometric like those in Section 1 (*A, B, C, D,* etc.) or irregular like the tree shape at *G.*

Architects often use simple contour lines to express the cross sections of individual moldings, as at *H,* or of groups of moldings such as those forming the cornice at *I.*

For most purposes, however, such meager outline work is insufficient. It needs to be supplemented with enough additional line work, within the forms bounded by the profile lines, to render the whole understandable and interesting. At *K* and *M,* for example, lines have been added with the leaf forms outlined at *J* and *L.* The resulting sketches tell a more complete and satisfactory story.

This at *K* and *M* is the most common simple form of outline drawing: a line bounding each object, with additional lines within to mark off or define every essential portion and to give adequate expression to the whole, all the lines being approximately one width. This kind of work is applicable to many types of subjects. Without copying these drawings, select subjects which appeal to you, either objects or photographs (making sure that they offer good variety of practice), and draw them in this general manner. Fig. 10, illustrating equipment, was done by this method; all lines except for the margins were drawn with a Gillott 303 pen.

A Word for the Draftsman

A bit later we shall offer a few special instructions for the architectural student or draftsman. But for now, practice this simple form of outline work; it is excellent preparation for office practice, where the draftsman is often called upon to draw ornaments or moldings or to do lettering of a type which will harmonize well with the instrumental portions of architectural drawings. The draftsman should not only use the customary types of drawing papers and boards. He should, in addition, practice on tracing cloth and tracing paper, working for clean-cut lines, as they are the type that blueprint well. Even the instrumental portions of almost all architectural drawings resemble this kind of outline work, each object being either fully represented by instrumental outline or adequately suggested by some conventional indication.

The kind of freehand outline drawing which we have so far described (in which lines of uniform width are used) is suitable for many architectural purposes, and excellent wherever an extremely simple expression of objects is sufficient. However, it offers too little variety to serve more than a limited purpose. At *N,* Fig. 53, we show another kind of work: two widths of line are used instead of one, the work being sometimes done by the previous method first, and a wider profile added later. This, again, is a method of working quite common to architectural subjects where it is desired to give the greatest emphasis to some object or detail as a whole rather than to its parts. When architectural drawings of this type are to be blueprinted, they are made on tracing cloth or paper. Diluted ink—which blueprints somewhat indistinctly—is sometimes substituted for black ink for the fine lines, the coarse ones remaining black. This naturally results in still greater contrast in the prints than would be obtained by the two widths of line alone.

Don't assume from this that the method of using two widths of lines is applicable only to architectural forms of work. The use of two or even more widths is also common to many other classes of work, particularly decorative drawing.

Accented Outline

We next turn to a type of outline work which is far more subtle than either of these so far considered: accented outline.

Here the lines vary in width and character so as to express more fully the objects represented. At *P,* Fig. 53, is a bit of Gothic ornament based on the grape. This was first done in simple outline. Next some of the lines—especially those below and to the right of every projecting portion—were darkened to suggest the shadows, adding to the sense of relief. Many of the lines were accented at their points of junction, too. Notice the grapes in particular. The outline here not only suggests the natural darkness which might exist at such points but it also tends to make the drawing "snappy" and interesting. In the little sketch at *O* similar accents in Sections 1 and 2 show very plainly. No definite rules can be given for the placing of such accents; it is all a matter of natural feeling plus observation and practice.

Still more subtle, and for many purposes more realistically suggestive and consequently more valuable, is the type of accented outline work shown at *S* and *T,* Fig. 52. Here there was no continuous or definite pen outline drawn. If you study the word *Hat,* at *Q,* it will be seen that each letter is surrounded by outline. At *R* the same word is shown with about half the outline omitted, yet we are still able to read the word; the reader supplies the missing parts through memory and imagination. To suggest or indicate brings more interesting and more artistic results in many cases than does tiresomely complete outline. In literature or the drama we like those things best, as a rule, which were written with the assumption that we have some intelligence ourselves. Those of us who employ linear drawing as our medium of expression should give our viewers credit for equal readiness of comprehension. Now, turning again to the leaf at *S,* and the sweet pea at *T,* we see that part of the outline is omitted, part of it suggested by broken or dotted lines, and part drawn with lines varying in width. We see, too, that many

Fig. 55. This box has been drawn in three ways: (1) with lines of uniform width, (2) with accented outlines, and (3) with a broken outline.

Fig. 56. Both broken and accented lines are varied to indicate texture on these objects.

Fig. 57. This sketch borders on outline drawing and shaded work.

Fig. 58. This is another example of a drawing that applies accented outline to a still life object.

small accents of black are added at the junctures of the lines. This suggestive and broken type of accented outline is perhaps one of the most common in all pen work. It is so important that it should be conscientiously studied and practiced.

Fig. 54 has been drawn to show additional examples of the use of accented outline. Sketches 1 and 2 are naturalistic forms; Sketches 3 and 4 are conventional forms based upon naturalistic ones. This sheet, as well as the others illustrating the chapter, was drawn at the same size as this reproduction. Sketch 1 was drawn with a Gillott 303 pen. Notice the use of the broken outline at point A, which seems to bring the flower form forward. In Sketch 2 this same pen was used for the grapes and stem. Sketch 3, an Egyptian lotus flower and bud motive, was drawn with the 303, the darker lines being reinforced by use of the Gillott 404. The conventional acanthus leaf (Sketch 4) was done entirely with the No. 1.

Objects in Outline

Fig. 55 shows an application of the same types of line to the drawing of a box. In Sketch 1 the small box was drawn with lines of uniform width. In Sketch 2 the same box was drawn with accented outlines. Notice that by making the lines heavier towards the front of the box (A), it seems to come forward. Notice, too, that by allowing the table line to fade away as it approaches the box (B) it appears to pass behind the box, remaining in the background. In Sketch 3 the same box is shown with a delicate broken outline such as might be needed to indicate a rough cloth or leather covering. In Fig. 56, at A, a metal pitcher is shown with the outline partly omitted and the rest sketchily suggested. The dark line beneath serves to set it down firmly onto the table. Crisp, sharp lines are usually the best for expressing smooth metal or glass objects. When we have softer textures, such as those of the book, at B, a greater variety of line is needed. Objects of this sort are particularly fine subjects for drawing the widest possible variety in your subjects. In Chapter 8 a list of suitable objects is presented to aid you in your selection. Generally speaking, look for beautiful things, for in many ways more is gained from studying beautiful things than ordinary ones. But the artist cannot always draw beautiful things; he must be sufficiently versatile to handle any and every sort of subject. He must be able, above all, to represent the individuality of his subject, whatever it may be. Consequently it is often well for the student to select some object which has a strong individuality; certain characteristics of its own which distinguish it from other objects. If beautiful, so much the better. It should not be merely "pretty," however. Some objects which are in a sense positively ugly are so full of character that they are well worth drawing. This author personally gained a stronger grasp of the essentials of pictorial delineation through drawing old worn-out shoes and hats, dilapidated books and antique dishes, which were battered to the point of appearing entirely useless for any purpose, than from any other type of subject. If you learn to look for the individual characteristics of each subject and to picture them to advantage you gain a real power of analysis and of expression.

To turn again to our illustrations we see in Fig. 57 a drawing that has, in addition to its outline, a few lines which give it somewhat the appearance of simple shaded work. It is shaded, yet it is truly a piece of outline work. This is on the border where it is difficult to differentiate between outline and shading. The suggestion of shading on the bear is obtained, to a large extent, by using accented outlines representing some of the many tool marks which were made to give the wood its shaggy, furlike appearance. The beginner would do well to avoid subjects of this kind until he has obtained considerable shading practice.

Objects in Accented Outline

In Fig. 58 we show another example of accented outline drawing as applied to a still life object. This is, again on the border between outline work and work in light and shade. The jug was drawn at this exact size directly from the object, first in pencil, even to each stroke suggesting the shading. Then the inking was done, the blacker areas first, partly with a Gillott 404 pen and partly with a ball-pointed nib. It is valuable practice to make many drawings at least as large as this, and even larger.

How to Proceed with Outline Drawing

In this chapter we have discussed types of outline drawing but have said nothing about the method of actually laying out the freehand work. As we have already mentioned, it is assumed that the reader is sufficiently familiar with freehand sketching to do the preparatory penciling that is customary before the inking is started. There can be no harm, however, in reviewing the usual method of procedure for the benefit of the beginner. Let us turn to Fig. 59 for a moment. Here in Sketch 1 is a first-stage drawing of some simple objects, done in pencil. The first lines drawn were those at A, B, C, and D. These located the extremities of the entire mass upon the paper. Next the objects were sketched in a simple manner, the general proportions being worked over and corrected until satisfactory. In the second stage, Sketch 2, more detail was added in pencil, the smaller proportions being studied until they, too, were right. The third stage, Sketch 3, is simply a natural further development of the whole thing, the pencil lines being carried to completion. In Sketch 4 the outline has been inked, and the drawing now stands ready for the erasure of the pencil work and the final touching up of the pen lines, which may be finished in any of the manners just described. The same method of procedure would be used for other types of subjects, each drawing showing a logical advance from the simple beginning to the completed results.

Architecture in Outline

If you are not interested in drawing the things we have shown — flowers, fruit, ornament, books, dishes, etc.—select any kind of subject so long as it offers good practice. Buildings or parts of buildings are favored by many. These may be done in very simple outline or, if you are sufficiently advanced, they may be handled in a more complicated way, and still the results may remain outline drawings in spirit. In connection with the drawing of buildings, refer to Fig. 60. In Sketch 1 (B) there is a suggestion in outline of the top of a chimney, the simplest sort of representation. At A is a somewhat more elaborate study in which the outlines of some of the bricks and other building materials give to the whole an effect of light and shade. C shows how such a subject might be interpreted by free methods of light and shade work. At D is a portion of a stone wall; here the effect of masonry is obtained by outlining the separate stones with accented outlines, the darker lines suggesting the shadows cast by the stones in the mortar joints.

Sketch 2, Fig. 60, shows a different treatment, in the drawing of a porch corner of an old house on Long Island. This is less suggestive of form, for here every visible architectural member has been definitely outlined, the projecting portions being still further strengthened by the addition of heavier profile lines.

Sketch 3 of Fig. 60 is another drawing that stands on the dividing line between complex outline and simple shaded work. The lines that give the effect of shading are mainly outlines indicative of the irregular courses of shingles, the branches of the trees, and the scattered masses of foliage. To these were added touches of solid black in the windows and under the cornices to emphasize the center of interest.

The drawings in Fig. 61 show similar subjects in outline, while those in Fig. 62 represent interiors handled in much the same way. (For additional examples of outline treatment of interior subjects refer to Chapter 19.)

Whereas Fig. 60 shows architectural subjects only, they should not be of interest exclusively to architects. On the other hand, Fig. 63 was drawn with some of their particular requirements in mind. Sketch 1 (Fig. 63) shows at A a typical small-scale instrumental elevation of a double-hung window. We have already pointed out that architectural work such as this is really outline drawing, and whether we have a small detail as this one or the working drawings of an entire building, this is still true. The architect and draftsman become so accustomed to working in outline instrumentally that it

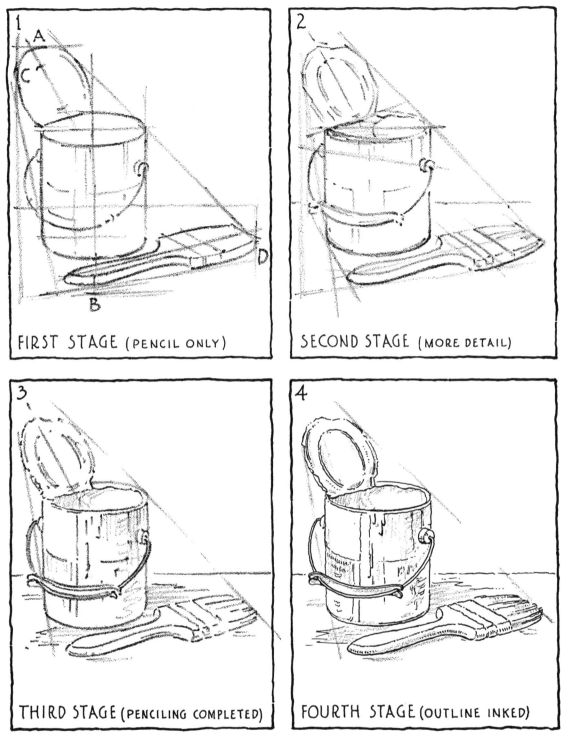

FIRST STAGE (PENCIL ONLY)

SECOND STAGE (MORE DETAIL)

THIRD STAGE (PENCILING COMPLETED)

FOURTH STAGE (OUTLINE INKED)

Fig. 59. Here is a practical method for drawing objects in outline: (1) Block out the main proportions in pencil and correct them. (2) Add and correct the smaller subdivisions. (3) Perfect the outline. (4) Ink the outline, erase the pencil lines, and make final corrections on the ink lines.

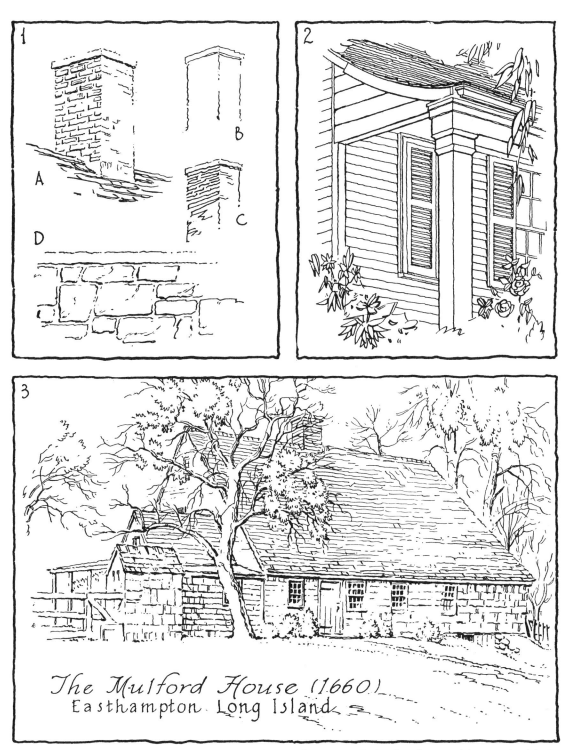

Fig. 60. Outline drawing may be used to treat subjects of any size. Notice that these architectural subjects are expressed in much the same manner as the small objects pictured earlier.

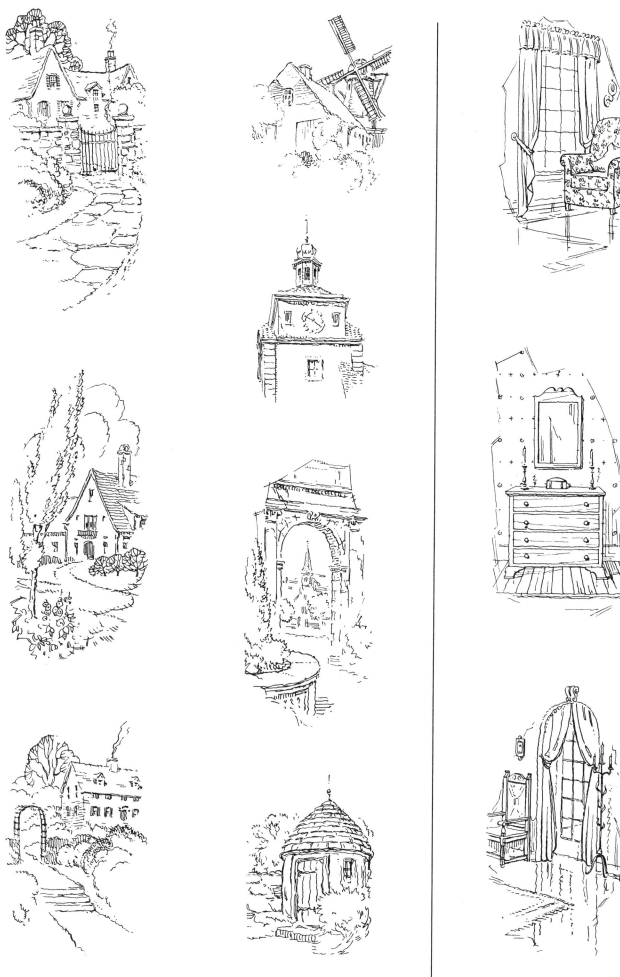

Fig. 61. Here architectural subjects are handled in a very similar way.

Fig. 62. Interior subjects are also effectively indicated in outline.

Fig. 63. Here the outline approach has been adapted to rendering various architectural details.

Fig. 64. H. Van Buren Magonigle: Details of the old Madison Square Garden, New York. Notice that an elevation such as this is nothing more than a complex outline drawing. McKim, Mead and White, Architects.

is natural and easy for them to interpret subjects by freehand means in a somewhat similar manner, using lines of a crisp, clean-cut character. Freehand drawings done in this way harmonize nicely with instrumental work; a freehand outline elevation or perspective of a house, for instance, is harmonious with the instrumentally drawn plans.

The draftsman may be called upon to do freehand work in direct conjunction with instrumental line work, particularly in the drawing of ornament. It is very important, therefore, as we have said before, for the draftsman to learn to make clean-cut freehand lines. He should know how to do this on both paper and tracing cloth. By tracing good ornamental forms on the linen in pen and ink, two objectives are accomplished at the same time. Facility in freehand drawing is acquired and a knowledge of ornament is gained, both essential to an architect's training.

Sketch 1 (Fig. 63) shows at B an example of the type of work in which clean-cut freehand lines are used in conjunction with ruled lines. This is a common type of work, though more often in working drawings, especially if at small scale, the freehand lines are uniform in character rather than accented as in this example. In large-scale work, however, and particularly in full-size detailing, modeling is often suggested in this or some similar accented way. In fact, draftsmen frequently fall back on the methods of outline drawing that we have described already and that we now illustrate again in Sketch 2, in Fig. 63. At A we have drawn a rosette with uniform lines;

at B we have silhouetted it with a heavy outline to give emphasis; at C we have used the uniform line but have accented most of the points of junction indiscriminately; at D we have used broken and suggestive forms of accented outline indicating light and shade, with a few other lines added to increase the effect of the modeling of the parts.

In Sketch 3 we show several moldings in accented outline; needless to repeat, these are very important subjects for the draftsman, as are the many types of architectural lettering, one of which we illustrate in Sketch 4.

Sketch 5 shows a treatment not uncommon in architectural practice. Here the little interior was first laid out instrumentally in pencil and was then inked freehand. After the pencil lines were finally erased, much of the accuracy of instrumental work plus some of the sketchiness of freehand work became apparent.

Studying Other Examples of Outline Work

The architectural student or draftsman should search for additional examples of such types of work as we have shown here and should practice the kinds that seem applicable to his own problems. In Fig. 64 notice the fine drawing by H. Van Buren Magonigle. Do not be content simply to glance at this kind of drawing. Analyze it with care, studying the different kinds of lines, both freehand and instrumental, and the methods of employment. Copy portions of it at larger scale, of course, as this was reduced a great deal

in reproduction.

As a further illustration of architectural work in outline we show, in Fig. 65, a drawing by Francis H. Bacon. This is a less common type of architectural drawing than that by Magonigle (being in perspective rather than elevation), but one requiring similar patience and skill. Unfortunately, the limits of our page make considerable reduction necessary, yet careful inspection will reveal that this drawing, like the other, shows both instrumental and freehand lines combined in a most interesting way. If you have a reading glass at hand, study this drawing through it in order to gain a better conception of the vast amount of beautifully suggested detail that it contains.

Students not interested in architecture should hunt for examples of published outline drawings that do interest them; the magazines and papers are literally full of them: fashion drawings, caricatures, advertising sketches, decorative drawings, etc. Pick simple ones and study them, trying similar ones yourself. Avoid those which are too complex, as complicated outline drawings are often more difficult to do than simple shaded ones. In any case, remember that no matter how simple or how complex the subject may seem, it should be drawn accurately; the fewer the lines to be used, the greater the need for accuracy.

When you have learned to handle outlines that are comparatively simple, turn to elementary shaded work described in the next chapter, later turning back to outline and applying it to more difficult subjects.

Fig. 65. Francis H. Bacon: The Agora at Assos, restored. A typical perspective drawing of a complex architectural subject is obtained through the use of outline.

7. First Thoughts on Light and Shade

Doris Hupp

In the previous chapter we called attention to the value of outline drawing, discussed a number of the common kinds or types, and showed certain ways in which some of these kinds are used in the representation of various subjects.

This discussion — though by no means exhaustive — was sufficiently complete to make clear the value of such work. No one would deny, however, that drawings done completely in outline are often either inadequate, from a practical standpoint, or fall short of satisfying the eye when considered esthetically.

Conscious of this fact, artists many times combine outline with areas of black, as in Figs. 66 and 67, or with conventional tones of gray (often in wash) or color; such work seems more complete and interesting for many purposes besides outline.

There are some subjects or requirements, however, that demand the more realistic interpretation afforded by a generous use of pure light and shade, or light and shade in combination with outline used in a restricted way. Drawings that rely largely on light and shade often convey their messages in a more telling and a more artistic manner. So, though the uses of the several types of outline are many, they cannot be favorably compared in number or importance with the uses of light and shade.

As this means that the artist must have a thorough knowledge of working in light and shade, the major portion of the remainder of this book is given over to it, nearly every chapter dealing with the application of light and shade by some special method or to some particular class subject. As a preliminary measure, here we will consider a few random thoughts on naturalistic light and shade, pointing out also how the student can most easily become acquainted with true appearances in nature and the principles which govern them. Once you gain such knowledge through study and practice, you can later turn from naturalistic to more highly conventionalized methods of representation, having a background which will permit you to do so intelligently.

Observation and Analysis of Form

Perhaps we should pause here to make clear that what we have in mind as a "naturalistic representation" is not a photographically complete delineation, but one which interprets the subject as realistically as the nature of the medium warrants, without undue forcing.

There are few principles of light and shade which can be easily explained by a textbook or an instructor. Instead you must learn mainly through observation and thoughtful analysis.

Some people are surprised when they hear that the artist must observe and think; they apparently take it for granted that the artist draws instinctively, and is incapable of any deep thought or real common sense. Yet all drawing is much more a matter of reason than is generally supposed, and artists are usually thinkers of the keenest sort. In fact many individuals have become artists mainly through their power to observe things thoughtfully and to figure out by logical methods why things appear as they do, and by equally logical methods how to suggest such appearances on paper. Anyone who can shake himself free from preconceived notions·of the appearance of some object, and who can analyze its appearance in an unbiased manner, has gone a long way towards learning to draw that object, and similar objects, as well.

First Select a Simple Object

It seems needless to repeat that the principles governing the appearance of both large and small objects are identical. If you study small objects, stripped bare of confusing detail, and learn how they appear and why, you find out much concerning the appearance of other things, regardless of size. Through careful observation of a simple wooden cube, for instance, and analysis of its light and shade (as well as its perspective appearance and other facts not connected with our present thought), you can learn almost unconsciously principles that apply to the drawing of the largest building as well as to the cube itself. In the same way, if you study a small sphere (such as a light-colored rubber ball), you can apply this knowledge to any spherical form — the human head, for instance, or a round tree, or the dome of a building. For this reason it is possible for the beginner to profit greatly from the study of such simple objects as cubes and spheres, or still life like that discussed in Chapter 8. For additional exemplification of these points, refer to Figs. 68 to 74.

Art supply houses sell sets of wooden models, including spheres, ellipsoids, ovoids, cylinders, and other rounded forms, as well as flat-sided solids like the cube, pyramid, and prism. These are excellent subjects for observation and early sketching, although still life objects found in daily use, such as small boxes, dishes and the like, afford splendid practice for the beginner, too, particularly when they have little strong color or detail to prove confusing.

The best way to learn to observe and analyze light and shade is obviously through practice. The natural way is to take a simple object, such as one of these just mentioned, and expose it to light coming from a single direct source (as at a window), studying it earnestly, with your mind as free as possible from any preconception of its appearance.

When you have selected the object (let's assume that a sphere has been cho-

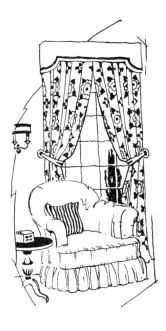

sen) and have put yourself at ease where the light is good and where you can muse undisturbed, you might say the following to yourself: "Here is a round white ball. How do I know its shape and color, using the sense of sight alone? If it were pitch dark here I could not see it at all and therefore would know nothing about its appearance, except through memory. If there were just a little light, I might know little about it. But the sun is shining, and I can see it plainly. I know it to be white because the part turned directly towards the sun shows absence of color. If I turn it to a new position, this is still true. The parts turned somewhat away from the direct rays of light do not appear white; they seem gray. As a rule, the more directly the rays hit the surface, the lighter it appears. If there were several suns in different positions shining on the ball, all parts of it might look white; but it would also look flat, like a disk. However, there is only one sun, and the more the surface turns away from the sun, the darker it seems to get. Does it? Here at the back edge, opposite the spot where the rays hit the most directly, it seems a bit lighter again. Why? Because the sun is also shining on that light sheet of paper below the ball, which, in turn, is reflecting light back onto it. The paper is similar to another, but much weaker, sun. How do I know the ball is round? Because I see it as a circular form silhouetted against the background. Why? Because it is lighter than the background, which is not well illuminated. It is light and the background is dark, so it stands out by contrast. If the background were all equally white and the ball uniformly illuminated from every side, the latter might not be visible at all. The light comes from the left because the sun happens to be on the left. The right side of the ball appears gray because it is in shade. The shade takes a form which is so rounded and graded that I can plainly see that the surface of the ball facing me is not only round in contour but is raised in hemispherical convexity. If the sunlight were less bright, the ball would seem darker; if there were no light, the ball would be invisible."

This undoubtedly sounds rather simple-minded, and it is true that these rambling thoughts regarding the ball mean little in themselves, but the whole paragraph is most important in pointing out the general way your thoughts should be directed when some object is under observation. Many artists consciously analyze each subject in a similar manner before starting to draw; others, as the drawing progresses. Usually, however, except in the case of the beginner, the artist is hardly conscious that he is thinking at all, but unless he does think or has thought deeply at some previous time concerning a similar subject, his drawing is certain to show it. It probably will not convey its message convincingly.

Some artists and students, instead of drawing honestly — according to what they observe or have observed — simply perform a series of borrowed tricks of

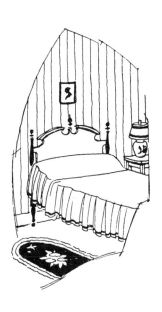

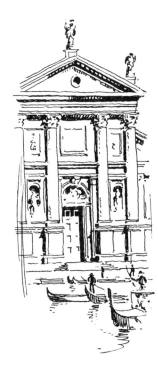

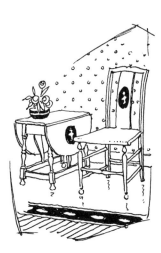

Fig. 66. With interior subjects it is possible to combine outline with areas of black to good effect.

Fig. 67. Exterior subjects can also be rendered successfully by a combination of outline and black areas.

Fig. 68. Many trees and bushes are spherical in form.

Fig. 69. Other trees are based on ellipsoidal or ovoidal solids.

Fig. 70. Still life objects are often rounded in shape.

Fig. 71. The cylinder and cone are also frequently found in nature and in objects.

technique. Other and greater artists may use the very same tricks, perhaps; but if so, they apply them with a knowledge gained through observation, which makes their work more true.

Reversing Nature

You won't study this way for long before arriving at some very interesting conclusions. One of these is that, as a rule, the worker in almost any linear medium, including pen and ink, practically reverses nature's processes so far as light and shade are concerned. In nature, things are not visible at all until there is light; then the light shines on certain surfaces which are turned toward it and makes them visible. Reflected light makes others visible but less brilliant than those directly illuminated. The amount of brilliance of each surface depends largely on how it is turned in reference to the sources of direct and reflected illumination. The shade and shadow parts are simply those which are not so turned as to receive the rays of light directly.

Nature, to repeat, starts with dark and adds illumination until her effects of brilliance are gained, and the shade and shadow remain much as they were, though somewhat lighter through reflection of light. In pen drawing the artist usually does the reverse, even when naturalistic effects are sought: he starts with the white paper and allows that to represent the most brilliantly lighted surfaces; then with the pen he applies the shade and shadows. In other words, he puts darks on the areas that represent shade and shadow, leaving the white paper to represent the lights, while nature, contrarily, puts on lights or illuminates the objects themselves in the areas turned towards the source of illumination, leaving the remainder in almost its original darkness. The effect is much the same; the method contrary. If the student fully comprehends this reversal, all his work will be more intelligently handled from the very start.

In this connection it is excellent practice for the beginner, as a preliminary to his regular pen practice in light and shade, to make a number of very quick sketches somewhat like the ones shown in Fig. 75. First select some simple subject for each sketch. As the pen is not especially well suited to this purpose, obtain a few sheets of black or dark gray paper. Then with white chalk or crayon, or with white or colored watercolor paint, if you prefer, render each subject. Add light to your paper much as nature has added it to the subject, grading from the brightest to the deepest tones in a natural way, allowing the black or gray of the paper to represent the darkest values. If you work in this manner for a short time, you will build a foundation for correct thinking which will help you all through your art training. The examples here reproduced were done very quickly at about twice the size shown, with Chinese white watercolor on black paper.

Fig. 72. Tanks are often based on geometrical shapes.

Fig. 73. Architecture is almost entirely geometric in its masses. Notice the cylinders and hemispheres suggested in this drawing alone.

Fig. 74. Straight-line shapes also frequently appear in architecture. Here we have a pyramid, cube, and square prism.

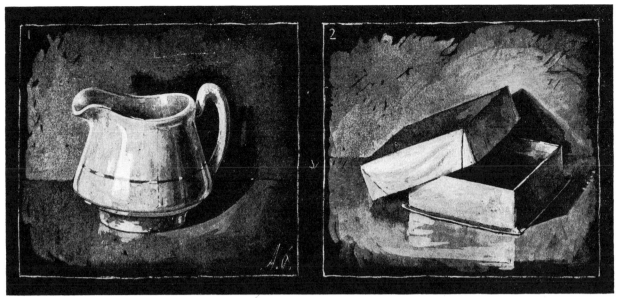

Fig. 75. This sketch is drawn with white paint on black paper to illustrate a natural phenomenon.

Pen artists sometimes fall back on this same general method of procedure, making finished drawings with white ink upon a black or very dark background, or covering scratchboard with black ink and picking out the lights with a sharply pointed knife.

Two Categories for Objects

You will observe in nature that, as a whole, objects fall into two classes: the bold and rugged, and the refined and delicate. The first class contains objects that are sharp and angular in form (and perhaps rough in texture). Among simple objects, the cubes, prisms, and pyramids fall into this class. The second group includes the rounded, less angular forms (or those with smoother textures): the spheres, ovoids, and cones, and the shapes based on them. In the former type, the contrasts in light and shade are often sudden and great; one surface or plane of light or shade stands out sharply against another. In the latter type, there is gradual change in light and shade, a subtle adjustment of values. It is most important to be aware of this difference and to look for it in every subject.

You will discover that, as a rule, it is easier to draw the bold, rugged type of subjects than the soft, delicate ones. This is partly because the contours or silhouettes themselves are more angular and therefore easier to understand and picture, and partly because the various planes of light and shade are more clearly defined and show less gradation of tone. This fact permits representation in simple flat values, a process easier to carry out in pen than the subtle gradations which we mentioned in connection with

the second type.

The beginner will find, too, that this first category of subject has a strength not found in the other. This makes it more interesting, on the whole, and more individual. The rounded forms are all pretty much alike; the others offer endless variety. This is one reason why we like drawings of old shoes, battered hats, dilapidated buildings, and wind-torn trees.

Because it is easier to draw the more rugged types of form with their sharp angles and flat planes of tone, it is often best to practice them first. Some teachers even recommend a modest exaggeration of the individual peculiarities of each subject—an added sharpening of the angles and a corresponding defining of the various planes of light and shade. Even in drawing the rounder forms, it is often advisable to seek out the angles in the subtly curving profiles, even though they are barely visible, and exaggerate them slightly, at the same time breaking up the gradations of tone into somewhat simpler planes, if the subject offers the slightest suggestion as a guide. Such a course brings added force into the drawing. If it is of a person, the likeness itself is thus strengthened. It is far easier, as a rule, to picture the rugged character of the male face than the rounded refinement of the delicately molded female countenance. Naturally this exaggeration just mentioned should not be pushed so far in portrait work as to injure the likeness or to give masculine character to feminine form.

Study These Principles Closely

Fig. 76 illustrates some of the general principles we have discussed. In

Sketches 1, 2, and 3, a sphere has been drawn in pencil. In Sketch 1 the light is coming downward from the left, as indicated by the arrow. Where the light falls most directly on the curved surface there is a highlight, the most brilliant spot on the entire sphere. From this spot the spherical surface gradually darkens in every direction, particularly in that opposite the source of light. As shown here, however, the darkest spot is not at the exact edge; that is quite bright because of reflection of light from some unknown source which is below and towards the right. The brightest area of reflected light is almost opposite the brightest spot of direct light.

In Sketch 2, the source of light is no longer at the left but in front of and above the sphere, and so the light shines downward. This causes the area of highlight to move towards the center, near the top, and the darkest dark to move towards the bottom, as indicated. The area of reflected light also moves towards the bottom, and — though the location of such a tone is always dependent on the position of the surface from which the light is reflected — here, as is generally customary, it shows directly below the darkest dark.

In Sketch 3 the source of light is again differently located, the rays falling upon the sphere from a source in front and to the right. This brings the area of highlight towards the right, and the darkest dark and the brightest reflected area towards the left.

In the case of the three rounded forms, Sketches 4, 5, and 6, the light is coming from a source similarly located to that in Sketch 1, as shown both on the plans and the perspectives. Note that the ovoidal form in Sketch 4 is almost like the spheri-

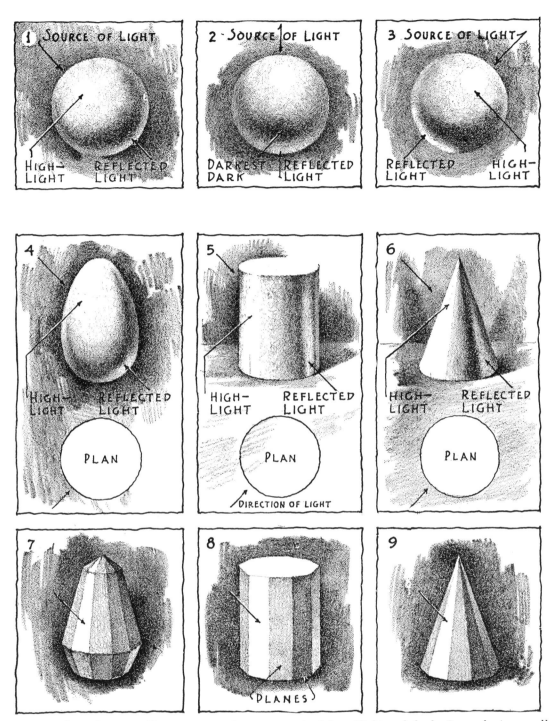

Fig. 76. *These drawings illustrate some elementary principles of light and shade. By analyzing small objects and basic shapes you learn many vital principles which will aid you in more complex work.*

cal solid above it in Sketch 1 in its general disposition of light and shade. In the case of the cylinder of Sketch 5 and the cone in Sketch 6, the highlight is also towards the left and the reflected light towards the right, with the darkest dark near the reflected light. These reflections as shown here, though no brighter than such tones often are, are rather extreme. Reflections should usually be sacrificed by darkening a bit. They were made too prominent here in order to make their locations plain.

Don't assume from these sketches that such forms are always lighted from these directions, for obviously this could not be so. Moreover, don't assume that reflected light is always present, for without something to cause reflected light, it could not exist. These are the most common directions of lighting, however, and as reflections are often evident the student must become well acquainted with them.

Now turn to Sketches 7, 8, and 9. These flat-sided solids take the same general shapes as Sketches 4, 5, and 6, respectively. Under the same lighting, however, note that they appear quite different. First, most of their profiles seem more angular and pointed. Second, the light and shade is now broken up into flat planes, instead of being graded as in the rounded solids above.

What we have already pointed out is even more evident in these illustrations: you will have less trouble interpreting flat-sided solids, in pen and ink, than rounded ones.

We have gone to considerable pains to explain the various differences in a few small and easily understood objects, mainly in order to teach you to analyze all subjects in this way, not only simple geometric shapes, but also still life forms such as those discussed in the next chapters, as well as larger and more advanced subjects to come even later.

Also read the next two chapters and illustrate the thoughts expressed in them, and simply carry these facts in mind as you do so. Later we will again refer to some of these thoughts as related to other subjects, and will also touch on additional principles of appearances and their representation.

8. Starting to Draw in Light and Shade

Thomas F. Bancroft

Drawing in light and shade! How welcome this subject usually is to the would-be artist, and particularly to the beginner who has patiently prepared for it. If you have followed us so far you have not only worked through many exercises in line practice and tone building (including the making of value scales), but also conscientiously experimented with numerous kinds of outline, applying them to a wide variety of subjects. Light and shade work should stand as a sort of reward for all this practice, a large part of which has perhaps been rather unrewarding. By now you should regard light and shade not only with enthusiasm, but with confidence.

It is true that some beginners may omit the early preparation, starting their pen practice by immediately drawing in light and shade. Sometimes this method is successful. The danger of this, however, is that sudden discouragement is likely to come unless the beginner already has a thorough working knowledge of some similar medium, or more than ordinary ability coupled with a persevering nature. This is particularly true if he attempts subjects which are too difficult, a temptation he should avoid. I have known beginners to try at once to draw in pen faces, figures, street scenes, large buildings, and complex landscapes. Failing to get the desired effects, these beginners have abandoned the whole thing in disgust, with the feeling that they were lacking in the necessary talent. Instead, their trouble was lack of judgment and perseverance rather than lack of innate ability.

So, whether or not you have ever done any preparatory pen work, you should realize that light and shade will tax both patience and skill. So start with simple subjects, such as the geometric solids or still life objects described in previous chapters (and to which we shall allude again presently). From this simple beginning, gradually attempt more difficult subjects, advancing only as fast as your increased skill permits. There is nothing but harm in a superficial rushing on from one kind of subject and method of treatment to another.

Working Space

Whatever subjects you may select to study and draw as your first problems in light and shade representation, you will be laboring under a distinct handicap unless you have a satisfactory place to work. This should preferably be one where you can be alone and undisturbed, or where others about you are doing the same or similar exercises, as in an art school or studio. In many ways your own home is the best place of all. The ideal arrangement is to have an entire room, or at least one end of it, where objects can be placed or compositions arranged to the best advantage and left untouched until the drawings are completed; a place where drawing table or easel, pens and inks, and other materials will remain undisturbed. Above all, a place permitting proper lighting of both drawing board and objects to be drawn.

Fig. 77 was designed to show what is possibly the most practical way in which a room for such work can be arranged. At A is a strong chair, which has no arms or other projections, and which is not so comfortable as to invite laziness. At B is a small table or object stand (which will be more fully described in a few moments). At C is an adjustable drawing table of the type which may be raised or lowered at will and used either vertically, similarly to an easel, or slightly tipped, or in a horizontal or an almost horizontal position much like a table. These three essential objects are grouped in logical positions (though the placing of the adjustable table always depends on the kind and size of work to be done).

Lighting

The only source of daylight in the room is the one window, which is some 5 or 6 feet, 1.3 or 1.4 meter to the left of the object stand. A single source of light like this is preferable to two or more; the more sources there are, the more complicated the light and shade. With light from a single source, for instance, the shade and shadow effects are comparatively simple, the shadow shapes themselves being quite plainly defined. With light from several sources there are often several shadows from each object, and these are frequently blurred together in a most confusing way. Aside from this, there are complications due to reflected light. Even when the light comes from one window, it is often better if the area of the exposed glass is reduced until rather small. In order to control the light from the window shown in our diagram, two opaque roller shades have been provided as indicated at D-D. Of these, the lower one would ordinarily be raised to cover the lower sash entirely. (Cardboard or heavy paper can be substituted for one or both of these shades.)

In Fig. 77 the light is supposedly coming from the left; this is the approved direction. With such an arrangement the light would never annoy you by casting shadows of your hand and pen across the paper (providing, of course, that you are right-handed).

At E notice that there is an adjustable electric light of telescopic design which permits extension in any direction. If

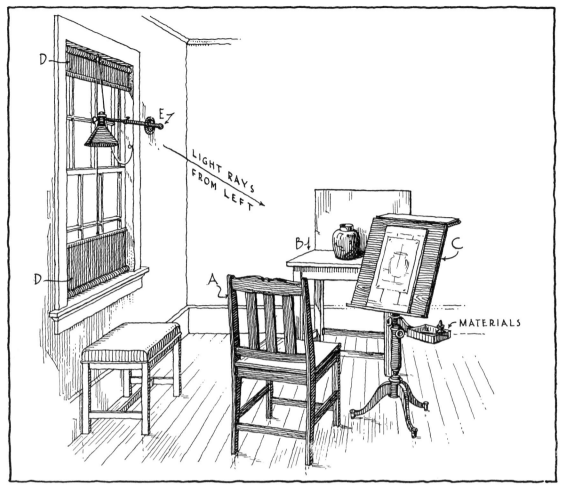

Fig. 77. A room conveniently arranged as a studio for object drawing may contain: (A) a comfortable chair, (B) a stand for objects, (C) an adjustable table, (D) two roller shades, and (E) an adjustable light.

Fig. 78. Here is a folding object rest or shadow box made of cardboard or thin wood.

such a light is not available, some simpler form on an extension cord may be substituted. Artificial light should be arranged so it casts much the same shadows as are cast by daylight; naturally, the shadows themselves would not be of the same quality.

Our last word about the lighting of the room is perhaps the most important of all: the window should face north, if possible. North light, being largely reflected from the sky, is more pure in hue and more uniformly steady than light from any other direction. This means that if you set up a still life composition in the morning, you will find that its light and shade will remain almost constant throughout the day, an obvious advantage. It is particularly disturbing to have brilliant sunlight streaming into a room where work in light and shade is being done. The sunlight is not only constantly changing in its own intensity and direction, but it causes additional changes through reflection from the many surfaces on which it falls. Its dazzling light also confuses your perception of the values in the objects themselves.

Object Stand

Now to return for a moment to the object stand, usually a small table of about 30 inches/76 cm. Sometimes the objects are placed upon it just as it is. It is much better, however, to provide some sort of background against which the objects may be plainly seen. If the table can be pushed against the wall and still have the proper light, the wall itself may form a sufficiently contrasting background. If the wallpaper is a distracting pattern or color, plain light paper or cloth thumbtacked to the wall makes an excellent background, particularly if it is also brought forward to cover the top of the table, and allowed to hang down over the front so nothing of the table near the objects is visible. There are many places where it is not practical to put the table back against a wall and some other background must be provided.

It is easy to make a background of cardboard or thin wood or wall board, as illustrated by the diagrams in Fig. 78. The one shown at A consists of two sheets of fairly stiff cardboard 15 x 22 inches/31 x 50 cm and two 15 inches/31 cm square, bound together with tape. Sometimes such an object rest or background is left exactly like a box, with the top and front off. Then one end, such as C in the diagram, is allowed to cast a shadow over the objects; in this way many interesting effects may be obtained. More often, however, these ends are folded back out of the way, as in the diagram at B, where they are used as braces to hold the back upright. In Fig. 77 an object is shown in place, standing out plainly so one may view it without distraction. If a supporting table is dark or of a conspicuous color, it is advisable to throw a cover of white over it.

Other Equipment

So much concerning the larger pieces of essential equipment. You should be able to find satisfactory positions for the pens and ink, probably to the right, if you are right-handed. Many adjustable tables provide for these smaller accessories in some way, such as we have shown in the diagram where a movable tray is indicated.

This concludes our list of special equipment for object drawing. If you are going to do a great amount of this work, get a convenient cabinet to store interesting still life objects and other reference material. If you plan to do little of this sort of work, on the other hand, you may not need the cabinet. You may wish instead to substitute an ordinary small table for the adjustable one described. In any case, a portfolio for the storage of paper and drawings is useful, and a wastebasket handy.

Selecting the Subject

When this equipment has been gathered and arranged, you are ready to select the first subject. This, as we have pointed out, might be very simple, consisting of a single object showing no marked texture and little contrast in color.

Analyzing the Subject

Once selected, the next task is to analyze the subject before starting to draw. What are its principal attributes? Is it large or small? Is it high or low? Is it round or square? Is it light or dark in tone? Is it rough or smooth? Are its edges regular or irregular? The amount of time given to this sort of analysis should depend on the subject itself and your own ability. With a little practice you should learn to grasp essentials of form, color, value, texture, and the like, almost at a glance.

Drawing the Subject

As soon as this analysis has been made, the tack your paper to the board and start to draw, determining first just where you wish to locate the drawing on the paper. The main proportions should be blocked in with a few sweeps of the pencil, the point barely touching the paper surface. Here correct form and perspective should be the aim. It is not our purpose to go fully into such matters as these, though the general method would of course be that described in Fig. 59 in Chapter 6.

Tests

One extremely important test of the accuracy of your work is simply to put the drawing near the object or objects drawn, for direct comparison. I remember one studio where a folding music rack was placed beside each object stand. The student could set his drawing on the music stand in an almost vertical position exactly where needed for ease in comparison. With your own drawing held in this

Fig. 79. This is the position for "thumb" or "pencil" measurement. Dotted lines indicate lines of sight.

Fig. 80. This is a full-value pencil study of a pyramid. The arrow at left indicates the lightest light; the arrow at right, the darkest dark.

Fig. 81. Try using a pen for a value study of geometric solids.

Fig. 82. Here pencil is used in this value study of the cube.

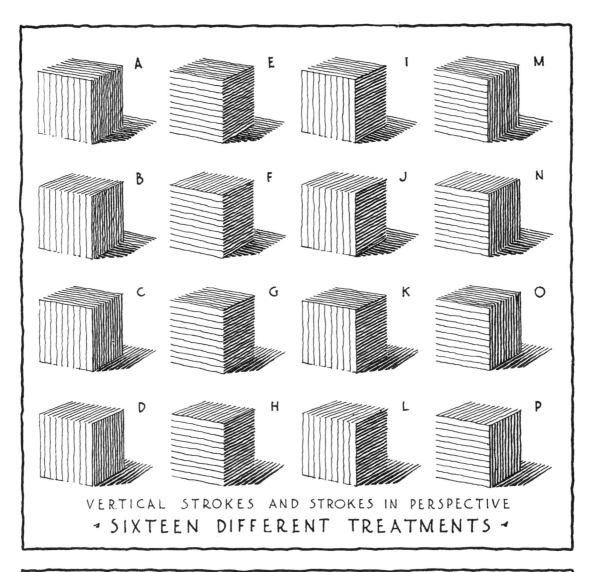

VERTICAL STROKES AND STROKES IN PERSPECTIVE
◄ SIXTEEN DIFFERENT TREATMENTS ►

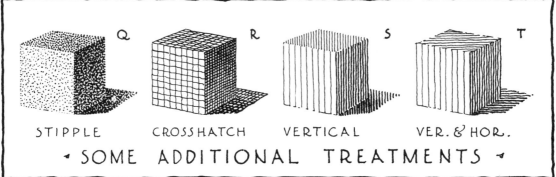

STIPPLE CROSSHATCH VERTICAL VER. & HOR.

◄ SOME ADDITIONAL TREATMENTS ►

Fig. 83. Even an object as simple as a cube may be interpreted in an infinite number of ways. Here are comparative methods of expressing a straight-line object in light and shade.

way, ask yourself how correctly you have worked. Are the heights right in relation to the widths? If you are not sure, there is a valuable test to aid you.

Thumb Measurement

This test is known as thumb or pencil measurement. Close one eye, and out-stretch your arm at full length towards the object, grasping a pencil in your hand with the pointed end near the little finger (Fig. 79). Hold the pencil at right angles to the arm or, more properly, at right angles to the central line of sight from the eye to the object. The unsharpened end of the pencil can then be used as a measure for comparing width and height or the length of one line with another. This method is like applying a ruler directly to the objects themselves. Using the end of the pencil to mark one point, slide your thumbnail along the pencil until it marks the next desired point. Then compare the amount of pencil exposed from the uncut tip to the nail as a unit of measure with some other line or space to be measured.

When you want to compare one line with another in length, take the smaller on the pencil first and use it as a unit of measure for the other. Just as you compare the various proportions in each object in this way, so you may compare the corresponding proportions on the drawing, either by the eye or by laying the pencil flat on the paper itself. If they are not relatively the same, the differences will be obvious and corrections can be made. The value of this test is lost unless, while measuring, you keep the pencil at exactly the same distance from the eye. So don't bend your elbow or turn your body; keep your shoulders firm against the chair back.

At best, this method of measurement is useful merely as a test; it is only approximately accurate. Don't depend on it too frequently, but rely mainly on your eye, especially for the smaller proportions. As a test, however, it is valuable, not only in object drawing, but in life drawing, nature sketching, and other types of work.

The pencil may be used in another way, too, as an aid in getting true proportion and the slant of various lines. Hold it at arm's length so that it hides, or coincides with, some important line in the object; then compare its direction with the same line in your drawing. Or you can hold it vertically or horizontally and then sight across it to some sloping line, comparing slopes, and the angles formed by various intersecting edges.

Value Studies

Once you have blocked out the subject in pencil, tested, and worked over the drawing until correct in form, the pencil lines should be softened by erasing until they become merely faint guides for the inking. Before inking, it is often advisable in a first subject, or in complicated later ones, to make a study in pencil (or pen) of the values of light and shade. This may be in the form of a little separate sketch, possibly on the margin of the paper, similar to Figs. 80, 81, and 82. Such a sketch helps to determine, before you pick up the pen, just how dark to make the tones.

Often, just before the inking is begun, a larger study is made in pencil on tracing paper laid over the drawing. This is an excellent method when the drawing is small, but takes almost too long when large.

At any rate, no matter what method you use, in whatever size, work thoughtfully. Look for the lightest value. It is not always easy to tell this, or to tell how light or dark any tone is. As an aid, hold up a bit of white paper and perhaps a piece of black paper for comparison with the tones of the object. How light is the lightest value in relation to the white paper? How dark is the darkest? How does the darkest value compare with the black paper? Is the shadow as dark as the black paper? When you have decided which area in the object is the lightest and which the darkest, and have determined the relative degrees of light and dark in the others, represent them in your trial sketch. In doing this, notice whether or not the various values are flat in tone or graded, and interpret them accordingly. Likewise, give attention to the edges of each plane of tone, whether sharp and clean-cut or blotted and indefinite. Look for the sharpest edge of all and keep it the sharpest one in the sketch. This trial sketch for the first subjects should be as accurate an interpretation of form and of values as time permits, with little attention given to technique or to indicating textures.

Inking

For a few problems at this stage, it is usually best to carry on the pen work in quite a naturalistic way, in accordance with the true values as laid out in the value sketch. After the first sketch, however, you will recall the technical limitations of the pen, remembering that values as a whole must be simplified or changed in various ways, sometimes being eliminated entirely. When you plan these characteristic pen drawings, you may decide in your trial sketch on their strength and arrangement, and then express them in the final pen work that you do.

Technique

Too often the student thinks so much about the kind of technique to use that he neglects his values. Technique is important, of course, yet the essential thing is to let the technique be a natural expression of the form and texture and color of the subject. We will come back to this later.

A Practical Problem

For this exercise we selected a simple wooden cube, a couple of inches or so in size (Fig. 83) to illustrate some of the possibilities of its representation. We suggest you try this too. Place the cube near the center of the object rest and block out a trial sketch in pencil. Note that the object stand itself, being made of white cardboard, appears very light — lighter than the wood of the cube — so let the white of the paper stand for that white background tone. Observe that the front of the cube facing you is well lighted; represent that in pencil by very light gray. The top of the cube is the next darker value, so add that with a darker pencil tone. The side of the cube turned away from the light is still darker; pencil this in correctly. Each of these three tones seems almost uniformly flat; represent them that way. The shadow tone seems the darkest of all, especially towards the front, so grade it as it appears. Your trial sketch should now look much like our Fig. 82. Set your sketch near the cube for comparison, and if it meets with your approval, you are ready to ink.

Now comes that question of technique again. Decide what directions to give your lines. In some subjects the forms or textures of the surfaces or some other definite factors determine this. Here in the cube the form is so simple that direction makes little difference, as is shown by the many drawings of the cube in Fig. 83, and the accompanying sketches shown in Figs. 84 to 89. In Fig. 83, from A to P, are sixteen treatments of a simple nature, no two alike; yet all are of approximately the same value, so much so that it is hard to tell them apart from a few feet distance. This shows that it is impossible to say that there is one right method. Most of the lines used here are either vertical or are representing horizontal lines as they appear in perspective, receding towards the left or right invisible vanishing points of the cube itself. Incidentally, these drawings were made at the size shown here, with a Gillott 303 pen, by both varying spacing of lines and changing pen pressure for the different values. The shadow tones were graded, too, by varying the force exerted on the pen. The lines on the nearest vertical plane in all sixteen of these might have been omitted entirely. If they had been, substituting a little outline would have made the drawings satisfactory.

At the bottom of Fig. 83, from Q to T, four other methods of rendering the same cube are shown. They are self-explanatory. The first one, done by hand stippling, and the second, which was crosshatched, are too dark in value in relation to the others on the sheet. The one in stippling might easily have been left lighter, but in the crosshatched example at R the drawing was first rendered just like A above, and then the lines were crossed with strokes like those at H. So as it finally stands, it is really a combination of the two, and it naturally follows that it is darker than either. The example at S was done entirely with vertical lines, shadow and all. It has somewhat the effect of an open box, as the value of the top might be mistaken easily for tone on the

Fig. 84. Here a cube is drawn in outline only.

Fig. 85. This cube is rendered with both outline and shading.

Fig. 86. This cube is drawn with shading only.

Fig. 87. This cube is shaded by another method.

Fig. 88. Notice how much larger the cube appears when this method of outline and shading is used.

Fig. 89. This method of outline and shading also makes the cube seem larger.

inside at the back and side. At *T*, vertical and horizontal lines were combined; they were the only ones used.

Relating Form to Line Direction

These sketches are sufficient to show that a great variety of treatments is possible for a single subject, even when the subject has uniform color and little texture. If it had more color or greater texture, or greater variety of form, or if one turned to the use of curved lines, the satisfactory combinations would be limitless.

A few additional treatments are shown in Figs. 84 to 89. Although these latter cubes were drawn exactly alike in pencil, as were those in Fig. 83, they do not all appear of equal size or shape in their finished state. Neither do all their perspective lines seem to converge in just the same manner. This leads us to an interesting fact: the direction of lines used in pen technique often makes forms appear different than they are—taller, for instance, or shorter, or wrong in some other proportion or distorted in perspective. This is especially true when slanted lines are used as in Figs. 88 and 89. These, and similar distortions, are due to various optical illusions, one of which we more definitely illustrate in Fig. 90. Here lines *A* and *B* are actually drawn of exactly equal length, which makes *C* and *D* parallel. With the slanted lines of rendering added, however, line *A* seems shorter than *B*, line *C* no longer appearing parallel to *D*.

As it is often impossible to foresee such illusions, there is no way in which to avoid them. If, in a rendering, some object develops too much distortion, there is nothing to do but to add lines in other directions, in the form of crosshatching perhaps, or to erase the offending portion, or patch it, and begin again. Generally speaking, the finer the rendering is, the less conspicuous the distortion appears, as the tendency for the individual lines to merge into homogeneous tone nullifies it to quite an extent. As a general rule, a subject offers some hint as to a natural arrangement of lines, and when this is followed there is little danger of distortion. The brick courses in Fig. 91 for instance, suggest strokes in perspective that are mainly horizontal, while the fence boards in Fig. 92 seem to call for vertical lining.

More Practice

Now, to turn back to your own practice, it is by no means necessary to make as many drawings of a simple cube, or any one subject, as we have done here. After you have inked one to the best of your ability, however, make a few others. Draw some cubes in one direction, some in another, some all in tone and some based on combinations of outline and tone. Then substitute a simple object which, like the cube, has little color or confusing pattern. A plain cardboard or wooden box, for instance, like one of those in Fig. 93, would do very well. Place it in some interesting

Fig. 90. In this optical illusion, lines C and D are parallel but do not appear to be so.

Fig. 91. The courses of these bricks suggest lines that are horizontal in perspective.

Fig. 92. The placement of these boards suggests a vertical direction.

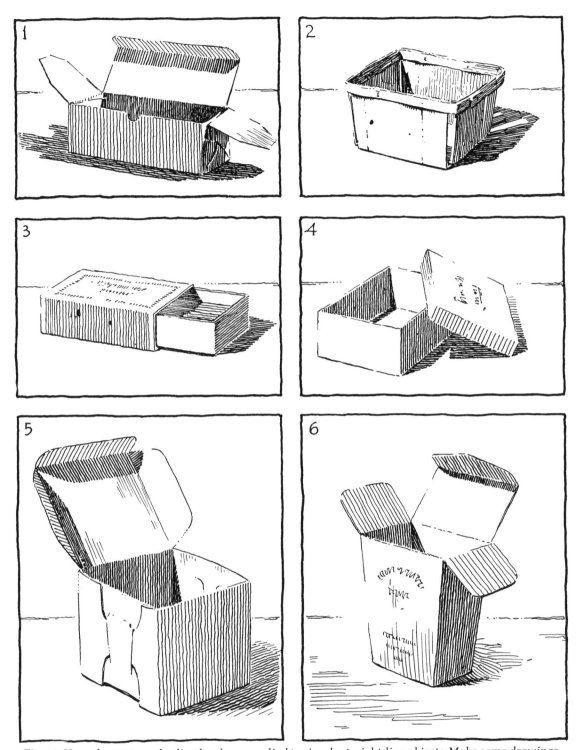

Fig. 93. Here elementary shading has been applied to simple straight-line objects. Make some drawings of your own, but try working in a looser, sketchier style than the one above.

position and draw it in what seems a natural and direct manner. The drawing need not be large; it is better to make several small ones than one large one. These in Fig. 93 were drawn at the size reproduced, with the Gillott 303 and 404 pens. Notice that these drawings have shadows of very definite shapes. This is because all of them, with the exception of the strawberry box, Sketch 2, were done in the evening under artificial light from a fairly brilliant source. Sketch 2 was from a subject in open sunlight, outdoors. As such direct light brings about definite contrasts in all tones of light and shade and shadow, it is sometimes advantageous for the beginner to work by it. With an adjustable artificial light, the direction of the rays may be changed at will, which is of itself an immense advantage on occasions; the artist sometimes wishes he could move the sun as easily! As you gain greater skill you may prefer to substitute a light of less brilliance or have it at a greater distance, to soften the tones, and particularly the shadow edges.

Table Line

Notice in Fig. 93 that in every sketch every single or double horizontal line representing the back edge of the object stand is drawn in such a way that it seems to disappear behind each object. Such a line is usually referred to as a "table line." Because the line of the object stand does not always come in a pleasing position, however, you may take the liberty of drawing it where it will best serve your purpose. It must be high enough so no part of an object seems to hang off over the back of the horizontal plane. (See Fig. 114.) Though almost any still life object that would naturally rest on a table usually looks better with a table line behind it (the line seems to hold the object down, preventing an effect of floating in the air), objects like a hanging lantern, being suspended, obviously need none.

Frequently two table lines are used, the front edge of the table being drawn, as well as the back, as at 4, Fig. 94, and 3, Fig. 116. Sometimes, too, the vertical back plane of the object stand functions very prominently, as in the drawing in Fig. 115 where the bag is actually leaning against it.

When the background is not shaded, the table line will almost invariably seem to go behind the objects better if allowed to die out as it approaches them, as shown in most of the still life sketches in this volume.

Margin Line

As a rule, a freehand line drawn an inch or so from the edges of the paper all around, acting as a sort of frame for a sketch or sheet of sketches, is advisable. Sometimes such a line goes only part way around, as in Fig. 112. Not infrequently it cuts the object or objects as in Sketch 7 (Fig. 104) and in Figs. 110, 112, and 113. The character of such a line should be

harmonious with the technique of the whole, heavy or light, broken or unbroken, single or double, wavy or straight.

As each drawing or sheet of drawings is finished, it should be signed and dated and laid away for safe keeping. Then from time to time, as the collection of sketches grows, it would be interesting and helpful to get them out for comparison, laying them side by side in order to note the progress made.

Further Study of Straight Line Work

Now to go back, for a moment, compare further Figs. 83 and 93. Notice that in the former all the surfaces of the cube are shown in gray, but in the latter the lightest tones seen in the objects themselves have been omitted. This omission required an increase in the amount of outline used to make the forms clearly understood. Even in Fig. 93, however, there is little unbroken outline employed; a wiry effect is avoided by relying on dashes and dots and on lines interrupted by blanks.

Don't leave Fig. 93 without analyzing the tones of shade and shadow. The simple objects shown here, like the cubes in Fig. 83, offer little to suggest stroke directions, so a large percentage of the lines follow the surfaces of the objects, often emphasizing the perspective convergence. The lines composing the shadow tones on the object rest take various courses, too. In Sketch 1 they recede towards the left-hand vanishing point of the box itself; in Sketch 2 they radiate; in Sketch 3 they follow the direction suggested by the rays of light on the object rest; in 4 they are horizontal; in Sketch 5 they converge towards the right; and in Sketch 6 they are freely arranged.

When you have completed a drawing or two of your first object, in somewhat the way these were drawn, do another from a similar subject, remembering that the value arrangement and representation is more important than the actual technique. Keep the technique simple, however, as the surfaces themselves are simple. As a general rule, too, don't overwork curved lines in sketches of flat-sided objects; save them, instead, for objects in which curved surfaces are predominant.

Next do a half-dozen more drawings, based on other simple straight line objects, such as pyramids, prisms and the like, first making trial sketches similar to those in Figs. 80, 81, and 82. These may be in pencil or pen. This should give you sufficient practice to prepare for rounded shapes.

Rounded Shapes

The sphere makes a good starting point for working on rounded shapes as pictured in Fig. 94, as the drawing of it involves no perspective knowledge. In fact, because of the simplicity of such rounded forms, many teachers prefer to start their

students with this class of subject rather than the straight line objects which we have used for our first problems.

As in the case of the straight line objects, it is advisable to sit and study each form for a few moments before drawing it, making a trial sketch or two in pencil or pen for the values. We have considered the sphere in the preceding chapter, so we need say little concerning it. It is worth mentioning, though, that no matter how any particular sphere is placed on the object stand, it looks about the same from any angle, its effect changing only with different lighting.

In Fig. 94 Section 1, there are five drawings of a hemisphere. A full sphere would look exactly the same but would cast a differently shaped shadow on the background. Since the values no longer appear flat, as they did in the case of the straight line objects, it is not so easy to represent them. At A the shading is accomplished with lines which are portions of circles, concentric with the circumference of the whole. Some of the pen lines fade out to dots at the ends; various pressures have been used to make lines of different widths. At B the lines radiate, in a general way, from near the center, each stroke being shaded with a Gillott No. 1 pen. The third sketch, at C, was done with more freedom; the fourth depends for effect on crosshatch; the last is stippled. The lighting, though from the left in all, differs to some extent in direction, as is seen by the variations in the forms of the shade areas. The amount of reflected light varies, too, strongest in D. The student is often inclined to over-emphasize such reflected tones.

A background tone was put behind these sketches, made freely with the Gillott 404 pen. This tone, by its contrast with the hemispherical forms, and taken together with the shadow tones, helps to make the objects seem to project from the paper. There are times when it is desirable to represent spherical forms in a more simple and conventional manner than this; Figs. 95 and 96 show some of the methods. In Fig. 95 one crescent-shaped plane of flat tone was used, plus the circular outline; in Fig. 96 two planes of tone take the place of the one. Such tones might be built up of strokes varying widely in direction.

The cylinder is a little more difficult to construct than the sphere, because of the ellipses representing the foreshortened circular planes of the top and bottom, but it offers the next logical step, unless you would rather practice shapes more like the sphere, including ovoids, ellipsoids, etc. In Section 2, Fig. 94, we have drawn a right vertical cylinder in five of many possible ways. These drawings explain themselves. Close comparison will show similarities between the methods used here and for the hemispheres. Notice that to the background plane another plane has been added, representing the horizontal table surface or object rest which supports the cylinders. This is rendered

HEMISPHERES

CYLINDERS

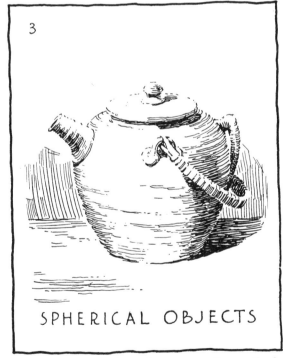

SPHERICAL OBJECTS

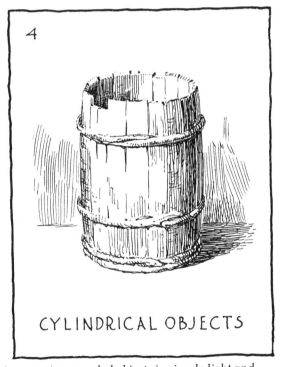

CYLINDRICAL OBJECTS

Fig. 94. Study this figure for comparative methods of expressing rounded objects in simple light and shade. Notice how the lines are arranged to interpret the surface curvature.

Fig. 95. This sphere indicates one plane of light and one plane of shade.

Fig. 96. Here you see one plane of white and two planes of gray.

in horizontal strokes, which cause it to seem flat and level. From cylinders you may naturally turn to simple cones or other solids, using a variety of line arrangements.

Memory Sketches

You do not need to spend long on these geometric objects, providing you work thoughtfully before mastering them sufficiently well to proceed to more interesting objects based upon them. Before doing so, it is often helpful to test your powers of retention by making memory sketches of some of the forms so far completed. No instructions are necessary; it is simply a matter of trying to draw without a model, or any reference or help, that which has just been drawn with a model.

After a few of these test sketches have been tried, you are ready to attempt single objects based on the same solids, such as the teapot in Sketch 3 and the barrel in Sketch 4 in Fig. 94. The teapot is almost spherical in general mass, yet with a cylindrical suggestion of rough texture, brought about by the method of manufacture. The old barrel is cylindrical in general form. Because it is made up of nearly vertical staves, and as the grain of the wood of each runs lengthwise of it, an up-and-down direction of line seemed natural to use. The hoops in the original were rough, with suggestions of the bark still on them, so a somewhat sketchy handling was reasonable. These sketches show that in many objects it is not enough to express the light and shade, but the textures of the materials must also be considered, and should influence the method of attack very strongly. Texture representation is so important that we will return to it in the following section. In both Sketches 3 and 4, outline has been very sparingly employed; the tones of the objects, plus the background and shadow tones on the object rest, tell all.

It will be helpful to copy a few drawings such as these, not with the idea of exactly duplicating every line in them, but more with the intention of producing their general effect. These, by the way, were drawn at this exact size, and with a Gillott 303 pen, except for the shadows on the horizontal plane for which a 404 was chosen. The 404 was also used for the outermost border line; the heavier border was done with a ball-pointed pen.

Fig. 97 presents drawings of four additional objects; the mass of each is based on combinations of simple rounded geometric solids. All four were drawn, at the same size as reproduced, from actual objects found in an attic in Maine. (Attics and cellars and outbuildings of old houses, particularly in the country, can often yield a surprisingly large number of interesting subjects for the artist.)

Textures

These drawings are particularly valuable for their honest suggestion of texture. Notice that the glass jug in Fig. 97, Sketch 1, is done mainly with crisp vertical strokes; their crispness is largely the cause of the glassy effect. Compare this with the representation of old oak in the bucket in the third sketch. Here, too, the strokes are mainly crisp and vertical in direction, but they are broken, and there are tiny dots of black and white that suggest the pitted surface of the wood. The iron hoops are drawn with lines which follow the ellipses around. The iron is generally darker than the wood, though far from black in effect. Notice the rope, in particular; the short, broken lines give a very clear impression that it is an old rope.

The basket in Sketch 2 is again an interesting study of textures. Here, even though the detail is almost overworked, the general appearance of simplicity of the whole is not lost. This would be a bit hard for the beginner to lay out, however, as would the basket in the first sketch. The old jug (Sketch 4), on the other hand, was easier to do, and could be copied without trouble. In this, outline has been avoided, except in a few spots; the broken lines, suggesting the corrugations of the material, follow the curvature of the surface sufficiently to give an effect of roundness. This example shows strong reflected light, separating the darkest shade on the jug from the deep shadow on the supporting table. This was a natural effect, because the jug, though rough, was glazed, and the projecting ridges or wrinkles reflected light as a similarly wrinkled mirror might do.

Working from subjects such as these, you come to realize that surface textures vary so greatly that studying their representation is essential. A half-dozen cylinders of equal size but of different materials would vary surprisingly in appearance. A cylinder of natural wood, for instance, would have a rather smooth, but dull surface. The same cylinder, coated with varnish, would take on a shiny look.

This causes us to ask why a thing looks shiny. If you study a few actual objects intently, you can answer this well enough for yourself. You will see that objects appear shiny because, being glossy, they mirror reflections of light and dark, which — added to their natural colors — give a great number of sharp and strong contrasts of tone. A shiny wooden cylinder, for instance, of slightly yellowish natural hue, might reflect bright light on one side (as from a mirror) and dark on the other (a distorted image, perhaps, of some dark object).

Sometimes such reflections take very definite shapes. It is common for a glazed object viewed indoors to show on its surface, in miniature, a very definite reflection of an entire window. Polished silver or other metal objects form almost as good reflectors as do looking glasses; cylinders of such materials would therefore show a wide variety of reflections. Bottles, too, are very glossy as a rule, and so they, whether cylindrical in form or not, mirror many tiny images of other objects.

Fig. 97. Here simple shading methods have been applied to a variety of rounded objects. The type of line you use should express the textures of the objects themselves.

Fig. 98. Here you can compare various methods of suggesting the textures of some typical surfaces. Metal objects in particular offer surfaces that vary widely in texture.

This all means that if you have such surfaces to represent, you must try to suggest some of these reflections. But don't over-emphasize them so they become too conspicuous, detracting from the effect of the surfaces themselves.

Aside from the shiny surfaces, there are many others you must be able to interpret in pen work; for instance, different kinds of cloth, leather, feathers, fur, and so on. It is advisable, then, to do some drawings simply to represent textures, selecting subjects that present real problems.

Fig. 98 offers several texture studies of this general nature. Those in Groups 1 and 2 are interesting, showing comparisons between old and worn and new objects. Notice that the hats in the first group were drawn with a sketchy type of line, yet these lines were by no means carelessly formed; they were made in what seemed the best method to represent those particular worn materials. The hats had real individuality and an attempt was made to express this honestly. The hats drawn in Group 2 were new and less individual, so they were treated in a corresponding manner; each line was drawn and each dot of stippling was done painstakingly. These comparative sketches show very plainly what diversity of treatment is possible with the pen, even when subjects are quite similar.

At the bottom of this same illustration notice the drawing of an old dull tin baking pan and a new and polished pewter pitcher. Notice what different techniques have been employed in rendering them. The pan was extremely dull; there was hardly a reflection on it and an attempt has been made to suggest this along with the expression of the form. Therefore, few sudden contrasts of light and shade are shown. The pitcher was a confusing mass of highly complex reflections of light and dark and color. To have drawn all these reflections would have been both difficult and highly undesirable; the drawing as made shows these complicated reflections simplified and conventionalized. Even here they are more confusing than is usually desirable.

This illustration is enough to prove what we have said: if you want to become versatile in pen handling, you must not only learn how to present appearances of form and of light and shade, but also effects of texture.

Color

Nor can color be entirely disregarded. There is little that can be said about how to represent color in pen, however. Owing to the limitations of the medium it is not possible to so picture an object that we can recognize its hue, unless one turns to colored ink (see Chapter 20). Therefore, color is either disregarded or expressed to some extent through values of light and dark; the slight variations of color in the object or objects are disregarded, but the larger contrasts are made evident by tones of different value. The drawings of the hats in the first group (Fig. 98), for instance, express the feeling that the materials were of some dark color; likewise it is evident that those of the second group were of light felt, but with dark bands.

Four considerations, then, are most important: (1) the representation of form; (2) the suggestion of light and shade; (3) the indication of textures; and (4) the interpretation of color. Keep these things in mind not only for still life objects but for every kind of subject.

9. Drawing Groups of Objects

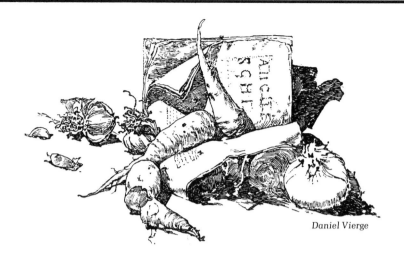

Daniel Vierge

Up to this point our instruction in light and shade drawing has been mainly concerned with representing single objects. Though affording a logical starting point for the beginner, single objects are generally less interesting than groups of two or more. They offer less valuable practice, too, not only in the drawing itself, but in their selection and particularly in their arrangement.

Soon we will describe the actual drawing of objects, but first let us consider the selection and arrangement of objects.

Selecting Objects

It is not enough to simply put two or three things on the table in a haphazard way and let it go at that. Instead, carefully select objects that are worth drawing because of good form, value, or texture, and arrange them logically and artistically.

Objects having distinct individuality are the best subjects for drawing. Those of rugged and bold characteristics described in Chapter 7 are usually better than merely "pretty" things. Quaint and old-fashioned objects are particularly interesting, or those which are worn or broken. Rummage the attic or cellar. Look in the garage or barn. Even the kitchen and laundry often yield implements and utensils excellent for our purpose. Things that grow are sometimes splendid subjects. At the end of this chapter you can find a list of suggestions for objects to draw.

This list was designed primarily for the art student. The student of architecture, looking through the list, might ask why it is essential to be able to draw books, hats, or dishes. It is not absolutely essential, of course, and, if he wishes, he may pass on to later chapters especially concerned with the representation of architecture. He should not do so, however, without realizing that the drawing of objects is valuable training for all students. For aside from the skill in form representation and the perspective knowledge gained from their study — directly applicable to large problems, such as buildings — the student also learns from small things, which are easily seen by the eye as complete units, how to suggest all sorts of textures and materials. When you have learned to express the leather of shoes and the glass or porcelain of dishes and the cloth or metal or wood of other small objects, it is not difficult to turn to brick, stone, plaster, shingle, and slate.

Composing the Objects

We stated a moment ago that it is not enough to put two or three things on the table in a haphazard way. This point is essential. All through your work, there are many problems of selection and arrangement to be solved; in any picture you will have to compose forms, values, and colors to the best advantage. The architect, too, in designing buildings, must give much thought to composing masses, even down to the smallest detail. The interior decorator must plan his spacing of wall and floor and ceiling, his arrangement of doors and windows, and his disposition of furniture, draperies, rugs, and so forth. There is perhaps no better way for students to acquire, almost unconsciously, a fundamental knowledge of composition than through practice in arranging and drawing still life objects.

As you are arranging and drawing, supplement this easy means of gaining knowledge of composition by reading some of the principles of composition discussed in Chapter 10. There are certain common sense facts, however, which especially apply to this type of work and are worth considering for now.

Select objects of real value to your drawing practice. Naturally the objects chosen should be related in some way; generally things associated by use form the most homogeneous compositions. But don't choose items that are related, or things of a kind, unless they also offer some variety of form or surface or texture, or of values of light and dark. Only a dull composition results with objects of equal roundness or squareness, for example, even if they are associated by use. The fruit and basket shown in Fig. 99, for example, form a monotonous group.

Look for some variety, but not too much: forms which are somewhat dissimilar, and dissimilar edges; some that are soft, broken, and indefinite; and some that are clean and sharp, yet avoid extreme dissimilarity. Though contrast in size is usually desirable, an enormous object fails to harmonize with something that is tiny, so too much difference in size may be as bad as too little. The best compositions are usually those in which the objects are related in some way, sufficiently different to prevent any feeling of monotony, yet not disturbingly dissimilar in any respect. An ink bottle with stationery and pen may be pleasingly arranged, for instance—these objects are all associated by use, yet vary in shape, size, color, material, and texture, and at the same time not to an extreme extent.

When you have selected two or three objects that seem to offer possibilities for pleasing and logical composition into a unified whole, place them on your object stand and shift them about until the whole effect seems good. For outline work, shadows have little importance, but in light and shade work the shadow forms must be considered. This means that the objects must be well arranged in terms of their own shapes and values, and you must study the lighting until all the shade and shadow tones also compose to the best advantage. (Remember, if light comes from many sources, the shadows are sure to be distracting.)

Viewfinder

You may find yourself at a loss to know when you have achieved a good arrangement. If so, a viewfinder may help. This is nothing more than a sheet of heavy paper or cardboard with one or more small rectangular openings cut through it, each an inch or two, 0.03 or 0.05 mm, or slightly more in size. When you have arranged the objects in a pleasing way, hold up the viewfinder. Close one eye, and look with the other straight through one of the openings at your composition, moving the finder nearer to or farther from the eye until the composition is well framed within it. In this way your attention is riveted on the objects, the viewfinder acting much like the mat or frame of a picture; anything distracting is cut off by it. The edges of the opening represent the edges of the drawing paper to be used, or the margin lines around the proposed drawing. If the objects do not compose well when viewed through the finder (which, by the way, should vary in proportion and may be used in either horizontal or vertical position) they should be rearranged until they do.

It is particularly beneficial to make a few quick trial sketches at this point, not as value studies but more as studies in arrangement. In Figs. 100, 101, 102, and 103 we show four studies made for this very purpose. These explain themselves. When two or three arrangements of objects have been made and sketched quickly in this way, the objects should be grouped for the final drawing according to the best sketch. If one object does not seem to fit, substitute another for it; then try another tiny sketch (see Fig. 103). Use the best one as the basis for the final drawing, or go back to one of the previous arrangements. It is often wise to make several finished drawings from the same objects arranged in different ways.

The Triangle in Composition

Considering that still life objects are shown in repose, bear in mind that a triangle resting on its base always seems to express this feeling well. Many compositions of objects conform in general mass to a triangular proportion. In Fig. 104, Sketch 1, we show a simple composition of this triangular nature. Figs. 101 to 103 are also of this same general form.

When a triangle is placed on its apex, or on any one of its vertices, however, it no longer has this restful character. Objects, then, should not be arranged so that the entire mass seems to come to a sharp point at the bottom. (This is illustrated in Figs. 105 and 106.) On the contrary, except in rare instances, the more nearly horizontal the direction of the base line of any composition is, the more restful is the effect of the whole composition.

Other Compositions

In Sketch 2, Fig. 104, a square composition is shown, and, in Sketch 3, one that is circular in general arrangement appears.

Fig. 99. Grouping all rounded forms is monotonous.

Fig. 100. Make trial sketches to arrive at a good arrangement.

Fig. 101. Try several arrangements before selecting the best one.

Fig. 102. Work freely but thoughtfully.

Fig. 103. Add or substitute other objects.

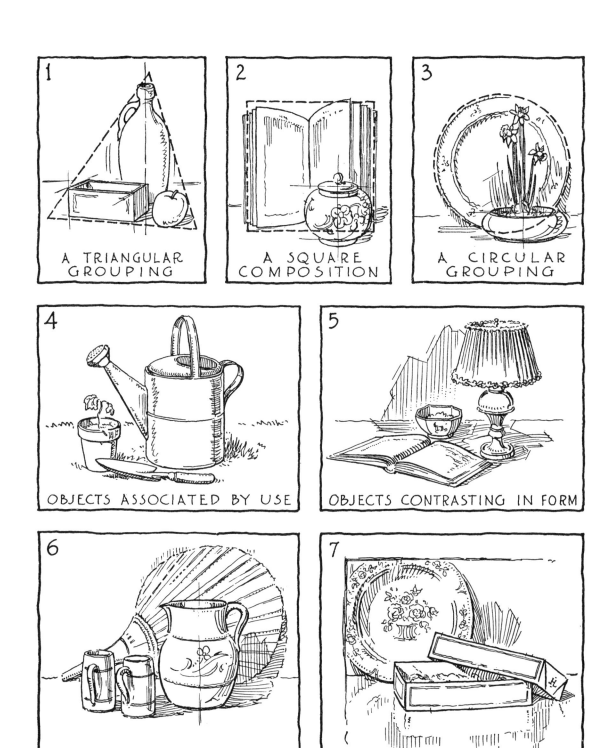

1 A TRIANGULAR GROUPING

2 A SQUARE COMPOSITION

3 A CIRCULAR GROUPING

4 OBJECTS ASSOCIATED BY USE

5 OBJECTS CONTRASTING IN FORM

6 OBJECTS CONTRASTING IN SIZE

7 MARGIN LINES CUTTING OBJECTS

Fig. 104. Here we have applied some of our thoughts on composition to arranging objects. Sketches like these serve as crude guides for the final drawings.

Few compositions take as definite geometric shapes as these, and there is no reason why they should. The objects in Sketch 4 might be circumscribed by a circle, yet here such a circular arrangement is hardly obvious. When using a circular or other rounded composition, make sure in the drawing that the entire group does not seem ready to roll off the paper when drawn, or at least rock back and forth. There must be a stable appearance to every composition that is supposed to be at rest. Each object will seem more satisfying, too, if it appears well supported. In Fig. 106, for example, we show a pitcher with its base entirely hidden behind a book. There is a sense of something lacking. The book itself is also too far below the eye to give the best effect, seeming to tip up, giving the same unpleasant feeling already mentioned.

The other sketches in Fig. 104 are self-explanatory, as are most of the sketches in Figs. 107 to 114. Experience will guide you in composing satisfactory arrangements.

Holding Your Position

Once the objects are in place, blocking in the drawing of any composition of several objects would proceed exactly as for one object. With several objects, however, it naturally takes longer for the construction work, and you must use pains to get each object right in mass and perspective in relation to every other object. This means that you must be careful not to gradually start to slump in your seat as the moments pass, which will cause you to see the objects differently. If you leave your work before the outline is fully constructed, you must be sure to sit in exactly the same position when you return, in order to view the objects in the same way. You should train yourself to look at the objects from the same exact spot, whether drawing one or more. Sit erectly and do not move your chair or object stand. It is the practice of some artists, and an excellent one, too, to mark with chalk on the floor around the chair legs and object stand legs, so that if either chair or stand becomes shifted, it can be easily returned to the proper place.

You may think we are over-emphasizing a minor point, but this is far from the case, for the slightest shift in position after a drawing is started is often enough to cause confusing and inaccurate results. If you move a bit to one side or to the other, or slump even an inch or two, each object may appear quite different, not only in form but in the location of highlights, etc.

A Warning to the Teacher

In this connection we wish to warn teachers, as well. When you take the students' places in order to criticize their drawings, do not begin until your eyes are in exactly the same positions as were those of the student. Much wrong and unfair criticism is given by teachers who

Fig. 105. This composition is much too pointed: it should not fall so far below eye level.

Fig. 106. This composition would be better if the base of the pitcher were partly visible. Notice that because the angle of the book is too sharp (arrow), the book looks tilted.

Fig. 107. This is better composed. Notice that the base of the vase is showing and the angle of the books has been corrected.

Fig. 108. These rounded forms show variety in mass.

Fig. 109. Here is a composition of all straight-line forms.

Fig. 110. This is a combination of straight-line and curved-line objects.

Fig. 111. Horizontal masses fit horizontal spaces.

Fig. 112. Margin lines are often left incomplete.

Fig. 113. Objects are often cut by the margin line. However, the square is not considered an ideal format.

Fig. 114. The line of the table is too low here and the object seems to be falling off its surface.

are either taller or shorter than many of their students, and who naturally view the objects, when criticizing them, from an entirely different level.

Some teachers, realizing this danger, check themselves with an interesting method. They have each student, when naturally seated, sight across some mark or point along the top of the object stand to some coinciding mark which can be made on the wall or other fixed place. Then the student, sighting from the first to the second point, establishes his position. If he finds at any time that these points are not in line — one behind the other — he knows that he is out of position. The same marks prove of value to the instructor when he sits to give criticism. These marks enable him to view the objects from exactly the same point used by the student.

Value Study

Proceed as you did with the single objects discussed in the preceding chapter. When drawing the first few compositions of a number of objects, pay attention to the truthful representation of the various values. As we have explained previously, we do not mean by this that each change in tone must be represented in pen, but we do mean that much more attention should be given to values than to technique. Preliminary pencil or pen value trial sketches, such as have been described, are helpful in the work. You can, for example, make your pencil drawing in full value, interpreting the whole subject in an almost photographic manner in pencil tone. Follow this with a second drawing, in either pencil or pen, in which you omit some values and simplify others, this sketch becoming the guide for the final pen work on the larger drawing.

Sometimes the beginner hardly knows just where to start applying the lines in his large drawing. Often he makes the mistake of outlining each object in the whole composition. Instead, once the entire composition has been penciled on the paper, work systematically at the values themselves, later adding only enough outline to round out the whole. You may draw the darkest tone first, then the next lighter, and so on all through the values. Or start with the lightest tones, then add the middle grays, and finally the darkest grays and the black.

With pencil or charcoal, work over the whole drawing, building up the various values gradually, without attempting, as a rule, to bring any one part up to the proper value at first.

In pen — which is far more direct — it is customary to try to get each value just right with the first lines drawn. Occasionally, however, a drawing in ink is done by a method more like that just described for pencil or charcoal. Fig. 115 is an example of this.

Analyzing a Value Study

The composition in Fig. 115 is of objects related by use. It is triangular in general form. The objects are related in shape as well, each being rounded; yet the whole offers interesting variety in both size and shape. Variety in textures is another attribute. The drawing of these objects was started with the thought of working for correct values, regardless of the technical means required to get them. The technique, therefore, is far from direct, and because of this the drawing might be criticized by one who failed to understand its purpose. This is a convenient example of how important it is for the student to study true appearances, even to the extent of neglecting technique, as was done here. Too often the opposite is the case—a drawing is all technique and nothing else.

In this subject, all of the objects were rather light in color, except for the dark bands around the bowl. Those portions of the bowl and bag that were turned directly towards the source of light were so bright that it was decided to allow the white of the paper to represent them. There was a brilliant highlight on the bowl which was impossible to represent without forcing other values. The objects being rounded, there were few distinct planes of light and dark, except some of small area.

The edges of the objects showed great variety: they are dark in places and light in others; in some they are very distinct, and in others actually lost in the background shadow. There is nothing more important in such studies than to draw the edges correctly in this way, sharpening them or losing them as in the objects themselves. Note in this drawing that at A the edge of the bag is omitted entirely; in other places it is simply dotted. Some objects become so lost in shadow on their shaded sides that it is hard even to distinguish their complete forms. This effect should be sought when employing a naturalistic kind of representation, the edges hardly showing.

Important as the edges of the objects may be, they are no more significant than the edges of the shadows. Note how these vary in Fig. 115. As a rule, when working under natural light indoors, you will find that the sharpest shadows are those cast where one surface touches, or almost touches, another. The chairs in the middle of a floor, for instance, will cast the darkest shadows on the floor, with the sharpest shadow edges occurring where the legs touch the floor. If you rest the point of a pencil lightly on the surface of a sheet of paper, the sharpest shadow will be at the point of contact. In our drawing the sharpest shadow edges are where one object touches, or comes near to touching, another. See how sharp the edges are at B, D, and H, and particularly at F. Note how soft they are at C and G, and how especially soft at E.

In a rendering such as this, you often find yourself forced to use considerable crosshatching, stipple, and the like, in order to get the desired effect. You may even need to scratch out, sometimes, with a knife. Now and then some artists resort

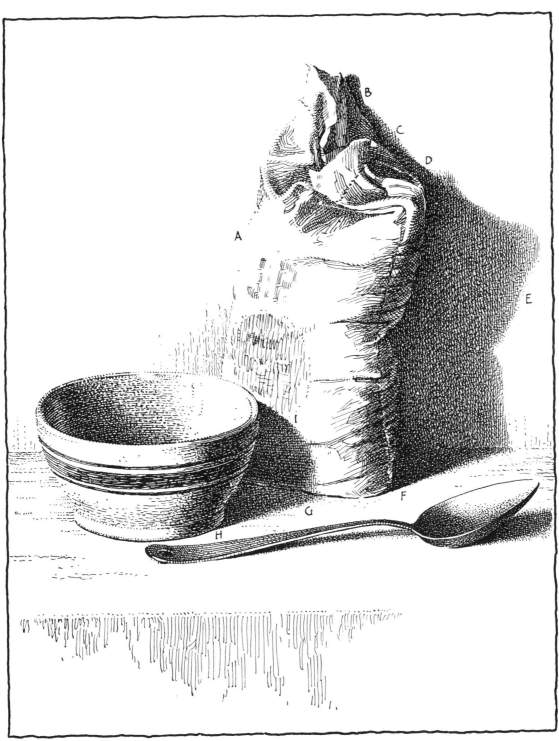

Fig. 115. This is a study in values. Notice the free use of crosshatch and stipple. Give some thought to technical handling as you make these studies of true values.

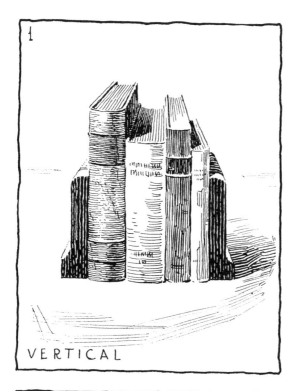

VERTICAL

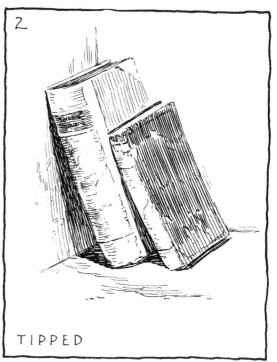

TIPPED

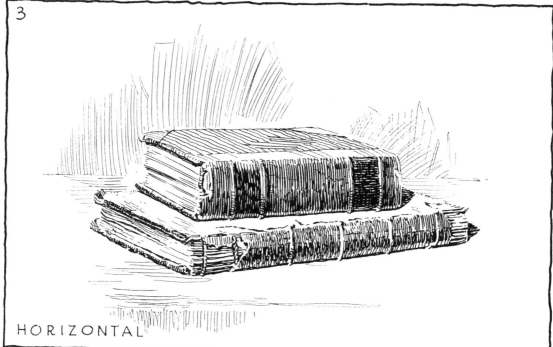

HORIZONTAL

Fig. 116. Here simple shading is applied to a variety of straight-line objects, with particular attention to form, values, and textures.

to a bit of white ink, white strokes being carried over tones which have become too dark. If this helps to give a more truthful result, there can be no harm in doing it. You shouldn't worry about such things as this in your first attempts at this kind of drawing.

In the large shadow tone of the bag in Fig. 115, an attempt was made to suggest the shadow with a tone dark enough, yet with something of the quality of transparency and vibration seen in the shadow itself. This fine line crosshatch seemed a natural way to obtain this effect.

Finishing Up

As you work on this kind of drawing, set it back now and then for comparison. When you are finished, walk away for a few minutes to rest your eyes; then return and thoughtfully analyze it. Are there the right degrees of light and dark to express the subject satisfactorily? Is there the correct sharpness and softness of edges? Is there too much dark in some portion so the drawing does not hold together well? Are the tones clear and transparent where they should be, or dead and heavy? Is there a fairly successful expression of space, depth, weight, texture?

Now partly close your eyes and squint at the drawing, reducing it to its simplest elements. Do the nearer parts seem to come forward naturally and the farther parts go back? If not, the nearer parts should be forced a bit and the distant portions sacrificed. Is a highlight too complex? If so, tone down some of it a little or simplify it. Are the dark tones too complex? Then simplify them, too. Then, if practical, leave the drawing for an hour or two, or even for a day or more, and come back to criticize it again with a fresh eye. There is nothing more helpful for the artist in almost any stage of his work, regardless of subject or medium, than to get away from it for a while. Returning, he will see mistakes that will cause him to wonder how in the world he happened to make them. (Subjects such as outdoor scenes are sometimes exceptions, as they demand haste for their satisfactory interpretation.)

Vary the Subjects

We have recommended that you select a variety of subjects. If you have been working from light-colored objects and objects made up of curves, as in Fig. 115, turn next to straight-line objects of darker value, or to something else offering a similar change. Simple subjects of this sort are shown in Fig. 116, picturing books variously placed. Comparison of Figs. 115 and 116 will show a great difference in technique, the first being somewhat overworked. (Fig. 115, by the way, was done with a Gillott 170 pen, at the size shown.)

Fig. 116 shows a relatively simple and direct technique. In the foreground and background, the No. 1 pen was used; some of the lines drawn with the No. 1 were so fine that in reproduction they have broken up here and there into dots and dashes. The objects represented here varied much more in their color than those in Fig. 115. In Sketch 1, for instance, the contrasting values plainly suggest some of the variety which existed in the tones of the books themselves and the book rack ends. The books in Sketches 2 and 3 show similar differences. The latter were extremely old, particularly the lower one. Old, worn and dilapidated books are much more interesting to draw than newer ones, but more difficult. See what a variety of strokes has been used in this one drawing, yet it is simple, after all. The drawings on this sheet would be good ones to copy, by the way, or you might do some of this general type from your own subjects.

Stylized or Decorative Work

Some artists claim that the pen is not well suited for realistic drawings. They base their claim on the fact that it is impossible — with the pen — to represent all of the subtle variations in value that are found in objects. These artists prefer to use the pen for more stylized work or "decorative work," as we have chosen to call it. This kind of work varies greatly in kind, and demands closer study.

Fig. 117 was drawn from an actual book, and a glass candlestick with candle. In many ways it is quite naturalistic, yet some lines that were not particularly conspicuous in the objects themselves have been made so here, and vice versa. In a certain way the drawing is somewhat posterlike, yet its complexity removes it from the poster class. There really is little that can be said about such a drawing except that the artist, in working in this way, takes as many liberties with his subject as he pleases. He amuses himself by trying to arrange his lines and tones in a well-balanced and interesting and, at the same time, somewhat decorative manner. Fig. 117 is really simply a natural advance from the accented outline drawings shown in Figs. 54 and 55. It is the same idea pushed a bit further. So far as pens are concerned, most of this drawing was made with the Gillott 404 point, some of the blacks being added with a ball-pointed nib.

Fig. 118 shows other examples of light and shade representations of objects treated in a somewhat decorative manner, all of them having been drawn directly from actual objects. In Sketches 1, 2, and 3, accented outline was first used for the objects, then the backgrounds, etc., were added in a highly conventional way, in tones of gray and black. In the first drawing the horizontal plane of support is done as a flat tone made up of vertical lines. Sketch 2 is really the same, except for the change from vertical to horizontal lines in this area, and the addition of the black behind the objects. In Sketch 3 quite a different effect is obtained by making the supporting plane black and the background a gray value, built up by the simple use of vertical lines.

Note that there are no shadows in these three drawings. In such work if shadows are not wanted they are omitted. Sketches 4, 5, and 6 are a bit more naturalistic, perhaps, because shadows were used. Here again the drawings are the same in many ways, yet entirely different in others. Notice that no two of the backgrounds are alike. Compare, also, the treatment of the cherries themselves. The leaves in Sketches 4 and 6 are much the same; those in Sketch 5 show greater difference.

Drawings 7 and 8 require little explanation. Both suggest shade as well as shadow. Both feature an economical use of line. (Study the careful yet simple way in which the teapot handle in Sketch 8 was drawn.) And, to a certain extent, both are naturalistic in treatment. Sketch 7 has something of the character of a woodcut; Sketch 8, however, is plainly a pen drawing. Here the effect of roundness is gained largely through the disposition of the conventionalized values representing the surface decoration.

Balancing the Lights and Darks

We should not leave Fig. 118 without some reference to one of the greatest difficulties of this sort of treatment, one which every worker in strong contrasts of light and dark runs up against. This is the difficulty of properly adjusting the values in order to obtain good balance of all of the parts. When values are rather light, the effect of a drawing is sometimes not bad even when the values are poorly disposed. A single value made black, on the other hand, attracts a great deal of attention. This means that some other area of tone must frequently be made black to balance the first.

In Sketch 6, Fig. 118, the cherries were first made black and the partially hidden leaves were left as in Sketch 4. The cherries seemed too black, however, in relation to the whole, so these leaves were blackened, and in this way balance was restored. It takes considerable practice to handle these extreme contrasts, and a suitable subject is necessary also.

It may be worth pointing out that in an entire sheet containing a number of individual drawings of this general nature, it is equally important and equally difficult to keep a balanced distribution of values. It is all too easy to get so much black on one side of the sheet, in contrast with the other, that the eye is pulled to it. Study Fig. 118 and see how an attempt has been made through careful distribution of all the black and gray and white areas to keep the entire effect of the sheet restful. Notice also that in the whole illustration only three values are used: pure white, solid black, and a gray of about middle tone. The large black areas, by the way, were put on with a brush, but a broad-pointed pen would have done as well.

Fig. 117. This is a somewhat stylized or decorative treatment of light and shade. For some purposes it is good to combine accented outline with tone.

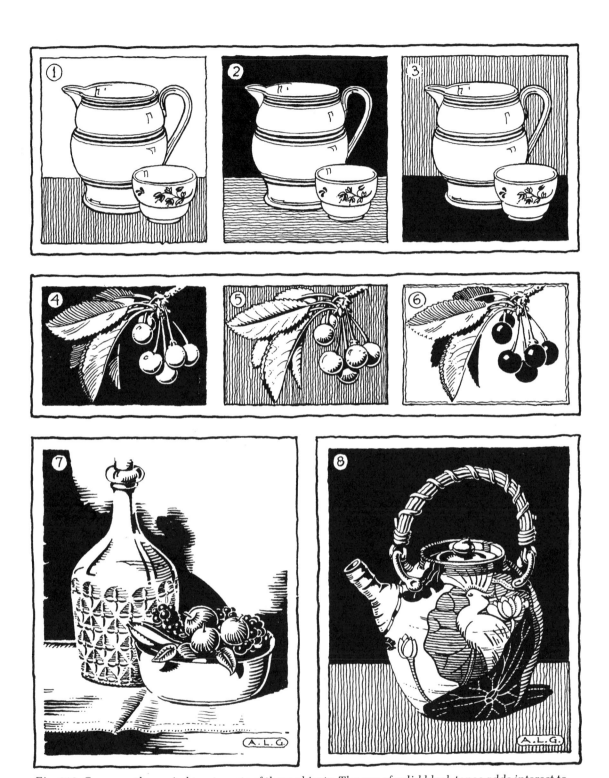

Fig. 118. Compare the varied treatments of these objects. The use of solid black tones adds interest to these sketches.

Books can always be arranged effectively: piled up, tumbled down, spread out, open or closed. They can be combined with other objects, too: book, candlestick and matches; old novel partly opened, apple between leaves; half-open newspaper with books; book with eyeglasses; paperweight, half-open letter and envelope, etc.

Then there are other objects that can be found around the house, things that are in everyday use: gloves; photograph in frame, bowl of flowers; checker board and playing cards; pipe, tobacco jar, matches, etc.; opera glasses, bag, and program; slippers, gloves; hats or caps; basket or bag with sewing or knitting; brush, comb and mirror; children's toys and dolls.

Combinations for fruits, vegetables, etc., are, of course, innumerable: paper bag with fruit, vegetables or candy falling out and at the side; bananas half peeled on plate with knife; lemons, squeezer, glass, sugar and spoon; box of sardines, sliced lemons and plate of crackers; cocoanut, broken open; bunches of beets or carrots or similar vegetables with tops; several apples, one cut in half, another partly pared; teapot, teacups, plate of sandwiches; fruit bowl or basket filled with fruit; pineapple with knife and plate; squash or pumpkin cut open, partly sliced; pumpkin made into jack-o'-lantern; bread on plate, some sliced, with knife; salad plate with lobster and lettuce, mayonnaise bowl, spoon and fork; roasted meat on platter with carving knife; plate of beans, catsup bottle, napkin; sugar bowl, cubes of sugar, sugar tongs; box of candy open or partly open; crackers in box or bag, bowl of milk, spoon; strawberries or grapes in basket; bunches of grapes with bit of vine, leaves, and tendrils; apples, pears, or peaches hanging on branches with leaves; heads of lettuce, cauliflower, and bunches of celery; sliced meat on platter, garnished with parsley. And bowls and vases of flowers are always good, too, or branches of leaves or berries.

For more elaborate studies, views of room corners or portions of a yard or street offer many possibilities.

More Practice in Object Drawing

Now just a few final words on object drawing in light and shade. First, there are so many ways of representing objects in pen that it has been impossible, even in these lengthy chapters, to touch on more than a few of them. This means that the student who is interested in work of this sort must go to other references for additional material. Study many pen drawings and take similar objects and represent them in your own way. There are endless chances for originality along these lines.

If you are interested in approaching the subject from the standpoint of design rather than that of somewhat realistic interpretation, you will find that it is possible to take many subjects from everyday objects like the ones we have discussed, and to combine them into extremely interesting compositions to be used as applied designs. For anything of that sort, object drawing in light and shade lays an excellent foundation.

As additional practice, test your skill by making memory drawings such as we have already described. This will show you whether or not you are developing powers of observation and retention. As a speed test it is often valuable, too, to make quick sketches of objects at fairly large size. To work very fast at times is the best of practice for acquiring skill to grasp and delineate the essentials of any subject quickly. It is preferable to set a limit of time and then to see how good a drawing you can produce within the limit. The speed and dexterity gained with this practice will prove indispensable when it comes to working from the living model or moving objects. Too much such work, on the other hand, leads to carelessness and inaccuracy, which will be detrimental rather than beneficial. Alternate your problems, then, making some quick sketches and some painstaking studies, and progress should be steady and consistent.

List of Objects Suitable for Drawing

The following objects are recommended for elementary or comparatively small compositions: garden trowel and flowerpots; hammer, box of nails; screwdriver and screws; basket of clothespins, coil of clothesline; pail with cloth hanging over side, scrub brush and scouring powder; tack hammer, box of tacks, etc.; whetstone with knife and piece of wood half whittled; sponge, soap, and basin of water; dustpan and brush, feather duster, etc.

Among larger objects, you might draw: snowshovel, rubber boots, and mittens; shovel and tongs; washing machine with basket of clothes; wheelbarrow, rake, and basket; broken box with axe; watering pot, trowel, broken flowerpots; hat and coat on a nail; old trunk partly opened, etc.; old hats and hatboxes; umbrellas in various positions, opened, closed, and half closed; brooms and mops with dustpans and pails; chopping block, sticks of wood, axe; basket of kindling and hatchet; old churn with chair beside it; baseball bat, mitt, and ball.

10. Basic Principles of Composition

Daniel Vierge

If you place a single object on your object stand and draw it as described in Chapter 8, even though your technique itself may show some originality, your drawing is primarily an imitative representation, showing a minimum of individuality or inventiveness. It is important for you to do this type of work, however, for many reasons. We have mentioned, for instance, that it helps you train to observe with care and to translate the results of your observation with skill, thereby disciplining the hand and eye. Such work also helps develop your patience and perseverance, stimulating at the same time your powers of concentration. Nevertheless, at best the work is too imitative to greatly assist you in becoming very individual or original either in approach or in execution. All too often, knowledge or appreciation of beauty acquired through such work is also superficial.

When you draw more than one object, arranging several into a group according to some scheme of your own, you are exercising your imagination to a greater extent. The arrangement, at least, is your own individual creation.

Why Learn These Principles?

Drawings, as a whole, may be divided into two general classes. The first consists of those which appear generally to have been drawn from real persons, places, or things, though often with some show of individuality. The second includes highly original and usually stylized designs of a more creative nature. This second class is usually called *design,* and does not fall altogether within the scope of this volume.

The first general class may be again divided into two types, one consisting of naturalistic or realistic representations, and another showing greater *personal* interpretation of the subject. At the present time we are primarily interested in this second type. It includes drawings that are actually composed; their subjects are treated with imagination, originality, and a true appreciation of beauty. It is an important class, for composition (and its allied subject of design) is really the foundation of much that is living and vital in art.

It is regrettable, then, that so many students who can imitatively represent single objects or simple groups, or artists who can accurately draw from photographs, are unable to do much more than this because of lack of imagination or inadequate knowledge of composition. There are students, for instance, who are able to delineate small details of buildings—such as shingles and slates, bricks and stones, and even such larger parts as doors and windows—yet lack the ability to compose these elements into a complete whole.

If you do not wish to be handicapped like this, take advantage of every opportunity to master this difficult art of composition before you become almost an automaton, stamping out a repetition of imitative drawings. Such knowledge can come only through long experimentation and practice. Nevertheless, you can apply these essential principles immediately and find them useful for all subjects in all sizes and, in fact, to all media.

It is impossible, in a single chapter, to do more than point the way for you in composition. First we will define rather broadly a number of the commonly used terms, discussing a few of the principles and offering some specific advice where it seems worthwhile to do so.

What is Composition?

According to the dictionary, one meaning of the noun *composition* is "the act of composing, or the state of being composed; . . . a compound; a combination." To compose means to make up of elements or parts, to arrange, to construct, to form. A composition is a composite thing made up or composed of separate units or elements.

As a simple illustration of this refer to Figs. 119 to 127. Notice that in Fig. 122, a number of straight lines have been drawn without plan or thought. In Fig. 123 they have been moved about and combined until they form complete units; they seem to belong together. In Fig. 124 they have been arranged in another way, yet the separate elements are once more brought into a complete whole.

This is clearly an example of an extremely elementary type of composition. As a rule the artist has a widely diversified group of things, often seemingly unrelated, as his essential elements, not a few straight lines or geometric forms. He must bring these together to form a unit which is not only esthetically satisfying, but which tells a story or in some other way suits his requirements.

Fulfilling the Purpose

The poster artist has a problem all his own. He must work for an extremely simple composition, directly expressed, which will attract and hold the attention of the spectator, and which can be comprehended almost at a glance.

The advertising artist who uses the magazine page has a somewhat similar problem. He, too, must attract and hold attention. He must direct all attention to the object advertised, and create as favorable an impression of that object as possible.

Magazine illustration frequently presents the same challenge. Each drawing must make the magazine as a whole seem more attractive, and should also create in

Fig. 119. Scattered letters like these have very little meaning.

MERIT

Fig. 120. Properly arranged, letters may have much meaning.

MERIT
REMIT
TIMER
MITER

Fig. 121. Arranged differently, letters may have a variety of different meanings.

Fig. 122. Scattered lines, like scattered letters, mean little.

Fig. 123. Lines may be arranged to mean more than letters.

the mind of the spectator a desire to read the text which it illustrates. Furthermore, it must correctly illustrate some thought in the story, supplementing or emphasizing it, without giving away the whole plot.

The architectural renderer also has a unique challenge: he must picture some building that has not yet been built, generally placed in an imaginary environment; yet the drawing must look convincingly real, down to the last detail. The architectural renderer must have an extremely well-trained memory and fertile imagination.

The fine artist has distinct problems, too. He works in a far different manner from the poster artist, for instance. Once the message which a poster is designed to convey has been read, the poster holds little interest. An imaginative painting, on the other hand, is often something not understood at a glance. Its interest grows as it is studied; all is not revealed at once. Bit by bit its hidden story becomes apparent to the viewer.

This is enough to make clear that there should be a definite purpose behind every drawing, and that everything done to the drawing should contribute towards the expression of this purpose.

Selecting the Subject

Many drawings are worthless, apart from the practice of drawing itself, because they are made with no purpose behind them. Each subject for a drawing should be selected with care. You should know just what your purpose is, so that every detail and accessory can contribute to its complete and clear expression. Obviously you cannot make an ideal composition when you have poor things to compose. Thoughtful selection, then, is the first essential of every successful composition.

If you are composing a group of still life objects to draw, for instance, try to find things that logically go together, as explained in Chapter 9. No unrelated object should be used.

If you prefer to use a photograph, select one which is satisfactory as a whole, or concentrate on some pleasing part of one. The choice may seem confusing at first.

Even if you draw from nature you will find that not everything offers a suitable subject. You will have to select, perhaps with the aid of a viewfinder, a subject with interesting possibilities. Every artist knows that in nature, as elsewhere, certain types of subjects are very intriguing, and that others have little to inspire. Beginners have much trouble selecting suitable subjects from nature, and there is little outside of experience to aid them. Amateur photographers soon learn that to get pleasing pictures from nature it is not enough simply to point the camera and snap a shot. Real thought is required in selecting the subject, its lighting, and the point from which the exposure is made. In the same way, the student of drawing must learn what will make a good subject.

Fig. 124. A few simple straight lines may form an interesting design or pattern.

Fig. 125. There are endless possible groupings of simple straight lines.

Fig. 126. Innumerable borders or patterns based on simple shapes may be arranged.

Fig. 127. Curved lines offer even more variety.

Often a scene that is inappropriate for a photographer is excellent for the discerning artist, because the artist can omit or subordinate anything which is confusing or irrelevant, or can rearrange the elements entirely.

Regardless of the subject you select, however, make sure you include or do nothing in your representation of it to cloud or obscure the main intention.

Unity

Observing the principle of unity requires that your composition be a homogeneous whole. All the parts must be related and so merge or blend together that they become a single unit, expressing one main thought. In order to secure unity in a drawing, select only as much of the material that relates directly to the subject of his sketch. Separate your subject from everything else that is visible, and then think of it as a single harmonious whole. This rule applies whether the subject be a still life grouping, a portion of a photograph, a bit of nature, or something quite different.

Once you have determined what the subject is to be and have decided whether or not some of the visible things are irrelevant, discarding them if they are, next decide on the relative importance of those you have retained. Unity in a drawing depends not only on the selection or rejection of material, but on its emphasis or subordination as well. Unless each detail is given just the amount of attention proportionate to its importance, the composition will not count as a complete and satisfactory unit. Failure to give sufficient emphasis or accent to the leading parts of a drawing greatly diminishes the force of the entire composition. In the same way, the unimportant parts will confuse and complicate your composition if they are not subordinated properly.

To further illustrate this principle of unity, consider some simple objects. An ink bottle, a turnip, and a vase of roses might be arranged into a pleasing composition so far as variety of form, size, and value are concerned, but unity would always be lacking in such a group, because these objects are not sufficiently well related by use to ever become a satisfying single whole. It would be equally difficult to compose a shovel, a hair brush, and a cut-glass pitcher, but a comparatively simple matter to form a fine composition with a partially sliced loaf of bread, knife, plate, etc., or a garden trowel, flowerpot, and package of seeds.

When it comes to drawing larger things such as buildings or parts of buildings, nearly all architectural objects are so closely related that it is easy to find things that go well together. The architectural renderer has much less trouble in this respect than the artist depicting still life.

Unity in architectural work is often injured, however, because certain accessories are made too important in relation to the architecture itself. It is not inappropriate to show an automobile at the curb before a Colonial doorway, but if the doorway is the subject of the sketch, and the automobile is indicated so large in size or so strong in value or technique or so conspicuous in any manner that it detracts from the doorway, it then prevents perfect unity in the sketch. For this reason, in rendering architectural subjects such accessories are often indicated in what sometimes seems to the beginner to be an unfinished state. Trees are shown in an inconspicuous manner, clouds are often either omitted or only lightly indicated, and shadows are simplified.

Balance

This brings us to a discussion of the principle of balance, which is so closely related to the principle of unity that it is really a part of it. In fact, without balance there could be no unity, for by balance we mean establishing the equilibrium or restfulness that results from having all the parts of a composition so arranged that each receives just its correct share of attention. Every part of a picture has a certain attractive force which acts upon the eye. In proportion to its own power to attract, it detracts from every other part. If we find our interest in a drawing divided definitely between several parts — if certain tones or lines seem too insistent or prominent — we know that the composition is lacking in balance.

It is impossible to give concise and definite rules for obtaining balance in drawings, mainly because the attractive force of each portion of a drawing depends on an infinite number of variable circumstances. We are all familiar with optical illusions, for example. A short, straight line drawn near the center of a clean sheet of paper has a power to catch and hold the eye. Let a figure 6 or some other curved line be drawn near the straight one, and even though they are of equal size, the curved line will prove the more powerful attraction of the two. In the same way, a star-shaped form or a triangle has more strength to attract than a square or rectangle of similar size.

Such power depends not entirely on shape, however, but on the value of light and dark as well. Draw two squares on paper side by side, the one dark and the other light. If the paper is white, the dark square will exert the strongest force. If the paper is black, the white square will jump into prominence.

The attractive power of an object also varies in proportion to its proximity to other objects. If, for example, a man is shown at small scale in a standing or sitting position near the center of the sheet, he will receive considerable attention if by himself. If he is surrounded by other objects, however, he will seem much less noticeable.

A moving object or one which suggests motion will be more prominent than a similar object in repose. A man shown running will usually be seen far more quickly than if he is pictured at rest. Also, objects near the edges of the sheet, or in the corners, usually arrest the eye more quickly than they would if nearer the center of the paper.

These examples are sufficient to show the difficulty of giving definite rules for obtaining good balance. To best arrive at sound judgment, the student should first select a subject, block it in on his paper, and make a trial sketch. A painter is able to make many corrections in his work as he progresses, until excellent balance of every part is gained. But in pen work, where the nature of the medium demands direct work with few changes, it is difficult to make well-balanced drawings unless the artist or student has had considerable practice, or unless preliminary studies are made. Almost invariably such studies save time and help obtain end results that justify the labor spent on their preparation. As an additional precaution, set the final sketch aside at intervals, or turn it upside down, or on end, or even reflect it in a mirror to see it in a reversed position. When viewed in this way, the balance should still be good. If not, the necessary adjustments should be made. If some part seems too prominent, either tone it down or accent other parts until balance is restored.

These principles of unity and balance are most important because they apply to all forms of drawing and design. In later chapters we will offer suggestions on how to apply these principles to various kinds of work.

Center of Interest

We have already mentioned that, once a subject is selected, it is permissible to omit certain portions if they are irrelevant to the thought of the whole, and to strengthen or emphasize others. Let us consider this for a moment. If you carefully examine any object in nature you will see an overwhelming mass of small detail. Even as you sit in a room and glance about, you will find, if you look, thousands of spots of light or color. These tiny spots are of many kinds, including the lines of the delicate graining of the wood, the hundreds of partially visible threads from which the hangings and upholstery materials are made, and the myriad indentations and projections of the masonry and plaster.

Obviously, it would be impossible to indicate each of these spots correctly on a small sheet of paper, even if you wanted to. Instead, to draw the room, you would try to represent the effect of the whole, the effect you get not when you hunt for details, but when you enter the room and look around in the usual way. If you do look directly at a single object, such as a chair in a room corner, you see little detail except in the chair itself and in those objects adjacent to it, for the eye is not clearly focused on other things when you are looking at the chair. Even here you are not conscious of each tiny spot, but you notice instead the general effect of color and tone. The chair — being directly in the range of vision — becomes the center

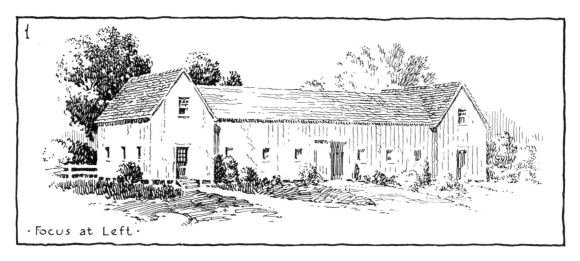

Fig. 128. Each example illustrated here emphasizes a different focal point through strong contrasts of black and white.

of interest, and the other objects become more and more blurred the farther they are from this center, unless, of course, the eye is turned.

We are so accustomed to shifting our eyes constantly from one object to another, that we fail to notice how small an area we are able to see plainly when looking in one direction only. Stand within 10 feet/3 meters of a door and gaze intently at the knob. Without shifting your eyes, can you see the top of the door distinctly? If you raise your eyes and look at the top, do you see the bottom plainly? Go to the window and look at some building across the street. Fix your attention on an upper window or the chimney or some point on the roof. Aren't the lower portions of the building blurred and indistinct until you shift your gaze to them? When you look at the foundation, you do not see the roof distinctly.

In making a drawing from actual things or places, it is generally assumed that the artist is looking mainly in one fixed direction at some interesting object. If the object is too large to come entirely within his range of vision, he selects some prominent feature of it. Then the object as a whole, or the feature, becomes the center of interest or the point of focus. In creating the drawing, the strongest contrasts and sharpest details appear at this center of interest, and grow less and less distinct towards the edges of the paper. Every drawing which is imitative of nature — such as sketches of landscape, street scenes, buildings, etc. — should have the center of interest thus emphasized, and all else subordinated to it. Above all, be careful not to have two or more centers showing equal emphasis.

Achieving Emphasis with Light and Shade

Turn now to Fig. 128, and carefully compare the three drawings made from the same old building. First cover the lower two and study the drawing at the top. In this sketch the artist was looking at that part of the building nearest to him, so he made this the center of interest or focal point; all else is subordinated.

Look at Sketch 2 in the center, covering Sketches 1 and 3. Here the artist's eye is on the middle of the building. Interest centers in the large doorway and that portion of the structure adjacent to it, where the details show most plainly and the strongest contrasts in light and shade occur. The two ends of the building have become rather blurred and indistinct; they are subordinated.

Now uncover Sketch 3 and cover Sketch 2. In Sketch 3 the artist was looking still farther to the right and even though that portion is some distance from the eye, it is the portion on which the eye was focused. The strongest contrasts and accents are there, and the rest of the building is subordinated. In many cases like this, the blurred end of the building would be omitted from the drawing entirely.

Now look at Fig. 129, the street scene. In Sketch 1 the artist was looking at the upper part of the tower. This was made the focal point or center of interest of the sketch. The lower portion of the drawing is blurred or softened; it is out of focus. In Sketch 2 the artist was gazing down the street; the lower portion of the subject — including the archway and the little donkey cart — has become the center of interest, and the tower is merely a faint outline against the sky. Now in drawing such a subject as this from nature you are likely to get into difficulty. You look first at the tower, perhaps, and draw that. If you stop there, all well and good. The tower becomes the center of interest of your sketch. But if you lower your gaze to the street and add that to the drawing, it is quite possible that the converging lines will lead the eye to a second center of interest which will compete with the tower. Thus the drawing will be a failure, because the eye will jump back and forth between the upper and lower portions of the sheet and balance will be destroyed. In such a composition as this — where there are two possible centers of interest — be sure that one is subordinated to the other.

Next turn to Fig. 130, the English interior. Where has the center of interest been represented in the drawing at the top of the sheet? How has the artist brought out or emphasized this center? The right end of the room is out of focus, and it is only when the eye turns towards it—as it does in the lower picture—that it becomes the center of vision or focal point. Now the fireplace is out of focus and might have been omitted from the drawing. In fact, this room might be made the subject of two sketches, one of the ingle-nook with its fireplace, and one of the window and the furniture adjacent to it. In this kind of room we can imagine that in the evening, the fireplace, with a blazing fire, would be the center of interest in the room; while in the daytime, the window feature would quite possibly take precedent over it.

Achieving Emphasis with Details

Now in all three of these illustrations, attention has been forced to the center of interest merely by using stronger contrasts of light and shade there. Other ways are available to you, however, when you wish to emphasize a certain part of a subject or characteristics of it. One of the most common ways is to add detail or heavy outline to the part to be emphasized.

Turn to Fig. 131 and look at the three sketches at the top. At Sketch 1, equal emphasis was given to the leaves and the cherries by using one weight of outline. At Sketch 2, however, the leaves have been emphasized by the use of heavy outline coupled with tones of shading. The cherries are subordinated, having been drawn with a fine line. In the third sketch, the opposite is true; the leaves have been represented with delicate strokes and the

cherries have been emphasized by strong outline and a suggestion of shading. This all goes to show that the artist is able to force any part of a composition to the attention of the spectator once he has learned how.

In Sketches 4 and 5 we have still further examples of emphasis. In Sketch 4, for instance, the detail of the flower box, though not strong in value, is brought out by the use of definite outline; the flowers in the box, on the other hand, are subordinated, almost no detail being indicated. In Sketch 5 the entire scheme of emphasis has been reversed. The brackets under the box, though as dark as formerly, are almost lost in the general shadow tone; the flowers have been forced to the attention both by added detail and by greater contrast in light and dark.

Sketches 6 and 7 are self-explanatory, the former emphasizing the shade and shadow, the latter bringing out much detail suggestive of the textures of the different building materials. There are many other ways in which emphasis can be given. The more of them you are able to discover and learn to command, the greater will be your versatility.

Achieving Emphasis with Contrasts

Different media have different ways of gaining emphasis. In work with color, for instance, some bright and contrasting hue may be selected as a means of compelling the eye to the desired spot. In pen drawing, however, the artist is often forced to employ strong contrasts of light and dark.

There are various ways of combining contrasting tones, some of which are illustrated in Fig. 132. A white spot against a black background always shows so plainly that the eye goes to it directly. Likewise a black spot against white exerts a strong attractive force. Many objects in nature are somewhat similar to such spots. A white house in strong sunlight against a background of dark trees is similar to the white spot just mentioned, and the eye sees it quickly because of the contrast. A dark building silhouetted against a light sky illustrates the other thought. Now a white spot against a dark tone appears even whiter if the dark tone fades gradually to white, eliminating the strongly contrasting edges that lead the eye away from the spot itself. In the same way, a dark spot against a white background will appear even blacker if the white background grades gradually into gray or black, as this will further emphasize the contrast. The spots in Sketches 1 and 2 at the top of Fig. 132 illustrate this to some extent, though the entire page is too full of things to make this impression as effective as it should be. For this reason, we suggest that you draw a small circle in the center of a clean white sheet of paper and then bring a very dark tone up to it, with pen or soft black pencil, much as in Sketch 1, allowing it to grade off gradually for an inch or two. You will see that the white circle actually

appears whiter than the white paper. Even in this illustration something of the same effect can be obtained if all of the sketches but Sketch 1 are hidden from view. You might experiment in the same way with a black spot, carrying out the idea of Sketch 2.

Doing this will help you see how to emphasize or make stand out the things you want to bring to the attention of the viewer. Of course, few things are as simple as these black and white spots. More often the black areas are pierced with whites and the light areas are spotted with darks, a thought which is suggested by Sketches 3 and 4. This spotting is sometimes very complex as in Sketches 5 and 6, yet even here with all the complexity of tone, it is possible to see that Sketch 5 is, after all, much like Sketch 1, and Sketch 6 like Sketch 2. Most subjects are more simple than these, however. Sketch 7, for instance, has a strong center of interest in the white bridge, mirrored in the water, forming a white spot; here the composition is almost identical to that in Sketch 4. Likewise Sketch 8, with its dark center, reversing the contrast in the preceding sketch, nearly duplicates Sketch 3. Experiment with similar subjects. Later you will unconsciously apply the method of emphasizing contrast most appropriate for your particular subject.

Fig. 129. *The emphasis in this street scene is altered through contrast, the focus being above in one sketch and at the bottom of the other.*

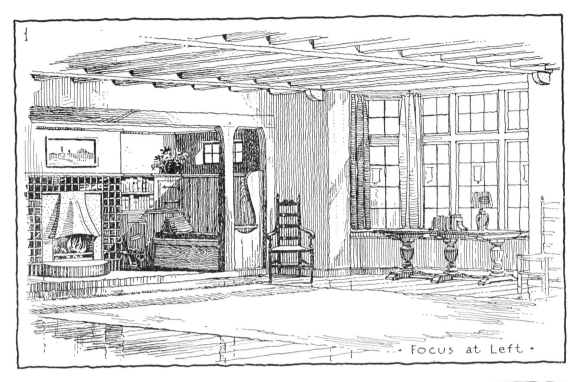

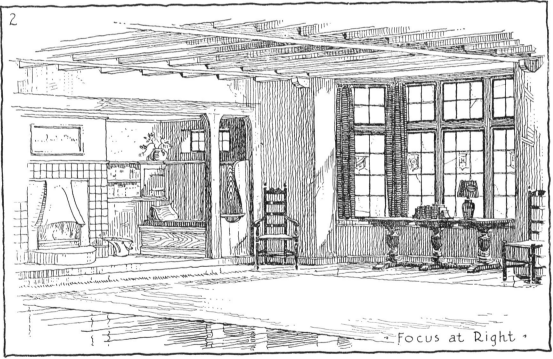

Fig. 130. Here we see the result of accenting or suppressing certain areas in an interior. In many subjects like this, the light areas are omitted entirely.

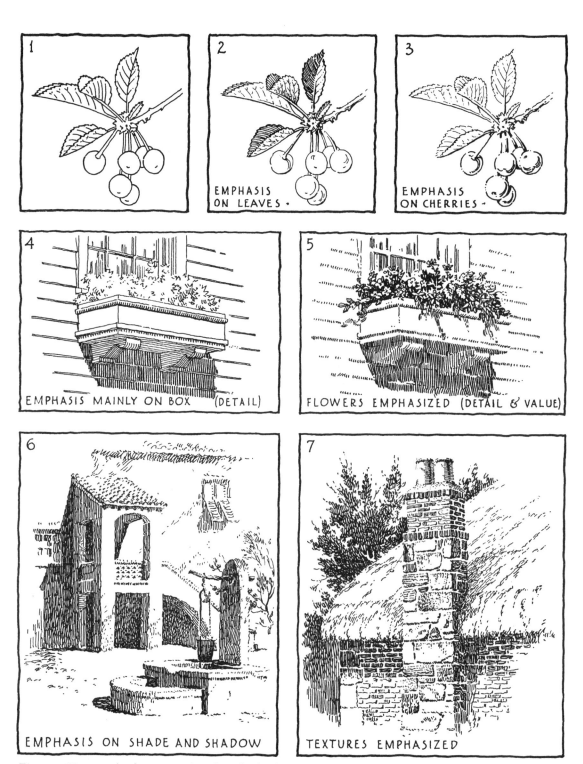

1

2 EMPHASIS ON LEAVES.

3 EMPHASIS ON CHERRIES.

4 EMPHASIS MAINLY ON BOX (DETAIL)

5 FLOWERS EMPHASIZED (DETAIL & VALUE)

6 EMPHASIS ON SHADE AND SHADOW

7 TEXTURES EMPHASIZED

Fig. 131. Here are further examples of methods of emphasizing or suppressing details. You must decide in advance the effects you want from every drawing you do.

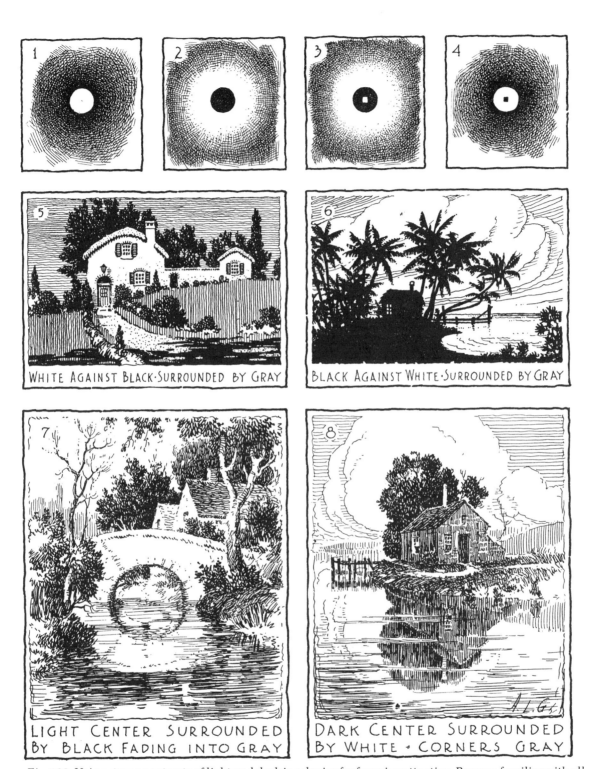

Fig. 132. Using strong contrasts of light and dark is a device for focusing attention. Become familiar with all of these kinds of value arrangements.

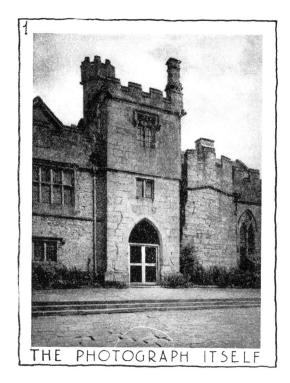

THE PHOTOGRAPH ITSELF

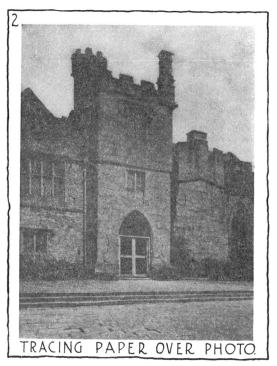

TRACING PAPER OVER PHOTO.

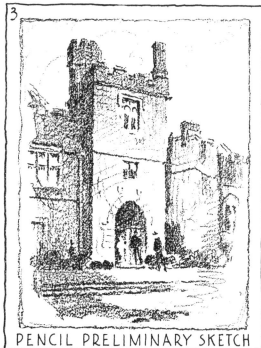

PENCIL PRELIMINARY SKETCH

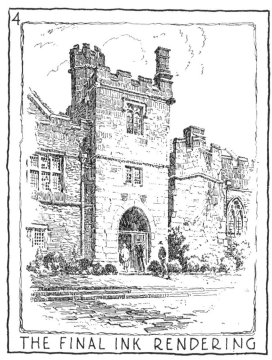

THE FINAL INK RENDERING

Fig. 133. Here are four progressive steps in making a pen drawing from an old photograph. Though these steps may not always be necessary, they are usually advisable.

11. Drawing from Photographs

Herbert S. Kates

In theory, it is undesirable to draw from photographs. Even granting the questionable claim that the camera cannot lie, it is nevertheless true that it does not see and record facts in a manner entirely consistent with the human eye and brain. Photographs are often full of apparent distortions of mass and errors in value. Photographs, too, present many of the cold facts of a subject but little else. When practical, therefore, it would seem much better to go to natural sources for subjects, where you have the chance to do your own seeing in a direct way instead of second-handedly through the interpretation of the inanimate camera. From nature you cannot only study each subject from various points of view, noting such things as mass, light and shade, color and texture, but you can also get the "feel" of the whole thing by absorbing the entire surroundings, and interpreting the essentials on in your own way.

In practice, however, it has been proved over and over again that the average art student, especially at first, is helplessly lost when he tries to do more than the simplest objects directly from nature. If he tries working outdoors, for instance, attempting a building or a street scene or a landscape, he sees such a bewildering quantity of things before him that he scarcely knows where to begin. Once started, he finds himself in doubt regarding how much to include, or the importance of this or that portion of the subject or pondering some problem in perspective or how to suggest some texture, or how to represent tones of color in light and shade only. Just as he finally thinks he is beginning to solve some of these troubles, the light has changed, bringing about entirely different effects of color and an altered lot of patterns of shade and shadow.

Nothing would be more helpful to a student at this stage than making at least a few drawings from photographs, particularly to prepare him for later work from nature. There are times, too, when it is impossible for even the experienced artist to go on location, times when the artist is forced to resort to photographs for a variety of reasons. It is of enormous value to the artist that so many types of subjects can be found in photographs. Because prints are so frequently used by artists it seems worthwhile for us to present some practical suggestions on how to use them to the fullest advantage.

Drawing from photographs is comparatively easy: with black and white photographs the artist need not be distracted by color. Light and shade are fixed, so they can be used at any time of the day and placed in any relationship to the artist, so that he can slump in his seat or leave his drawing and return to it again. The sun may come and go, without the least interference. Working indoors the artist does not have to fear the interruptions by curious passers-by. Owing to their small size, in proportion to the original subject from which they are taken, photographs represent these subjects in a conveniently simplified manner. They frequently fail to represent them without apparent distortion, however, as we have already hinted, especially in the corners or any such portions as would be outside the range of clear vision if the subjects were viewed by the human eye. They fail, too, in many cases, to represent values accurately. Shadow tones in particular are seldom shown with sufficient transparency; portions which in the original subjects could be readily penetrated by the eye often appear black or nearly so.

Selecting the Photograph

These things must all be taken into account in drawing from photographs. Obviously, you should first have good prints, only those that appear to be correct and natural, rejecting particularly any which show marked distortion of form. Try to find subjects that seem well composed, each making a pleasing picture with every part nicely balanced in relation to every other part. This will greatly simplify your problem, for if a photograph is not good in every respect, it is necessary to recompose or make changes, lightening tones that are too dark or darkening those that seem too light, correcting distorted shapes or unnatural perspective, and frequently omitting objectionable or nonessential features, all of which take extra time and skill.

As a general rule, and especially when you are working from complicated photographs, it is easiest to obtain interesting results if each photograph selected has some definite center of interest or focal point, something that stands as the real subject of the picture itself, to which all else is subordinate. This might be an archway or doorway in a building, or a converging street, or a tree or a mountain. Whatever it is, be sure there is not another equally important center of interest in the same composition, bidding against it for supremacy, though there may be one or more subordinate centers of lesser interest.

Study the Values

Once a photograph has been selected block out the subject carefully in pencil outline on the final paper. While doing this freehand work, it is important that you place the photograph in plain sight and not tipped, for unless your eye is looking at right angles to its surface, the forms will be foreshortened, producing incorrect proportions in the sketch. For the same reason, hold your paper in the

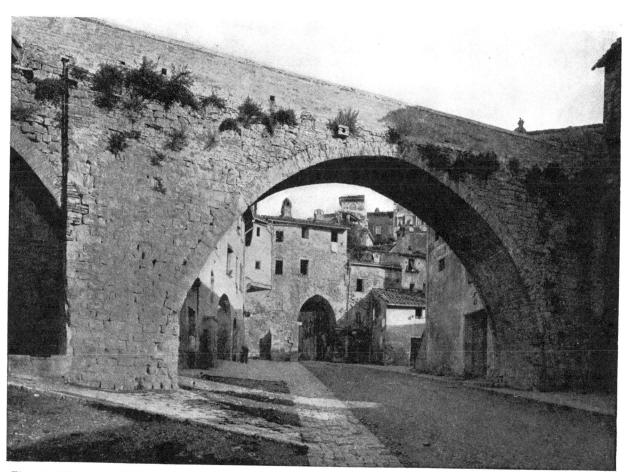

Fig. 134. This is an old photograph of Arco della Conca in Perugia, Italy.

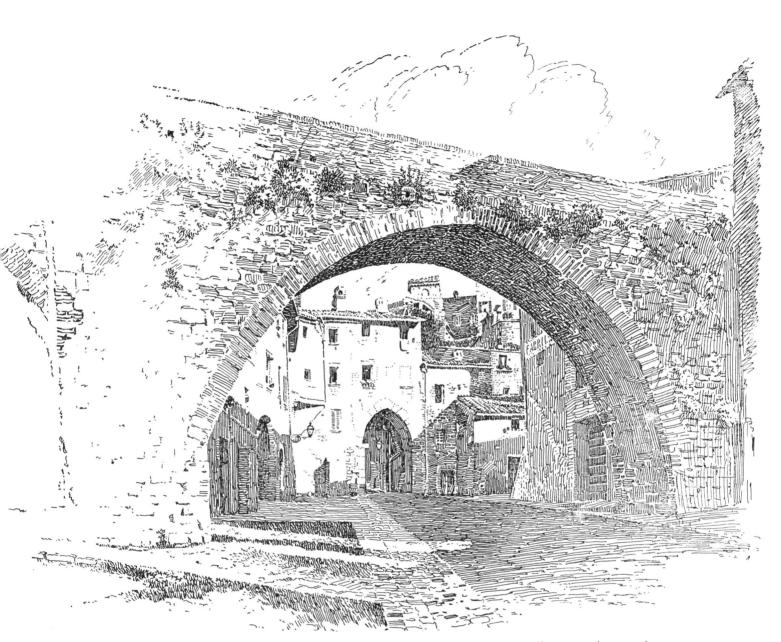

Fig. 135. This drawing was made from the photograph shown in Fig. 134. Here the entire photograph was used for reference.

proper position. If the photograph is small, the drawing may be made a bit larger. Don't lay out a subject so tiny that it demands finicky pen work.

When you have completely blocked out the subject, make a thorough analysis of the values, comparing them in relative strength, and studying to see which you can eliminate or simplify. At this point it may be easier to compare the values if you lay extremely thin tracing paper over the photograph through which the values will show a simplified form. Are some too dark or too light to look natural? Are all essential or can some be eliminated? Following a moment of analysis, take a soft pencil and, with the tracing paper still over the photograph, make a quick pencil sketch of the essentials, tracing important outlines right through the paper and completing by toning in the significant values. Then remove the photograph from below to eliminate the nonessentials. The tracing, touched up a bit more, stands ready to serve as a guide for the pen work itself.

As you make this tracing, consider the causes responsible for the efforts before you. Think of the direction in which the light is falling and of the source from which it comes, and of the shade and shadows which naturally result. (Remember, shadows frequently offer some of the most important dark values.) Then, too, note the textures and tones of the various materials. In deciding what areas are to be left white and what made dark, keep this in mind: if there is to be one principal light area and one leading dark area in the composition (a scheme both common and desirable) select them immediately.

The Pen Work

In doing the pen work it is best, as a rule, to start at the center of interest and work out from there, continuing the sketch only until the drawing includes enough area and is sufficiently rendered to properly convey its message. If you want the drawing vignetted at the outside edges, remember that the whole vignette should form an interesting pattern or design against the white background. The knowledge of where to stop and when to stop and how to stop comes only with practice; the preliminary sketch will help in all three respects.

There are very few hints that can be offered for the making of the sketch itself, for each subject demands its own peculiar treatment and every individual soon finds a favorite method. The size and kind of pen you use will be governed mainly by the size of the drawing and the type of subject. Don't think too much about technique. There is, and should be, no set rule. Represent everything, whether color, tone, or texture, in what seems to you a logical way. Usually something about each part of the subject will suggest both the character and direction of line. If in great doubt, refer to pen drawings of

similar subjects by other artists; compare their methods and then do the things in the way that appeals to you. In any case, don't allow the technique to become so conspicuous that it detracts from the subject itself.

A Simple Demonstration

As a simple illustration of working up a sketch from a photograph, see Fig. 133. Sketch 1 is a photograph of Haddon Hall, England. This photograph, as it stands, composes better than many photographs. A strong center of interest exists in the main arched doorway, which is conspicuous as a very dark spot cut by very light lines, surrounded by a gray area on the walls and terrace. This area grades out to a darker tone in almost every direction, somewhat as though a searchlight were directed towards the doorway. The battlemented tower, however, indented with its conspicuous crenelations, forms almost too strong an accent. Its sharp silhouette against the sky has a tendency to draw the eye away from the doorway below, and some of the shadow tones lack transparency.

After viewing the whole in a somewhat simplified and softened form through thin tracing paper in Sketch 2, it was decided to lighten the values against the sky and in parts of the shadow areas. The screen doors form too conspicuous a white cross against the black doorway, too, while the windows seem less lively than is customary in such subjects, and the three steps of the terrace appear somewhat detached from the rest of the composition. Consequently, the artist chose to make the screen doors less prominent, to show more light in the windows, and to add a tone on the terrace and running into the foreground to help tie the steps into the picture.

The pencil preliminary sketch (Sketch 3) was made very quickly on the tracing paper as a study of these changes. In this a few figures were suggested to increase the interest at the doorway, and the whole was left in vignetted form. With both this preliminary sketch and the photograph as guides, the final sketch was made in pen as in Sketch 4, special attention being given to the indication of the appearance of age through the use of broken and irregular strokes. Notice that the same direction of light as shown on the photograph has been retained. The dark tone in the foreground, at the bottom of the sketch, has an additional use to that just mentioned. It helps to set the subject back, giving a sense of space and distance. It also helps to frame the bottom of the sketch, directing attention to the center of interest.

After one drawing, like Sketch 4, has been made from a subject, it is extremely helpful to make additional drawings from the same sketch using different techniques. Or make another tracing paper study or two of the same subject, arranging the values differently, following these with pen studies based on them.

Another Demonstration

We have also reproduced a photograph of the Arco della Conca, Perugia, Italy (Fig. 134). This photograph is also well composed, having the interest centered in the arched doorway at the convergence of the street lines, which help to lead the eye to it. The doorway itself and the adjacent dark window openings form strong accents which help to focus the attention on the central group of buildings. Attention is also directed to this point of focus by the large archway, with its dark intrados tone, which serves as a frame for the whole composition.

In this photograph the values of light and shade are well disposed and natural, on the whole, with the exception of the principal dark of the large arch, which is too black. The shadow tones form an interesting composition or pattern: there is a pleasing variety of textures in the materials. Therefore, it was decided to carry out the same general scheme of composition in the drawing. But in the drawing in Fig. 135, the values generally have been kept lighter and more transparent, and the white paper takes the place of the lighter gray tones. The dark mass on the right has been made lighter and the vegetation above the larger arch, which seems somewhat too prominent, is brought out less distinctly. The entire left portion has also been simplified in the pen representation.

While no slavish attempt has been made to copy much detail, a type of line has been chosen which suggests the rough textures of the old materials. No absolutely straight lines have been employed; many of the lines are hooked on the ends, and in some places, notably the dark intrados tone of the large arch, crosshatch has been employed.

This drawing has been vignetted towards the edges, and these vary greatly in handling. We have already mentioned how easy it is to build up the values near the center of interest of a drawing. On the contrary, one of the hardest things to do is to blend the drawing into the paper interestingly at the edges. The silhouette or pattern which an entire drawing makes against the paper is most important.

A street scene of this sort often looks barren and deserted when there are no people visible. The photograph shows several figures almost lost in the tones towards the left, so nearly lost that they were omitted from the drawing. A figure or two in the foreground towards the right, catching the light and contrasting with the dark behind them, or placed beneath the arch and drawn almost black, would undoubtedly add much interest to this drawing, particularly in view of the large area of rather tiresome gray towards the right. When in doubt about a thing of this sort, put tracing paper over your drawing and experiment. Better yet, sketch the figures to the proper scale on another paper, cut them out and try them in different positions on the drawing, later adding the corrections to the

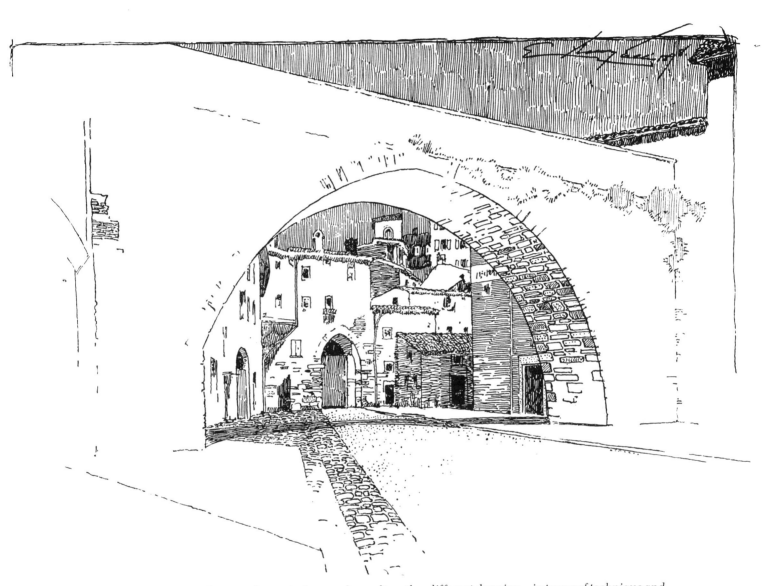

Fig. 136. Harvey Ellis: Another artist has made an altogether different drawing—in terms of technique and value placement—from the same photograph.

Fig. 137. The photograph in Fig. 134 can be cropped in many ways. Here are several possible variations composed from the same photograph.

finished work. In many photographs people are standing self-consciously facing the camera. They should not be drawn so, but should be represented in more natural positions.

Look at the drawing of this same subject by Harvey Ellis (Fig. 136). This drawing was probably done on the site from nearly (though not quite) the same viewpoint as that from which our photograph was taken. Ellis treated the subject with fewer lines and greater freedom. The angle of the light rays was also different, so the shadow masses were not the same in shape. The most interesting difference, however, is the way in which he reversed the values for the viaduct and the sky, the former having been left rather light and the latter made dark. The reversal in this case probably has no significance. Not infrequently, however, the pen artist deliberately reverses the values he finds in nature, if it serves his purpose to do so. For example, if the roof of a building were actually light against a dark blue sky, the artist may decide to let the white paper represent the sky and may darken the roof instead in order to gain the needed contrast. There is often an advantage in reversing nature's scheme, provided that you do so intelligently.

Cropping the Photograph

Now turn again to the first drawing of our subject, Fig. 135. It is sometimes interesting to test the finished drawing to see how much of it is really essential, to see how it would look trimmed to smaller proportions. In Fig. 137 we show the result of some experimentation with the Arco della Conca drawing just discussed. Upon closer examination it seemed that a subject having so much of its interest confined about its center hardly needed such large areas of tone around it, and particularly the monotonous gray at the right. Therefore strips of paper were cut and laid over the drawing, hiding first one part and then another. Though not a line was changed in the drawing itself, the compositions revealed with the strips in various positions appeared so different that it seemed worthwhile to reproduce some of them here. Fig. 137 shows the results, which are much the same as one might obtain by taking scissors and trimming the photograph itself or the large drawing of it. With this experiment we discover that even the small drawings of this subject contain practically all that is really vital. In this case it would have been more economical to have done the testing on the photograph itself before doing any drawing. This is the customary procedure.

To show how we crop a photograph to suit our needs, we have reproduced a photo, Fig. 138, over which L-shaped papers have been lapped to frame a pleasing composition. The strips are clipped in place to hide the unwanted portions of the photograph until the sketch has been made. Frequently a single photograph offers many good subjects for sketches and there is no easier way to select one than to experiment for a few moments with frames. This L-shaped type of viewfinder or frame is convenient because it can expand and contract within reasonable limits to any desired proportion. Hide as much as possible of those portions which are not wanted so that they will not distract you.

Another photograph, this time from Rome, is shown in Fig. 139, on which these framing experiments have been tried. This particular subject offers almost no end of possible compositions. The rectangles numbered 1 to 5 suggest a number of suitable selections for sketching, but these proportions by no means exhaust the possibilities of this one photograph, as you can see if you care to carry the same test still farther.

Going back to our Arco della Conca subject, we show in Fig. 140 how parts of the photograph might have been selected in this same way, one at a time of course, before the drawing in Fig. 135 was made. In this page, however, the same center of interest is used in each case.

Recomposing the Photograph

Not all photographs show subjects pleasingly composed, however, and the artist often has a certain amount of recomposing to do if the best results are to be obtained. Sometimes the recomposition is mainly a matter of readjusting the values, making some tones lighter and some darker, as we did in Fig. 133. Sometimes it means omitting irrelevant details or nonessential elements. Sometimes it requires correcting perspective distortion (a thing seldom to be attempted by a beginner). In architectural subjects it often means changing some accessory, the shape or size of a tree, for instance. It may involve an alteration in the form of shadows, or the introduction of figures, vehicles, clouds, or reflections.

For example, the artist would omit or modify ugly telephone wires stretched conspicuously in front of the façade of an important building, factory chimneys in the background, trees or vines that hide essential features, disturbing shadows, or vehicles in a street, substituting something else if it seemed desirable. In Fig. 139 an artist would feel free to omit the boats in the foreground, or change their positions, or add more boats, or alter the reflections in the water, or employ clouds, or do anything which would not detract from the truth or purpose of the drawing.

Occasionally such recomposition is deliberately carried to such extremes that the effect of the original photograph is largely lost, becoming little more than the inspiration or basis for the sketch. Often, too, the artist borrows a bit from one photograph and a bit from another, and draws also on imagination and memory. This is all right for an experienced artist, but sometimes causes amusing results when attempted by the novice. I recall one drawing in which a building was sketched from a photograph and an automobile in front of it from another; not only was the automobile so small that it was entirely out of scale with the building, but it was not in the same perspective, producing an absurd effect. In another sketch, a house was done from one photograph and trees were added from another; the shadows from the house were falling to the left and those from the trees to the right!

So as a beginner, then, don't attempt too much at first in the way of original composition. Select a photograph, part or all of which is suitable as it stands, and if you wish to make changes, let them be in the nature of subtraction rather than addition. And let your first treatments be quite photographic — use natural values instead of a stylized arrangement of your own invention. Once you gain skill, you may be as original as you wish.

Fig. 138. A viewfinder can be used to isolate a subject from within a photograph.

Fig. 139. Each rectangle marked off on this old photograph contains a composition suitable for the subject of a sketch.

Fig. 140. Using a viewfinder makes cropping photographs easier. Here the photograph shown in Fig. 134 is composed in a variety of ways before any drawing is made.

12. Studying Work by Other Artists

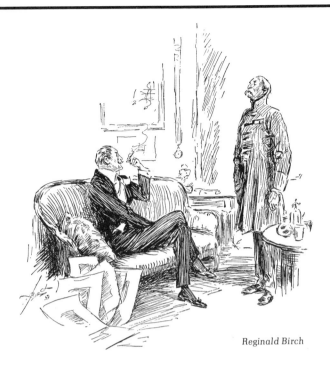

Reginald Birch

One of the most valuable methods of learning about pen drawing is through studying the best available originals or reproductions of work by other artists.

This statement needs defense, for there are those who argue against it. They claim that if a student honestly drew from real things, without any reference to other artists, the drawings would have a vitality and interest not commonly gained. They also claim that studying other drawings is merely to learn to mimic, that it stifles individuality, tending to force the artist into a rut.

There is something to this argument. Undeniably an artist emerges occasionally who seems particularly gifted. Such an artist, even though never having seen a pen drawing, may develop a satisfactory and original style. Such genius is rare, however.

Since developing an approach from nature alone is not particularly applicable to most students, let's consider the work of other artists. The art of pen drawing is a growth—an accumulation to which each of many individuals has contributed his bit. To turn from or ignore the results of this accumulation would be pure folly.

The Ethics of Copying

First of all, let's consider the question of ethics. If you copy a drawing, or parts of a drawing, done by some other artist, and then take credit for the work, without making clear that it is a copy, obviously this would be wrong. However, there is absolutely nothing wrong with the copying itself; often this is good.

The beginner sometimes faces another question, however. Do you have the right to copy and use repeatedly the style of some artist whose work appeals to you? In other words, how far can you honestly go towards "cribbing" technique, applying it to your own subjects? Generally speaking, it is wrong to try to mimic another artist's technique, particularly if he has an individual style which can be clearly identified as his own. There are artists who have spent years in developing methods peculiar to themselves; to appropriate these in full would be nothing but dishonest. There are many little tricks of technique, on the other hand, which belong in no sense to any one individual. They are, instead, the common heritage of all who wish to lay claim to them. A comparison of drawings will prove that there are enough of these to satisfy nearly every need of the student.

Profiting Without Imitating

There is little danger, at any rate, that the student who works thinkingly will long be satisfied to mimic any one artist. Regardless of how clever that artist may be, rarely will *all* of his work appeal in detail to any other artist. You will soon find that you may like the way in which one artist suggests trees, but not like his shadow tones, and so on.

The beginner, then, in studying drawings for their technique, should compare many, seeking the most honest and satisfactory way of rendering each of numerous typical details. Take shingles, as an example. If you look through a large number of drawings you are almost certain to find in the work of one individual the suggestion of shingles which appeals to you as the most logical and best for

general purposes. Study that particular detail, copying it over and over, if you wish, until you have mastered it. If you are working from a reproduction, be sure to allow for a reasonable amount of reduction in size from the original. Even in doing this copying you will probably find that it is not natural for you to work in exactly the same way as the other artist. Your individuality will assert itself. Next turn to still another artist's representation of the same detail, and master that. Or select some different detail, a window, for instance. You may find that the representation which most nearly approaches your ideal for this particular detail is that of still another artist. Study it as you did the other.

Out of all of this you will gradually develop a technique which is truly your own, for as you start combining the various details, you will undoubtedly change this one and that one to bring them all into closer harmony. If you work in this way, you cannot be accused of copying from any one individual. Instead, you will merely be profiting from many without in any way acting the mimic.

Looking Beyond Technique

Though technique is the first thing the beginner is likely to study in the work of other artists, that is not all that can be learned from it. Nor is technique the most important thing. You may become an expert technician and never be more than that. On the other hand, some artists whose technique in itself is far from being commendable have become famous for their work because of other fine qualities. In fact, it is often true that the artist who

is strong in one direction is weak in another. The expert technician, for instance, may fail to select interesting or worthwhile subjects, or to compose them well when they have been selected. His work may also lack that rather intangible quality called "style." Only rarely is good technique enough to overcome such handicaps as these.

Therefore, learn to look beneath the technique for something deeper, striving to see the purpose the artist had in mind when making the drawing. Don't condemn a drawing too severely nor praise it too highly without considering how successfully the artist has carried out this purpose or intention. To experienced artists it is often amusing and sometimes distressing to hear students — and particularly beginners—ignorantly or thoughtlessly condemning drawings (or paintings) when they have little or no conception of the purposes back of them. To those in charge of art galleries, where pictures are on sale, this inclination of many art students to scoff at works of art— many of which are recognized by connoisseurs as fine — is most disturbing. The head of a prominent firm of auctioneers once observed, "Much as I hate to admit it, I have reached the point where I would be only too glad to exclude most of the students who come here from the art schools, if such an exclusion were feasible. Many of them swagger about making such ridiculous and disparaging remarks before prospective purchasers that sales are actually lost to us. To make matters all the more annoying, the young fools think they are right." This may seem a digression. It is included simply to emphasize what we have already said: that you should not condemn another artist's work unless you know for what the artist was striving.

If the purpose of the work seems evident, you must decide to your satisfaction if that purpose has been fulfilled. If you have selected for analysis a pen picture of an old house, for example, analyze it something like this: "Given this subject, has the artist made the most of it? Has he drawn it from the best point of view? Has he failed to include enough, or has he shown too much? What might have been omitted without detriment to the sketch? What might have been advantageously added or given more emphasis? Has he composed the whole well? Is the interest nicely centered on the house, or are there irrelevant or over-emphasized details to prove disturbing? Is the light coming from the angle which best expresses the subject? Does the house really look old? Would a freer technique better express the age? Or should the expression of age be accomplished more through the drawing than technique? Is the technique itself too conspicuous? What of the accessories; do they contribute to the whole, or do they detract? Is the entire result convincing?"

Whatever your answers—whether you are right or wrong—this whole process of analysis is sure to prove most helpful. If you analyze in this way you will gain much more than you would by merely studying the technique. We emphasize this not because technique itself is unimportant, for it is not, but because the beginner often attaches too much importance to it.

Early Errors

Now for a word about some of the common errors made by beginners. First, the beginner too often fails to select interesting subjects. This does not mean that there is harm in doing commonplace things, such as we have shown in many parts of this volume, as aids along the line of progress. It does mean that in the drawings you prepare for exhibition or publication, you would be wise to try to present subjects which show beautiful or interesting things or which convey worthwhile messages of their own, or which supplement or illustrate some thought elsewhere expressed.

Having made his selection, the beginner frequently omits or suppresses important details that should be emphasized, and over-emphasizes nonessentials that should properly be omitted or suppressed. The result is lack of clarity and directness in the way in which the message is conveyed. The beginner also fails, perhaps, to make of each drawing a good composition — a pleasing pattern or design. In fact, most people are unaware of this particular quality of pattern unless it has been brought to their attention. Yet it is true that the silhouette, shape, or pattern that a drawing makes against the paper surface is sometimes very interesting, and adds to the pleasing effect of the whole. It is also true that the spotting of lights and darks within this silhouette needs real skill. The beginner too seldom thinks of this or has the ability to handle it. He fails, perhaps, to obtain proper balance or he gets two or more centers of interest of equal strength, so there is no dominant note in the composition.

Above all, however, the beginner's method is usually too indirect. He has not learned to use his means economically. He draws twenty lines where ten would do. He employs a dozen values where half that number would suffice. He covers large areas of paper surface, losing not only time and energy but also breadth and simplicity of effect, and he so overemphasizes technique that it becomes too conspicuous. By studying the work of other artists, the beginner can start to become sensitive to some of these important aspects of good drawing.

Rosenberg and Booth: Two Extremes

Note the simplicity of the little drawing by Louis Rosenberg in Fig. 248. The whole subject is largely expressed by the indication of the shadow tones. Many edges of planes are only suggested, much being left to the imagination. As a rule, strive for simplicity. Although you will probably not arrive at results that are as economical in line and tone as this, remember that in principle the pen is better suited to simple and direct work like Rosenberg's drawing than to work in which almost the entire paper surface is laboriously covered with lines.

There are exceptions to this, however. Study the drawing by Franklin Booth, Fig. 141, for example. This beautiful drawing is no less a fine piece of work because it is made up of many lines. Booth himself, whose work is nearly always quite similar to this, ranked as one of the leading pen artists. You must realize from a single glance, however, that of the two methods employed by Rosenberg and Booth, you would have greater chance for success—at least for a while—if you try the simpler one. Few individuals are capable of successfully working in the style that Booth handled so well.

While studying Booth's drawing in Fig. 141, notice that technique plays only a small part in the whole effect. As a foundation, there is first an interesting subject or motive. Moreover, this subject has been taken as the basis for a fine composition which has to a high degree the design or pattern quality just mentioned. As a contribution to the pattern effect of the whole, observe that the values are not only excellent individually but are well distributed. In fact, to have preserved these painting-like values while executing this marvelous technique seems nothing short of wonderful. The technique itself, though full of variety and interest, is also so restrained that it is not self-conscious.

Griggs: Tonal Control

Somewhat similar to the Booth drawing, though of quite different subject, composition, and technique, is the drawing by F. L. Griggs in Fig. 142. In studying this, notice that most of the paper surface — with the exception of the sky—is covered with tone, as in the Booth drawing, and that this tone is so closely knitted and graded that it hardly seems pen work at all. For in spite of the many lines that make up the whole, the effect is extremely simple, yet truthful. There is also a richness of tone and a character of vibration (due largely to the manner in which the lines cross and recross) which is unusual in pen work. Notice the admirable way in which the whole is composed, too, the interest centering in the arched hedge opening. Also observe the splendid effect of distance between the hedge and the building beyond, yet even in the distance the rendering of the architecture is adequately and beautifully handled.

Peixotto: Delicacy of Treatment

Wholly different from the handling in Fig. 142, yet likewise beautifully drawn, is the sketch in Fig. 143 by Ernest Peixotto. This is more like the Rosenberg sketch in its economy of line and in the fact that it is vignetted. Here, as in the

Fig. 141. Franklin Booth: Even though this drawing is composed of many lines, the technique is restrained and controlled. The design quality is carefully worked out.

Fig. 142. F. L. Griggs: The Green Forecourt. This drawing is rather washlike in handling. Notice the simple values built up largely of crosshatch.

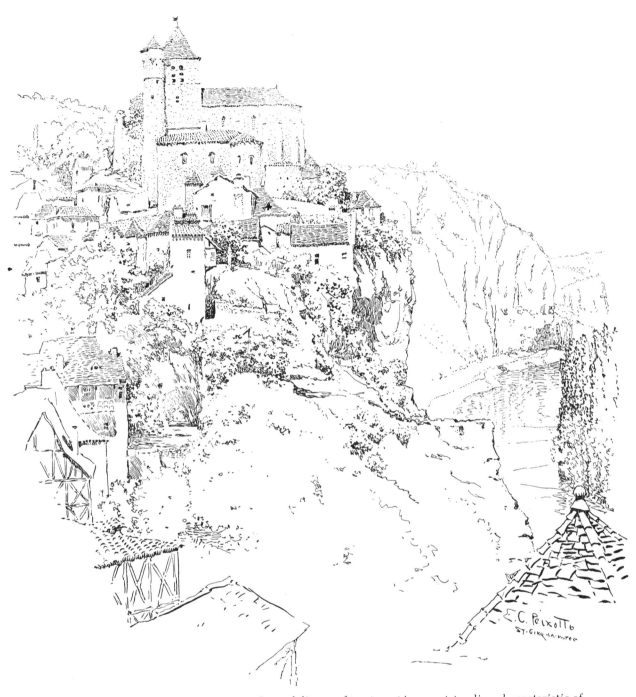

Fig. 143. Ernest Peixotto: St. Cirq-La-Popie. Great delicacy of treatment is an outstanding characteristic of this vignetted subject.

Griggs drawing, the contrast between foreground and distance is beautifully expressed. Note the dissimilarity between the vigorous lines indicating the roof in the lower right-hand corner and the delicate broken and dotted suggestions of the water and distant cliffs above. The whole sketch is a masterly treatment of an intricate subject, and is worthy of careful study.

Kent: Boldness of Treatment

In contrast to the delicacy of the Peixotto example, notice the strength and boldness of the drawing by Rockwell Kent in Fig. 144. Though the subject of this sketch is quite different from the other, technically there is much to learn from comparing two drawings so completely unlike. This example (and many other drawings in the volume) undoubtedly has much brush work on it, or work with very coarse pens, which permits a large variety of strokes. Study the decorative arrangement of these strokes in Fig. 144.

Neill: The Imaginative Drawing

Though Rockwell Kent's drawing in Fig. 144 contains a figure, the entire subject is really straightforward portraiture. The figures in the work of John R. Neill (Fig. 145), however, are totally imaginative. In respect to technique, it is another drawing which, like Franklin Booth's, can be gone over inch by inch and found interesting everywhere. Yet in its technique itself it is wholly unlike that of Booth's. It shows no greater variety, yet you can find on this single drawing samples of every sort of line or tone a pen is capable of making, a statement you should verify for yourself. Note particularly the spotting of pure black—which is exceptionally well handled. Not only this black but the whole drawing is marvelously well composed for so complex a subject. The pattern or design quality is clearly evident, though both this and the technique itself are so suppressed that under ordinary circumstances one would give no conscious thought to them.

Flanagan: The Shaped Drawing

The drawing in Fig. 146 by John R. Flanagan is another beautiful piece of work. This is an example in which the drawing as a whole makes a definite spot or silhouette against the paper. In this respect it differs from a drawing that is carried to the edges of a rectangular space (like the Booth drawing, for instance). It also differs from the usual sort of vignetted work which fades rather gradually into the paper. Here the shape of the entire silhouette was studied with the greatest care so that it would be beautiful in itself, while simultaneously contributing to the adequate and natural expression of the entire subject.

Gibson, Flagg, and Grant: Masters of Technique

Now for a word about technique. This, again, as we have repeatedly pointed out, is a less important matter than the beginner often supposes. The artist is trying to express an idea. If this idea is well expressed, the drawing is successful, regardless of the means employed. Individual taste concerning technique varies, however, and the young artist is usually keenly interested in it. Therefore, we have tried to bring together in this volume examples differing considerably when viewed from the technical standpoint, yet each is the work of an acknowledged expert.

Turn to the drawing by Charles Dana Gibson in Fig. 147, and for a moment study his technique. Gibson, it will be seen, had at his command almost every sort of line and dot the pen is capable of making. And he used them all. Though his work as a whole is extremely free and direct—being done with a dash and daring for which he was so famous—this was not carelessly accomplished in the sense the student sometimes seems to think such work to be. Gibson was undoubtedly interested in the message that his drawing was supposed to convey. In its making, he almost instinctively chose for every detail the sort of stroke which would lend itself best to the expression of his purpose, whether a delicate, hairlike line or a stroke a quarter of an inch wide.

James Montgomery Flagg, who made the drawing in Fig. 148, though in a sense working in quite a different manner from Gibson, possessed similar facility with the pen. He drew his lines very rapidly, as may be ascertained by a glance at his illustration, yet in spite of this rapidity, these lines were placed with great skill. Many of his blacks were added with a brush. If one of these spots seemed too black or solid to Flagg, he scratched through the ink to the surface of the paper, making white lines. This technique is evident in the hair of the girl and the man. Flagg also used crosshatch freely where needed.

Gordon Grant's drawing in Fig. 149 is in many ways technically similar to the example of Flagg's work just mentioned. It was done with the same quick line, makes a somewhat similar use of crosshatch, and as a composition has areas of white, gray, and black not unlike those employed by Flagg. Grant, however, has not used solid black areas in this particular example.

Penfield: Solid Blacks

We should not turn from the uses of black without pointing out that, fine as it is for many purposes, there are places where it would not do at all unless confined to small areas or in some way made to appear less dense. Many times, blacks can seem overly conspicuous. Edward Penfield (Fig. 150), however, knew how to control the blacks in his work that he used for emphasis and contrast.

Notice how Penfield combined a realistic treatment with one more stylized. The examples in Fig. 150 were drawn as decorations for a calendar and hence may be classed among so-called seasonal subjects. It takes little imagination to tell which represents September and which November. Although both subjects are expressed in a direct and natural way, they are composed in a manner that is much more decorative in their effect than are most drawings of similar type. The various elements have been arranged to balance nicely, yet without stiff formality. The areas of light and dark are well distributed. The drawing is bold and free; the technique simple and straightforward. The borders add unity to the designs, appropriately weighted in relation to the character of the drawings.

Clarke: Decorative Treatment

Although numerous drawings making use of the human figure are done *primarily* as decorations, in many other instances, drawings made for some different purpose still seem somewhat decorative in treatment. Many of the illustrations in books and magazines are of this general type. Fundamentally, they are illustrations for stories—they show people and places — yet the arrangement and handling, and the many liberties taken are such that the results are often highly decorative, and far from truly naturalistic interpretations.

Let us examine Fig. 151 to see how it fits in with this thought. This double-page spread by Harry Clarke is a drawing that counts, first of all, as an illustration. The general arrangement of the composition is little different from the more customary realistic type of representation. The Marchesa Aphrodite — in her light garments, and with her face forming a pure white silhouette against the background — is the center of interest. To direct the eye to this center, the artist arranged a majority of the supporting figures to turn toward it. The secondary figure standing in the gondola contributes particularly to this direction of interest, not only in his pose and facial expression but by means of the connecting sweeping lines of the rope and the gondola itself.

Therefore, it is not so much the general arrangement of this composition as the unusual value contrasts and the detail treatment that make it the striking decoration that it is. Note the pattern quality of the entire composition — a feeling not confined to the larger masses but extending even to the smallest areas. Compare one area with another and see the great variety in the patterns used, as well as in the technical means used to achieve this. Dots, dashes, straight lines, curved lines, tiny circles — all have been employed. Observe in particular the delineation of the costumes. Note how the large areas of black—areas of far greater size than usually found in such work—add individu-

Fig. 144. *Rockwell Kent: Berté the Yaghan. This vigorous drawing — so typical of Kent's work in general — is consistent in subject matter, composition, and bold technique.*

Fig. 145. John R. Neill: The Cobbler. Notice the great variety of line and tone in this highly imaginative treatment.

Fig. 146. John R. Flanagan: The entire drawing is conceived as a unit and given a very definite irregular shape or silhouette against the paper surface. Notice also the contrast of the foreground figure against its background.

Fig. 147. Charles Dana Gibson: In these humorous character studies, Gibson left the main action to the imagination. Nothing but the essentials are shown, expressed with a technique best suited to the end purpose.

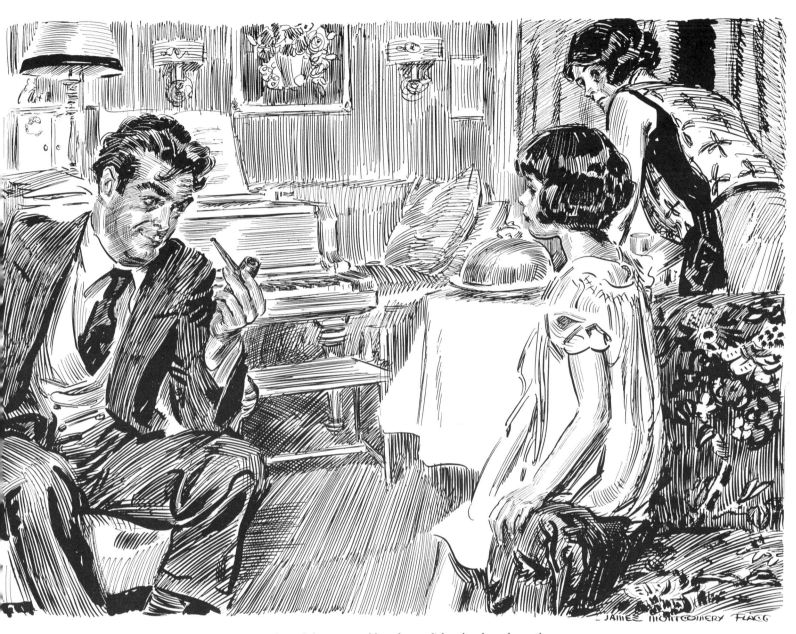

Fig. 148. James Montgomery Flagg: Rapid strokes of the pen and brush, confidently placed, are the hallmark of this master of the medium. Notice the solid black areas that have been scratched away to make white lines.

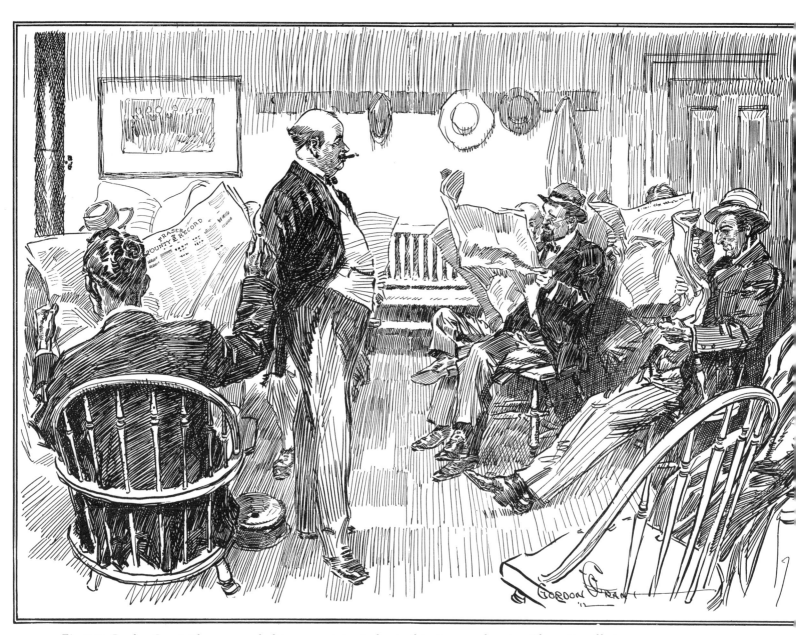

Fig. 149. Gordon Grant: There are no halting, uncertain strokes in this vigorous drawing. The entire effect
has been obtained with crisply drawn lines.

Fig. 150. Edward Penfield: In these depictions of the seasons designed for a calendar, Penfield used solid blacks with good taste and with sufficient emphasis and contrast.

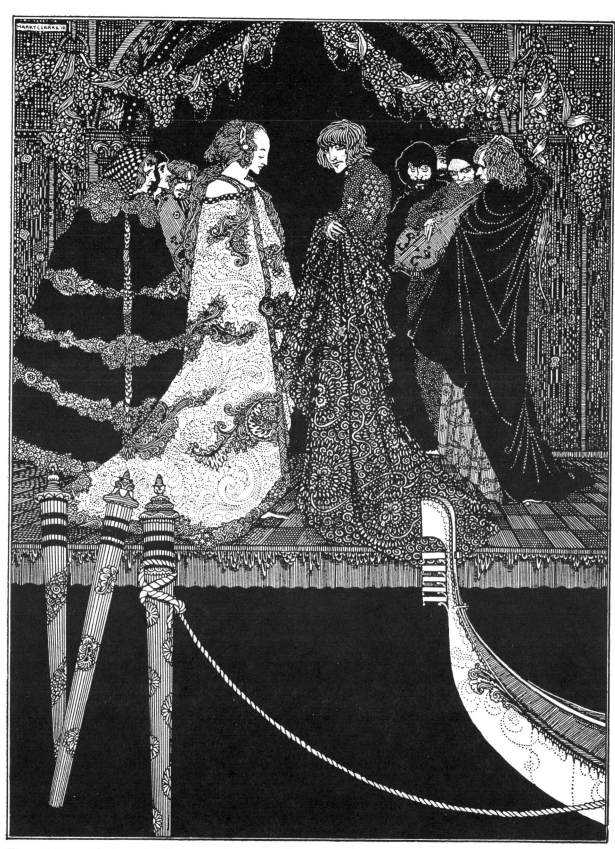

Fig. 151. Harry Clarke: In his illustration for Edgar Allen Poe's Tales of Mystery and Imagination, the artist made a decorative composition by spotting lights and darks into interesting patterns. Study the use of black and the varied combinations of lines and dots.

Fig. 152. Reginald Birch: This drawing has none of the "posed" look common to much illustration. Things are actually happening here and the artist has riveted our attention.

Fig. 153. Joseph Clement Coll: The elegance of this delicate line work offers much that is worthy of study. Notice how effectively the artist has used short and fine strokes.

ality to the whole. This black provides a background against which the delicate patterns and small white areas — such as the faces, the torches, and the prow of the gondola — show in sharp relief. This drawing stands, then, as an example of highly stylized and decorative value arrangement and detail treatment of subjects, a treatment that can also be found in very realistic illustration.

There are many drawings of a somewhat similar type that give slightly less attention to the finished treatment of the detail. Study the example of Rockwell Kent's work in Fig. 144. This example, though done with greater dash and freedom, is nonetheless decorative. The technique is quite different from that employed by Clarke, yet is perfectly suited to the subject. Black is used, but more sparingly. The handling of the sky and smoke is individual.

Birch: Free Line Work

Wholly different, technically, from the examples so far considered, though if anything still more free in method, are the drawings by Reginald Birch in Fig. 152. Here there is great variety in character (though not in width) of strokes, which gives us, among other things, few parallel straight lines. This drawing by Birch, by the way — to turn from technical considerations for a moment—illustrates very strongly the need to compose and draw figures so that they really seem to be doing something. There is no "posed" look about the figures here, no lack of action. And the sense of the dramatic is very evident. They urge us to ask who these people are, where they came from, what they are doing, and what they intend to do next.

Coll: Elegant Line Work

Now to swing back to a more delicate type of drawing, refer to the beautiful illustration by Joseph Clement Coll in Fig. 153. Here the pen strokes themselves are not emphasized. The lines, taken individually, are mostly crisp, rather fine, and comparatively short. The line work is elegant. It is not the technique alone, however splendid it is, which makes this drawing interesting. In spite of our intentions to confine this discussion mainly to the technical means employed, we wish just to point to the highly interesting subject matter and the unusual way in which it is composed.

Though we might go on with our discussion indefinitely, it seems needless to add more to our present comments, for this volume contains many other drawings as interesting as these. Don't hesitate to turn through the pages, with your eyes and mind open, to see what you can learn for yourself from all the other work shown in the book. Also study other examples you may find in books and magazines, cutting out and preserving what especially appeals to you. Try to collect as much material in this way as possible. It is not hard to get, at almost no expense, reproductions worth many dollars to you if you use them fully.

As you gradually collect such material, file it in some systematic way, as already suggested for photographs, and arrange the material according to different headings of interest. Drawings of landscape may be grouped together, for instance, and drawings of picturesque buildings — such as old barns and mills—may be filed elsewhere. Other groups might contain illustrations of ships, people, animals, and birds. It is valuable to group drawings according to types of technique, too, like drawings done in pen alone, drawings in pen and brush, in pen and color, or other combinations. In fact, you will probably think of enough headings to suit all your needs.

13. Sketching Outdoors

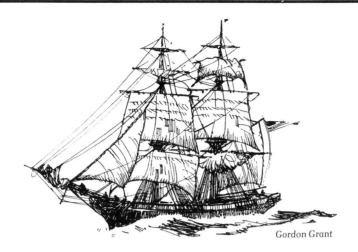

Gordon Grant

One usually goes sketching in response to an inward urge to get outdoors. Spring is in the air, perhaps, and you suddenly find yourself tired of the tasks confronting you daily. You decide to break free from restraint for a while, so you gather your materials hastily and venture forth joyously to play hookey.

Outdoor sketching, then, is so often the artist's recreation that he naturally approaches it in too much of a carefree mood to be at all receptive to words of advice as to the how or when or why of doing it. It would be futile, therefore, for us to offer what you do not want, so we shall confine ourselves very largely to hints for the beginner.

Outdoor Work with the Pen

There was a time when the pen was rarely employed as a medium for outdoor sketching. Pen sketches supposedly done on the spot were actually worked up in the studio from photographs or from rough sketches previously made in pencil or some other medium. The popularity of the pen for this purpose has now increased to such an extent, however, that for us to ignore this use of it entirely would seem almost unpardonable. (This new popularity is true particularly with the advent of the felt-tipped pen, which has become a most popular medium for outdoor sketching.)

The growth in popularity is not without solid foundation, for the pen really is an exceptionally fine instrument for the quick and accurate delineation of form and suggestion of tone. It may be conveniently carried about, too; aside from the pencil there is almost nothing which can be taken from place to place and used under varying circumstances more easily than the pen. For those who hesitate to run the risk of carrying an unprotected bottle — but prefer the touch of a pen,

rather than a felt-tipped pen — a cartridge pen would be more convenient. The fountain pen is a very adaptable tool for drawing outdoors, too — a fact to which we shall later return — and though it does not work to the best advantage with drawing ink, which is inclined to thicken more quickly and flow less readily than other kinds, it will do quite well if washed out frequently. If drawing inks are slightly diluted according to the manufacturers' directions, they will, of course, flow somewhat better. Brown drawing ink makes most attractive sketches; even the customary blue fountain pen ink will produce drawings with a definite charm of their own.

Aside from the ink and pens, almost nothing is needed in the way of materials except paper; and nearly any kind will do. A stiff-covered notebook or sketchbook is good. Plain white paper is less desirable in some ways than that which is slightly tinted—ivory or light gray being particularly satisfactory — especially for working in bright sunshine. The reflected glare from white paper may easily prove extremely trying to the eyes. Ivory or straw-colored paper and brown ink make an appropriate combination. As a final addition, a newspaper or magazine might be taken along to use as protection if you are forced to sit in a place which is too damp or dirty.

If you take a companion with you —and, as a rule, a single companion is enough—take someone who is congenial, and if a fellow student, preferably one of similar tastes and ability.

Selecting the Subject

As we have so often mentioned, selecting a subject should not be done hastily. Yet you don't want to be so indecisive that nothing gets drawn either! Whatever you plan to draw, whether buildings or street

scenes, mountains or trees, select the subject with some definite aim in view. The particular purpose may be to gain practice in perspective or proportion, or you may be working simply for the pleasure to be derived from producing interesting sketches. Your purpose will determine not only the selection of the subject, but also the manner of treating it.

In the beginning it would be better to confine your attempts to something that seems comparatively easy and not too large, or if you do choose a large subject, don't station yourself too close to it. Distance will bring it completely within the range of vision, and will simplify its effect surprisingly, even though it is actually complex. Work can be done to the greatest advantage if a quiet place is selected, for it is not easy to work surrounded by a curious crowd.

Farm buildings, country cottages, boat houses, and the like offer excellent material for the beginner. Not only are such things removed from crowds, but they are also simple and correspondingly easy to do, and the results usually look more attractive than the buildings themselves. Fig. 154 shows a number of small sketches from this kind of subject. These were made at the size shown here, with a fine pen, as were also the two sketches in Fig. 155. Fig. 156 was also drawn at the size of the reproduction, but is more ambitious. Buildings of this type which are partly in ruin are fascinating things to draw and offer the best practice in texture representation. Fig. 157 shows additional outdoor subjects of considerable variety. In the beginning you should make your drawings larger than all these, however, in order not to feel cramped for space.

When you have decided upon the subject, next determine from what point to draw it. Whether you pick a sunny or a shady position will depend largely on which gives the better view of the subject.

Fig. 154. Farm buildings and similar structures offer interesting subjects for outdoor sketching. These were sketched in this exact size with a Gillott 303 pen.

Fig. 155. Think less about technique than about honest indication. Give great care to the selection and emphasis of essentials.

Fig. 156. Old and dilapidated buildings are interesting to sketch. This sketch would have been better if less had been done in the foreground.

Fig. 157. Here are a variety of outdoor subjects that are commonly seen. Any one of these would be worthy of more ambitious treatment.

(A viewfinder, to which we shall refer again in a moment, will help you determine this.) The temperature often has a part in the decision, too. As a rule it is better to work in shade than in sunshine, even without considering temperature, for not only is there less glare from the paper in shady spots, but you avoid the somewhat disconcerting movement of the shadows cast by the arm and hand and pen across the paper. Moving clouds that cause sudden changes in sunlight and shadow will also be less troublesome if you sit in the shade, where the paper surface will not be dazzling one moment and dull the next.

When you have decided on the point of view, make yourself as comfortable as you can. In making the sketch in Fig. 158 I sat for the greater part of the time on the masonry wall which serves as a parapet separating the street from the River Arno. Sometimes, however, there is no such wall handy. If no seat is available you are forced to stand, of course, but a few attempts to draw standing for any great length of time will usually be enough to cause you to seek comfortable positions for your next subjects.

Using the Viewfinder

In Chapter 9 we recommended that you use a viewfinder. This is simply a piece of heavy paper or cardboard, postcard size or so, with a small rectangular opening through which you can peek while searching for a subject offering possibilities, employing it much as the photographer does the viewfinder of a camera. (In fact, the camera viewfinder itself is good for this purpose, too.)

Not only is the cardboard viewfinder useful in *locating* a subject, but you can use it to advantage while you are drawing as well. If you hold it vertically and sight through it or across it you can judge the correct pitch of any slanting line, such as the slope of a roof or a line converging in perspective. By comparing the various values in the subject with the paper of the viewfinder, you can achieve a clear idea of the relative importance of each.

If you are interested in composition, carry a little viewfinder all the time and use it frequently, even when you don't intend to draw. This will help you learn to select good subjects, and will also cause you to realize how many interesting compositions may be discovered in what often seems a barren neighborhood.

Composing the Subject

You will have a minimum of trouble in both selecting and working successfully from a subject if you obey the simple laws of composition, such as having a single and quite strong center of interest or focal point in each sketch. In the sketch of Florence in Fig. 158, for instance, interest is concentrated on the black doorway at the end of the street. This dark spot is particularly conspicuous because of its central location and its sharp tonal con-

trast with the large light area of the main façade of the building which terminates the street. This light area is surrounded by blacks and grays which frame it in a way that increases its effect of being bathed in brilliant sunlight. This is an example of a common but interesting form of composition: a large light area, punctuated with one leading black accent, and possibly one or more subordinate black accents, the whole surrounded by gray or black.

The Naples sketch (Fig. 159), on the other hand, is composed quite differently. Here the center of interest is at the street, made emphatic by the group of dark figures in silhouette. From this dark and broad foundation, the subject grows gradually lighter towards the top, narrowing as it does so. This is an example of a subject represented almost entirely through indication of the shadows, in strong contrast with the sketch in Fig. 156, which depends for its effect more largely on the indication of materials. Fig. 159 is technically interesting, too, because nearly all of the pen strokes, except those in the horizontal plane of the street, are vertical.

When blocking in a subject, work directly with the pen. You may either sketch a few of the main lines of boundary and subdivision, or you may touch your pen lightly here and there to dot off the salient points. Working directly in this way you learn to draw quickly and accurately. As soon as the main proportions are fixed, note the direction of light before rendering, for it is important — if you are going beyond the outline stage — that this be suggested with consistency. The larger shadow shapes should all be located at the same time, because they will change very rapidly.

The entire subject, including its values, should be simplified, nonessentials omitted or suppressed. If telephone wires or things of that sort bring confusing lines into the subject, leave them out. If, on the other hand, they contribute in any way towards the intended purpose of the sketch, retain them, of course.

Lighting and the More Finished Drawing

In making the suggestions above, we have in mind the rather quick sketch — the kind finished at one sitting while the inspiration lasts. In fact, many sketches are made in that way, since there is often less than a half-hour and occasionally only a moment or two of supreme interest, when the subject is revealed at its very best. Sometimes, however, carefully finished drawings must be made from outdoor subjects, and in cases like this it is preferable to go at things more deliberately.

For more finished drawings, first visit and study the subject a number of times from different angles and at different hours of the day, for there is an ideal time and place for the drawing of almost every subject. Having decided on the best view-

point and hour, block in all the main proportions of the sketch and then carry the shading only so far as possible while the light and shade masses compose to the greatest advantage. Then lay the drawing aside until a corresponding hour the next day, when the light will be about the same. This sometimes means returning to draw from the subject on two or three occasions, so the method is not recommended for general practice.

To save part of this trouble you might try a little trial sketch of the light and shade pattern at once, and quickly, as a guide for carrying on the work, which may be pushed to conclusion the first day. The sketch is then used as a reference for the desired appearance of the shadows. If light permits, and you do not have time to complete your sketch, you might take a snapshot of the subject. Then the sketch can be finished later with the snapshot as a guide. The true lover of sketching will probably not do this often, yet it is mentioned as an expedient worth having in mind for occasional use. As a rule, you should leave your camera at home, however, or at best use it only for catching transient effects which might otherwise be lost.

Advice to the Architectural Student

The style or method you adopt for your work will depend largely on the subject and your purpose in sketching it. The architectural student often sketches to add to his knowledge of architecture, caring less of what is going on in the street or wherever the subject may be than does the art student. And so it goes. If you are an architectural student, however, we should digress to add that you should not always work from architecture. If instead you select landscape or something with which you are less familiar it will give you greater training in observation coupled with freedom in delineation—a freedom much needed by the person accustomed to the instrumental representation of straight lines and geometric curves. Diverse subjects — boats, landscape details, or whatever—cannot be too highly recommended.

In the treatment of many subjects, however, the architectural student will doubtless fall back on outline, as he is so accustomed to its use. And there is no denying that, because of its directness, it may often be employed to advantage, particularly when it is essential to work rapidly. The landscape painter, however, is more likely to make greater use of contrasting values.

As a matter of fact, when working outdoors, seldom give much thought to method — just draw. The method which seems the most natural and easy is, for the moment, the best. If time is limited, or if there are important facts concerning the subject which are impractical for representation, you may write supplementary notes directly on the drawing.

Regardless of your way of working,

Fig. 158. This was an attempt to give an impression in a quick sketch directly in pen, ignoring technique.

Fig. 159. Notice the graded, tapering effect from dark below to light above, an effect obtained by shadow tones built largely of vertical lines.

Fig. 160. Directness of attack is essential in travel sketches where time is usually limited.

Fig. 161. Photographs may be taken if time does not allow you to complete your sketches while on travel. Here photos were used for reference.

however, try to develop the faculty of retaining mental impressions of each subject drawn. There are many advantages in learning to do this. To mention just one, retaining facts concerning the shapes of shadows as cast by objects of various forms will prove most helpful when drawing from memory or from the imagination.

Practical Uses of Outdoor Sketching

Up to now we have touched on outdoor sketching mainly as done for pastime or as a means of acquiring skill in accurately putting on record interesting or worthwhile things. There are many practical uses for such sketching, however special uses for such sketching, however, special the artist should be prepared to meet. Many times, for instance, illustrations are needed which seem to be sketches honestly done on the site. The artist may be asked to provide sketches as illustrations for travel literature, for instance, though he may never have visited the places to be pictured, or where his stay may have been too short to have permitted sketching, or where weather or other conditions may not have been conducive to obtaining the required results. Whatever the circumstances, the artist may have to fall back on photographs. In sketching from them he must try to picture the actual places, if he has seen them, and strive to put something more into the sketches than the cold facts expressed by the photographs. The artist should work freely and avoid too much detail.

The two sheets of sketches in Figs. 160 and 161 show that even the traveler who is supposedly sketching on the spot may occasionally be working from photographs. The two sketches of Assisi were honestly enough done on the spot, and that of the church of S. Francesco as seen through the archway was begun. Time failed or my interest lagged and the sheet was laid away. Some time later the bare right-hand corner of the sheet proved sufficiently attractive to inspire me to add the other two small sketches, which, as the town was then far behind, were done from postcards, the man and donkey being added to the left-hand sketch at the same time.

Sometimes, whether you work directly from a subject or from a photograph, considerable recomposition is necessary. The sketch of Santa Maria della Salute, for instance, in Fig. 161, though in most respects honestly enough drawn, was recomposed. One large umbrella which, from the point of view chosen, hid a considerable portion of the base of the distant church, was omitted; and the tree at the left and the projecting wing of the hotel at the right were forced apart to permit a still clearer view of the church. The sketch at the bottom of the sheet was also recomposed. In the beginning, however, it would be better to limit your attempts at recomposition for a while, drawing only subjects that seem satisfying as they appear.

In this chapter we have followed a rather rambling discussion of some kinds of outdoor sketches, with a word on how they are made. In closing, we would like in some way to inspire every reader at least to try outdoor work. Aside from all its other advantages, it offers so much real joy and pleasure, especially as you begin to make progress in it, that you should give yourself the opportunity to sketch outdoors as often as you can.

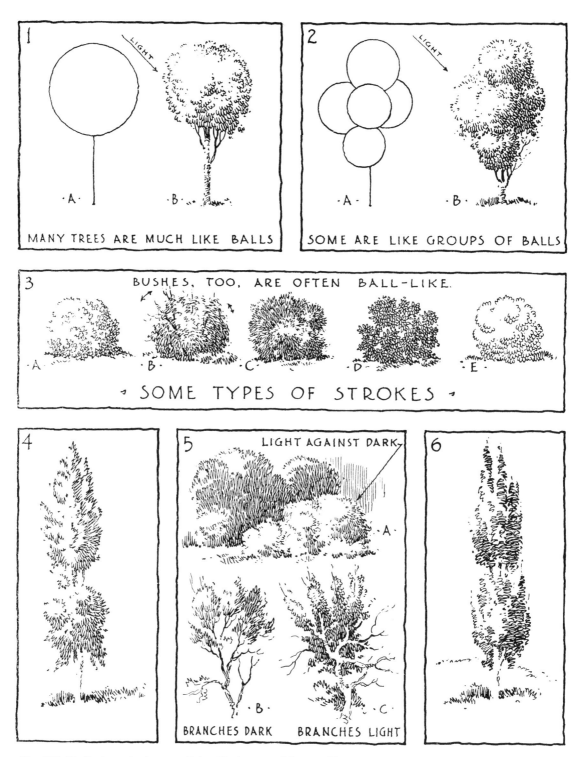

1 MANY TREES ARE MUCH LIKE BALLS

·A· ·B·

LIGHT

2 SOME ARE LIKE GROUPS OF BALLS

·A· ·B·

LIGHT

3 BUSHES, TOO, ARE OFTEN BALL-LIKE.

·A· ·B· ·C· ·D· ·E·

⌐ SOME TYPES OF STROKES ⌐

4

5 LIGHT AGAINST DARK

·A·

·B· ·C·

BRANCHES DARK BRANCHES LIGHT

6

Fig. 162. By first mastering small details, larger subjects will seem easier. Work for correct profiles and anatomical construction.

14. Trees and Other Landscape Features

T. F. Bancroft

The word "trees," as used above, is meant to be all-inclusive, for aside from them, we shall also touch on such similar things as bushes, vines, and grass.

The Importance of This Study

To acquire the skill to draw all of these landscape features is by no means easy, yet the need for doing so is apparent. The landscape artist and the landscape architect perhaps need the largest amount of special knowledge along these lines; all these things are of primary consideration to them. The architect and his assistants necessarily deal with the representation of trees and shrubs as a part of the setting for their buildings, and the architectural renderer who specializes in architectural delineation must have real skill in this direction. Even the art student needs to become familiar with them. If the artist uses them for nothing else, they will still be valuable as accessories to other subjects.

Obviously it is impossible to draw all these things well without knowledge of them. A too-frequent failing of beginners is that they think that because they have always been surrounded by such things they have automatically come to know them fully. They therefore try to draw them from memory when their mental impressions are too vague to make this practical. There are others who learn to do one or two types of trees and bushes with a fair degree of satisfaction and then grow indolent thereafter, employing the same ones repeatedly, regardless of their appropriateness to place or purpose.

Learn About Trees

Only from sketching outdoors can you hope to acquire a real knowledge of trees and other landscape features. Drawing from good photographs is valuable training, too, and may be easier for the beginner. Nor is there any harm in studying, and occasionally copying, representations of similar subjects by other artists. As a preparation for all of this work, however, or accompanying it, brush up on botany, and above all, study some of the books that are mainly devoted to trees. Examining these books will familiarize you with the names and leading characteristics of the more common varieties of trees, and train you in the laws which govern their growth. They should also strengthen your love and appreciation of the beautiful in nature.

It is by no means necessary to learn all the scientific terms, or to memorize more than a few essential facts concerning each species. But it is advantageous to gain enough knowledge to enable you to answer such questions as the following: What are evergreen trees? What are deciduous trees? Name some of the characteristics of the pine family; of the maple family; of the birch or beech family. Do elms grow in Ohio? Are hemlocks found in Kentucky? Name five trees that are tall and pointed. Name five that are short and widespread. Questions like these may seem unrelated to pen sketching, but they really are not. They are especially pertinent for the illustrator or the architectural renderer, either of whom may be called upon at any time to make drawings of places he never visited. Unless you have acquired such a knowledge, therefore, or know where you can easily secure the information when it is needed, you may make absurd errors.

It is, of course, particularly important to be familiar with the trees and shrubs and grass and vines of your own vicinity, so visit a park or the country, sketchbook in hand, looking for actual examples to illustrate the things you have read. Before starting to draw, take a walk for observation. First concentrate on the trees. How do they appear in the distance? Can you see the individual leaves? Do the trees look flat? Do they appear round? Do the trunks seem darker or lighter than the foliage? Do the trunks and branches seem uniform in tone?

Selecting the Subject

As you stroll about in this questioning way, comparing one tree with another, observing the shape of the general mass of each, analyzing its skeleton of trunk, limbs, branches, and twigs, you might be selecting the subject for your first sketch, using a viewfinder as an aid. As a rule you will have less trouble if you first draw some subject far enough away to show little confusion of detail. A tree in full foliage is often easier to do than one which is bare.

When you have selected the subject, search for the best viewpoint from which to draw. Then get out your materials and make yourself as comfortable as possible.

Analyzing the Subject

Take a few minutes to analyze the subject before you begin. What is the shape of the tree? What are its values? Is it lighter or darker than the sky? How are its edges— are they soft or sharp and clean-cut?

Such observation will show that some trees are nearly round and much like balls —a thought which has been illustrated in Sketch 1, Fig. 162. Others seem like groups of balls of varying size in combination, as in Sketch 2. Still others are suggestive of such geometric forms as cones, cylinders, ovoids, and ellipsoids. They can be represented, then, in much the same way, yet care must be taken that they do not seem too heavy and solid when finished. They rarely hold exactly to any geometric form, unless they have

Fig. 163. Even a solid black silhouette of a tree is surprisingly expressive of its true appearance.

been carefully trimmed. In fact, even a tree which seems ball-like in general mass usually deviates sufficiently from this curved form to make it possible to delineate it with a line made up largely or entirely of straight strokes. Although it is helpful to think of trees as similar in form to geometric solids, they should not be rendered without also taking these customary variations into account.

Contours or Silhouettes

When you have analyzed your subject, proceed with the sketch. There are several things essential to satisfactory delineation of trees. First, the outline or contour drawn for each tree should be a correct expression of its proportions. If it is, you have laid a good foundation for a convincing drawing. Otherwise, no amount of labor on the technique will make up for it. To show the importance of contour we have made sketches in Fig. 163. These illustrate that even a solid black silhouette drawing of a tree is surprisingly expressive of its true appearance. In these sketches, for instance, you would scarcely mistake the elm for the apple or maple.

Though we have just recommended accuracy in delineating tree contours, we do not mean that you have to be as painstakingly correct as when drawing portraits of people. Trees, even of one species, vary so in size and shape that the observer is not able to notice faults of proportion in a drawing which would seem alarmingly conspicuous in representations of many subjects. The important thing is for the artist to learn to express the main characteristics of contour well, and especially those that are peculiar to each species. If you do this your contour sketch will always be convincing when finally rendered.

As you work at perfecting the contour — which is usually lightly indicated by a few dots of the pen, or by delicate pencil lines — also locate the main lines of growth of the supporting framework or skeleton — the trunk and the branches. Faulty construction of these lines causes many of the most common failures. Therefore, it is best to suggest carefully, in pencil, not only the larger branches which are plainly visible, but also those which are partly hidden, if you can determine their directions through the foliage of the tree itself.

Values

With the contour right, and the framework correctly indicated, the values of light and dark are the next consideration. If a tree is nearby, its values often seem extremely complex. Each visible leaf has contrasts in light and shade of its own. In view of these complexities, we suggest you draw trees that are not too near. If a tree is in the extreme distance, and the sun is not too bright or the air too clear, it often shows only one plane of tone, which can be represented by a

Fig. 164. Here a bush and tree have been reduced to a single plane.

Fig. 165. The tree and background foliage are indicated by two planes, the darker one in the foreground.

Fig. 166. Here the values of the two planes have been reversed, and the light foreground stands out against a darker background.

Fig. 167. In the three planes here, the greatest contrast is in the light and shade of the foreground bush.

silhouette of gray, as you can see in Fig. 164. Sometimes a distant tree stands out as a single dark plane against another tree, or mass of trees, which appears as a lighter plane, as in Fig. 165. Now and then the opposite is true, as in Fig. 166.

These are extreme examples, however. More often, a tree, even in the distance, has at least two rather distinct planes. In addition, it is often seen in relief against a background plane of still different value (see Fig. 167). Still more often, it is hard to resolve the values of a tree into fewer than three planes, as suggested by Fig. 168. In the final interpretation of these planes, there is sometimes no definite line of demarcation left between them as can be seen in Fig. 169.

After completing your contour, therefore, and blocking out the framework of branches, observe the direction of light, and the resulting values of light and shade on your subject. If they appear to be confusingly complex, you may be able to see them in a more simplified form if you squint at them through partly closed eyes, thus blurring the detail. Or you may get a similar effect by walking directly away from the tree, observing it from a greater distance.

Try to think of the whole as resolved into a limited number of values. As an aid to this, you might make one or two little trial value sketches of it, similar to those shown as Figs. 170 and 171. Having done this, you are ready to render your larger sketch.

Proper Technique

This brings us to the actual technique used for this work, which is very important; for here the student, particularly the beginner, seems to have the greatest trouble. This is often because the student tries too hard. Instead of using the technique which seems to express logically what is there, the beginner attempts to apply some method used by some other artist, perhaps for an entirely different purpose.

It is obvious that you cannot hope to render every leaf. Instead you must study the general direction of growth in every part of a tree. In some trees or some parts of trees, leaves are drooping; in others, they are stiff and upright. Try to interpret these directions of growth using strokes that seem to offer a natural expression of this growth. The stroke you select to represent the drooping leafage of a willow, for instance, might not do at all for suggesting a bristling pine.

Sketch 3 in Fig. 162 shows a number of sketches of bushes in which a variety of strokes has been applied. Similar strokes would do as well for rendering trees. Fig. 172 offers several other applications. Fig. 173 presents one of the most popular strokes of all, for not only can this be done very quickly but it may be applied with variations to almost any subject having foliage. Before sketching outdoors, study these illustrations and other examples by various artists. Practice the ones that ap-

peal to you most, later applying the appropriate one to each outdoor subject.

Don't Overlook the Shadows

When you have finished the foliage in your first sketch, complete the branches, if they can be seen, and the visible portions of the trunk. Model these in a way that expresses their correct shapes. They will usually seem rounded unless they are in the distance.

Notice the great difference between the tone of the bark in light and in shade, a difference which is frequently even exaggerated to good advantage as is shown by Figs. 174, 175, and 176. In Fig. 174, for instance, the nearby limb is in the sunshine; it has been left white. The farther limb is in shadow and has been made dark by lines running lengthwise to it In Fig. 175 the branches are both left white, except the upper portion of the nearer one, which has been darkened by lines running around it. The nearer branch also casts a shadow on the other, which nicely detaches the two. Shadows of this type, cast on a limb by foliage or by another limb, are common to trees. In Fig. 176 a less usual effect is shown. The nearer branch is the one in shadow, the other being light behind it. In Fig. 177 all of the branches are light but run up into strong shadows where they disappear in the leafage, a very frequent condition.

Just as we have these sharp shadows on branches we often find the upper edges of holes through foliage very dark because they are in deep shade. This means that in rendering these holes it is necessary to accent the tops as in Fig. 178. This makes the holes look like holes and not like clumps of light leaves.

Shadows Expressing Form

You must pay attention not only to these *minor* shades and shadows which seem parts of the trees themselves, but to the *main* shadow which any tree casts on the ground as well. Often the shape of this shadow helps to give a correct impression of the shape of the tree and of the character of the ground itself.

The type of line used for suggesting the shadow on the ground will depend largely on whether the ground is smooth or rough, bare, or covered with grass. If smooth and bare, horizontal strokes normally give the best results. If covered with close-cropped grass, similar strokes may be used to advantage, but if the grass lacks the perfect smoothness of a newly mowed and well-kept lawn, use strokes with greater freedom in more or less a vertical direction.

Note the grass suggestion in Sketch 5 at the bottom of Fig. 173, as well as in Sketches 1 and 2 in Fig. 172. If you study the drawings reproduced here and throughout the book, you will see that in drawings where shadows fall on the grass, the white of the paper may sometimes be left blank or nearly so, for areas of grass in sunlight (see Sketch 1, Fig. 172).

Fig. 168. It may be difficult to reduce the planes to fewer than three.

Fig. 169. In the final interpretation there may be no definite line of demarcation between the planes.

Fig. 170. Your trial sketches should reduce the values to two planes.

Fig. 171. Perhaps your drawing will call for three planes.

Fig. 172. Note the direction of light before sketching. Here a variety of methods has been used for rendering trees, bushes, and grass.

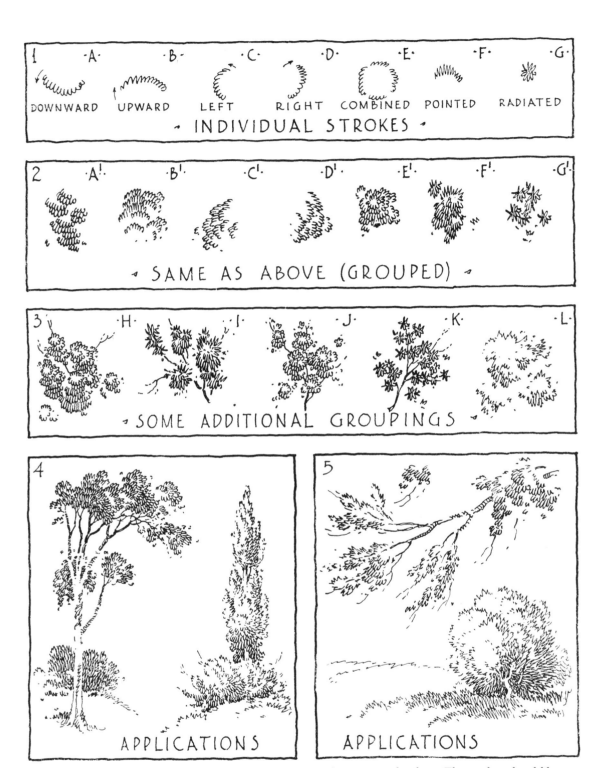

Fig. 173. Practice many strokes individually and in combination with others. The strokes should be naturally expressive of the subject.

Fig. 174. Dark limbs in shadow appear behind light limbs in sunlight.

Fig. 175. Shadows cast by one branch form rings on those behind it.

Fig. 176. Here a light branch appears behind a shadowed one.

Fig. 177. Notice how branches have been accented.

Fig. 178. The upper edges of sky holes in trees are generally in deep shade and are therefore dark.

If a tree casts a shadow on a building and this building is included in the sketch of the tree, it is important to get the shadow correct in shape, right in value, and at the same time expressive of the surfaces on which it falls.

Groups of Trees

When you have completed your first tree sketch, try some others. After you have done a few drawings of individual trees, adding bits of the surroundings if you choose, you might attempt groups of two or more trees. Here you must take care to represent shadows cast by each tree on its neighbor. Often when one tree or bush is partly in front of another, there are very interesting contrasts of light and dark. In Sketch 5, Fig. 162, at A one bush has been left almost white against a darker one behind it, the lightest values of green not indicated at all.

We have something of the same effect in Sketch 1, Fig. 172, for there the tree beyond the hedge starts light at the top and grades down to dark as it disappears behind the hedge. This in turn is light on the top where the sunlight strikes it most directly. Then it darkens until it forms a foil to set off the foreground bush. In the same figure, in Sketch 4, the dark of one bush and of the doorway throws the shrubbery beneath the door into relief.

Studying Tree Skeletons

Though you will do most outdoor tree sketching in the summer, you will add greatly to your knowledge of trees if you give some attention to the way they appear at different times of the year. In the autumn or winter, when the leaves have fallen from the deciduous trees, you have the best opportunity to study their skeletons. It is surprising what a variety of types exists. Some trees have a very meager arrangement of branches. Some have surprising richness. There seems almost no end to the combinations of trunks, limbs, branches, and twigs.

Sketch some of these various arrangements directly from trees. If the weather is too cold to permit this, you can make photographs and draw from them later.

The shadows cast by these skeletons on the ground or the snow, or on buildings, are also worthy of study. In fact, you can hardly afford to neglect them. Fig. 179 shows one of these skeleton forms done in the wintertime. Fig. 180 shows the same form partly clothed as it appeared in the spring. Another sketch, showing the tree in full leafage, would have added to the value of this study.

Vines, and especially those growing on houses, should also be drawn at different seasons of the year. They are not difficult, once tree representation has been mastered. For vines, hedges, and similar details refer to the illustrations of the next few chapters on architecture, where a wealth of such material is shown.

Continuing the Study

During all of this study and sketching, try to memorize the leading characteristics of the things investigated, building a firm foundation for future memory work. Save your sketches, too. No matter how imperfect or incomplete they may seem when made, they may prove of inestimable value for later reference.

Fig. 181 shows two outdoor sketches which you might try as early studies, the first being of a complete tree, the second of portions of a group of trees and bushes. Notice that in a number of places the nearest branches, which are out in sunshine, have been left white. The farther ones, beings in shadow, are shown dark. This gives depth to the sketches. The trees do not look flat as they sometimes do in drawings.

If you are an architectural student, make many studies like those in Fig. 172, particularly Sketches 2 and 4, because you will have to know how to represent trees, bushes, grass, and the like as part of the setting for buildings. In fact, this is important for almost anyone learning to draw. Trees used as part of an architectural setting are generally the most common kinds and are rendered in a somewhat typical manner so they will not detract from the architecture. Such trees are less interesting, however, than those that are unusual in character. Old, gnarled, wind-blown veterans, for example, that have fought the elements for years, bring joy to any lover of sketching. And when you have arrived at a reasonable degree of skill in delineating the more usual but less individual types, these are the kinds most sought.

Trees in Motion

Now for a word about trees in motion. The trees we have just described, especially those which have stood for years in exposed positions, frequently have become permanently deformed or crippled, either through reaching out towards the sun, or through the force of the wind. If such deformity exists in a tree, you must try to portray it. If you are unable to express these individual characteristics, your drawings will have failed to some degree. Trees, too, are often seen waving back and forth in the breeze or temporarily bent by the force of the wind, or perhaps there is simply a rustling or rippling tremor to the leaves. These movements are, of course, extremely difficult to suggest. It is interesting to try to do so now and then, however. The other effects of motion, particularly the bending of a tree by the wind, are not as difficult because they are less subtle.

A sumptuous example of trees as delineated by a real master is shown in Fig. 182. This drawing has an etching-like quality of delicacy and sensitivity which is remarkable. Fogarty preserved the feeling of air and sunshine, an effect obtained with his free technique. Study this and other landscape drawings for more ideas.

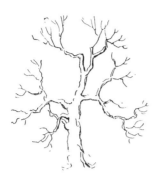

Fig. 179. Study skeletons
of trees during the winter.

Fig. 180. In the spring the
tree skeleton is partially
clothed.

Fig. 181. These are quick sketches of trees drawn directly from nature in pen and ink. It is often desirable to
depict trees more simply than in these examples.

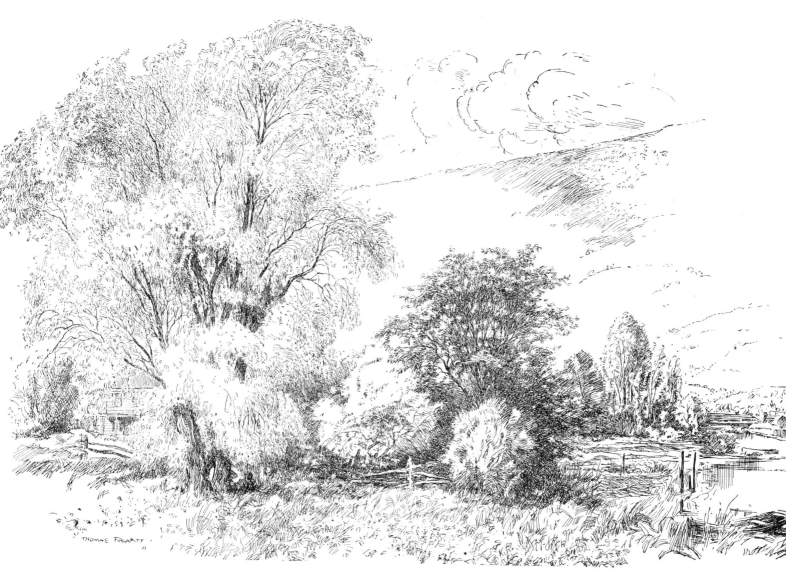

Fig. 182. Thomas Fogarty: Here are convincingly real trees —not mere groups of pen lines —thoughtfully and honestly drawn on a sheet of paper 20 1/2 x 13 1/2 inches/50 x 30 cm.

15. Drawing Building Details

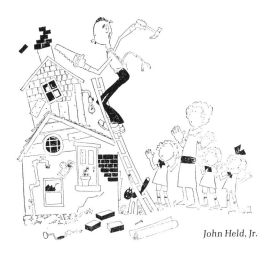

John Held, Jr.

The importance of delineating architecture pleasingly and correctly is undeniable. Yet it is also true that architectural representation ordinarily receives far too little attention in art schools, and is not taken seriously by many artists.

This neglect is probably due to the primary importance of other subjects, because many drawings and paintings do not include architecture, and when it does appear architecture frequently takes a subordinate position. This subordination, however, should be no excuse for the faulty work frequently seen.

A Word to the Architect

If such work is important to artists, however, to the architect it is indispensable. For the architect not only makes many plans, elevations, sections, and details which are instrumentally drawn (a subject that is outside the scope of this volume), but he also does numerous freehand sketches and studies, some for his own benefit and some to convey his schemes to his clients. Some drawings are even done to help get new clients. Naturally, then, the architect's manner of handling architecture will of necessity be more detailed and exact than the artist would care to emulate. Yet this work should also benefit the artist as well, helping him to avoid some of the most common errors frequently seen.

This, and the next three chapters, will be treated mainly from the standpoint of the architect and the student of architecture. We will try to show how to make detailed representations, first (in this chapter) of portions of buildings, and later of complete structures. In following this through, therefore, the art student should have in mind that, to the architect, the representation of architecture does not take the subordinate position that it so often does to the artist.

Starting with Building Details

As a rule, the easiest method of learning to render the architectural subject in its entirety is first to become familiar with ways of indicating the smaller component parts. You should learn to suggest such materials as bricks, stones, shingles, slates, and clapboards. You should acquire skill in details like chimneys, doors, windows, and cornices.

There is no one correct way of doing such things, however. In the first place, a method of representation which would do for a nearby building would not do at all, without great simplification, for a building some distance away, and a structure in the extreme distance would require even broader and simpler treatment. In the second place, if a detail, such as a window, is made the subject of a sketch, it can be treated with more elaboration than if it were shown as merely a part of a whole building.

In turning to the details shown in this chapter, then, bear in mind that they represent things close at hand. Each, with few exceptions, has been used here as the subject for a complete sketch. Therefore, the treatment in some cases is more complex than would otherwise be necessary. In later problems, where the representation of an entire building is being considered, you must realize that each detail should be subordinated to take its place comfortably in the entire composition.

First we will consider some of the various materials which commonly go to make up buildings. In this work, we suggest you turn for help to actual buildings, to photographs, and to renderings by other artists.

Stonework

Let us start with stonework as found in exterior walls. First, before seeking methods to represent it, consider some of the many effects which such walls have. You know that walls are sometimes in sunlight and sometimes in shade, and so do not always look the same. You know that some are nearby and some in the distance, and that this changes their appearance. You know that some are viewed from almost at right angles, appearing practically in direct elevation, while others are so turned that they appear greatly foreshortened. Understand, too, that stones themselves vary in tone, individually, some being light and others dark. They vary in texture, also, from extreme smoothness to extreme roughness, the rough stones appearing darker than they are because of their many small areas of shade and shadow.

Stones also vary in size, and in shape, and there are many ways of finishing them and laying them into walls. Some are laid just as they are picked up from the fields or brought from the quarries, for instance, with wide joints of different depths. Some, on the other hand, are carefully dressed and laid up with joints which scarcely show, giving a wall which in its smoothness appears almost like plaster. Sometimes there is no mortar at all in the joints, sometimes it fully fills the joints, and sometimes it is raked out to a considerable depth. Or the joints may be "struck" in any one of a number of ways, with special tools made for the purpose. The mortar itself may be lighter or darker than the stones.

Though this is far from being a description of all the types of walls, it serves its purpose in making clear that there can be no single way of representing such varied effects. The important thing to keep in mind, however, is that it is generally not the method of drawing each individual stone that counts—especially when large areas are considered — but rather the effect of the entire wall. In working for this

Fig. 183. In nearby stonework, sometimes each joint line is drawn.

Fig. 184. The mortar joints are often wide and expressed by double lines.

Fig. 185. The shadows in the joints are frequently enough to express stonework. Direction of light here comes from the upper left.

Fig. 186. Even a faint suggestion of the shadows is often sufficient.

effect it is seldom necessary to draw all the stones. Often a few patches here and there are sufficient to convey the desired impression. If the scale is large, however, more detail is needed.

In Figs. 183 to 200, we have shown a group of fairly large-scale indications of stonework in which many individual stones have been drawn. The sketches are largely self-explanatory, yet a few words concerning them may be helpful.

First, if the joints between stones are narrow, and are finished flush with the surfaces of the stones themselves, they are sometimes scarcely visible or they show as uniform lines. They may be drawn as in Fig. 183 or represented with delicate dotted lines. If the joints are sunk below the surfaces of the stones, however, tiny shadows will be cast into each joint, which will make the joints somewhat more conspicuous. In representing such masonry, first note the direction in which the light is falling, in order to locate these little shadows correctly. Sometimes the shadows themselves are all that is needed to express such stonework. They may be definitely drawn as in Fig. 185 or merely suggested as in Fig. 186.

Even though stonework may actually be gray in value, it often looks better in many places if left white. Large surfaces may remain perfectly plain, or simply have a few joints here and there indicated by dots. Sometimes, however, it is necessary to use a darker value for a part or all of the stone. Fig. 199 shows a darker rendering of a similar stone to that shown in Fig. 183. This stone, like all the examples to which we have so far referred, is smooth or nearly so.

Rough stone is perhaps harder to indicate. At any rate, it requires more modeling or shading, as in Fig. 198, and the joints between the stones may show greater variety of width and depth, with accompanying variety of shadow. In the case of rough stonework, individual stones often show different textures and different treatments. (See Fig. 197 and Sketch 7, Fig. 131.) It is by no means always necessary, however — even when drawing rough and irregularly coursed stone — to draw each stone separately. If the areas of stone are large, and if a medium gray effect is desired, the area may be first covered with patches of tone similar to that in Fig. 191. Then, with the direction of light in mind, accents such as the shadows in the joints may be added, and a few lines may be dragged across the surface, as in Fig. 192.

Not only do joint shadows play an important part in stone wall representation but so, likewise, do those in small depressions or cavities. In Fig. 193 we show one way of treating these little pits. The sketch explains itself. It can be readily understood, too, that the same trick can be applied to many things besides stone indication.

We have mentioned that joints may be lighter or darker than the stones themselves. They are often left white,

Fig. 187. This is a typical corner.

Fig. 188. This is wrong: stones do not match at the outer corner of the building.

Fig. 189. Avoid small stones at the corners.

Fig. 190. Avoid long vertical joints such as these.

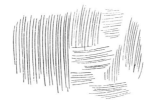

Fig. 191. First cover the desired area with tone like this.

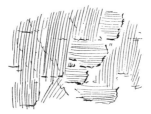

Fig. 192. Then add accents, such as the shadows in the joints.

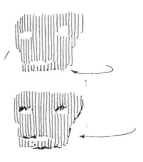

Fig. 193. Cavities may first be left as shown on top, and the shadows may be added as shown below.

Fig. 194. Joints are often left white. Some individual stones are drawn.

Fig. 195. Sometimes the joints themselves are made dark instead.

therefore, as in Fig. 194. However, if the joints are deep and consequently dark with shadow, or if they are of dark mortar, they may be rendered dark, as in Fig. 195. Frequently some appear light and some dark—an effect which has been recorded in Fig. 196.

Now look at Fig. 200. In this example, lines have been added to a group of completed stones to simplify them or tone them together, producing crosshatch. Often when too many individual stones have been drawn on some surface, especially a large one, the surface looks restless and spotty. In such a case a little crosshatch, judiciously used, sometimes does wonders towards unifying the whole.

Study stonework (and brick walls, too) closely. You may avoid some of the mistakes often made by the artist who lacks a knowledge of the fundamentals of construction — mistakes such as we have shown in some of our marginal sketches. Fig. 187, for instance, shows a typical outside corner of a stone building. The stones making up the corner itself are large and substantial, as they should be. Too often the artist uses small stones on such corners and around window and door openings—stones which have no structural significance, as in Fig. 189. Beginners not only make this mistake but, what is worse, as illustrated in Fig. 188, sometimes design a corner with each wall face absolutely independent of the other.

A less obvious mistake, but a common one, is pictured in Fig. 190. Here the stones are not well lapped, which results in long joints almost vertical in direction. This prevents good bonding of the wall and permits the rain water to flow down the joints themselves rather freely, causing a gradual disintegration of the mortar, which weakens and disfigures the entire structure.

With all these facts fresh in mind, turn through this book, and study the various drawings showing stone indication. There are several on the nearby pages; the chimney in Fig. 201, Sketch 5, for instance. There is also the drawing by Goodhue (Fig. 276), and that by Wilkinson (Fig. 278). Now try a few sketches of small areas of stonework.

Brickwork

Much that we have said concerning stonework applies to brickwork also. The main difference is in the smallness of the units in bricks and the greater regularity of their spacing.

The average brick shows on its face a rectangle about two inches high and eight inches long, which means that it is impractical to draw all the bricks on any large wall surface. Usually, then, some effective and simple method of indication is adopted. Fig. 201 illustrates a number of these methods, and there are many more examples of brick indication throughout this volume, particularly in the next few chapters. Often it is advisable to vary the technique in different parts

Fig. 196. Some joints are light; some are dark.

Fig. 197. Notice the variety in texture and value here.

Fig. 198. Some stonework is highly modeled. (Note light at top and left.)

Fig. 199. Some stonework is smooth, or nearly so.

Fig. 200. Crosshatch is added to completed stones.

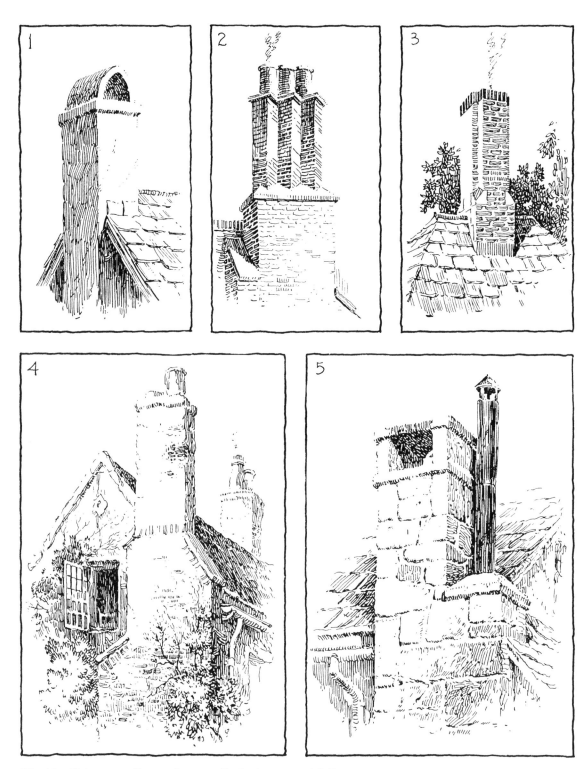

Fig. 201. Chimneys offer an almost unlimited variety of different materials. Vary the stroke according to what is needed to express the form.

Fig. 202. Schell Lewis: Careful attention is given to even the smallest details here. Notice the simple and satisfying rendering of the trees. Alfred Cookman Cass, Architect.

Fig. 203. Shadows on light surfaces (such as stucco) usually look light.

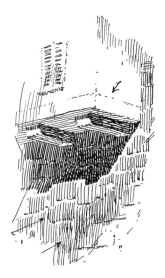

Fig. 204. Shadows on dark surfaces (such as stone) usually seem dark.

Fig. 205. The shadow seems dark on the dark window trim and light on the stucco.

Fig. 206. "Forcing" shadows increases sunlight brilliance.

of the same drawing, to avoid monotony. In some rather formal drawings a direct and highly stylized kind of suggestion which better harmonizes with the character of the whole should be selected.

A particularly fine example of brick representation appears in the drawing by Schell Lewis (Fig. 202). Not only is there great variety in the way in which the individual bricks are treated in different places (note particularly the wall by the sidewalk), but the entire tone of the brickwork as a whole is handled very skillfully. Though practically all of the brick areas have been filled with lines these lines vary in weight, spacing, and character in such a way that the tones formed by them contribute very nicely to the fine effect of the values of the whole composition. See how light the end of the house has been kept, for instance, in comparison with the front. Note, too, that the front wall starts rather dark at the top and grades down to light as it (together with the light bushes) goes behind the dark fence and its accompanying dark bushes. By this carefully arranged contrast, a splendid sense of depth and detachment has been achieved. Among the other reproductions well worth study, because of strong brickwork representation, are those in Figs. 252 and 253, made from a drawing by Richard Powers.

Stucco or Concrete

There is no wall surface easier to suggest in pen than smooth plaster or concrete. Often a little stippling or a few groups of sketchy short strokes here and there are all that is needed. The white paper itself is generally sufficient for representing the light surfaces. In shade almost any simple arrangement of strokes is good. It is perhaps better not to draw them horizontally, however, for if you do they may be taken for brick courses. Vertical lines are good. The chimney in Sketch 1, Fig. 201, suggests rather rough stucco. Sketch 4 shows a combination of rough stucco plastered over brick, the latter showing through in places. Figs. 203 to 206 offer other examples.

Clapboards

These are also easy to draw. Usually nothing is needed but a line of shadow under each one, as in Sketch 2, Fig. 215. Sometimes, especially if the clapboards are above the eye and the drawing large in scale, a double line is used (see Sketch 4, Fig. 131). However, if these lines are too conspicuous, as they sometimes are, particularly in the sunlit areas, dots may be substituted for part of these lines, as in Sketch 5, Fig. 131, and Sketch 4, Fig. 215. In both Sketches 4 and 5 of Fig. 131 are shown treatments of clapboards in shadow. Notice the reflected lights under each one. Many times the shadows cast on the clapboards by a shutter, the door or window trim, a corner board or some such feature, help to express the surfaces on which they fall.

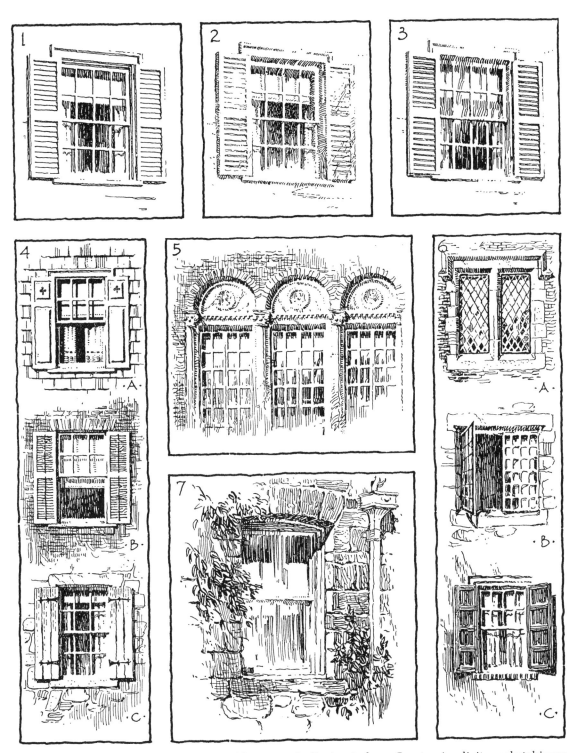

Fig. 207. Here are a few of the many possible ways to indicate windows. Greater simplicity or sketchiness is often better.

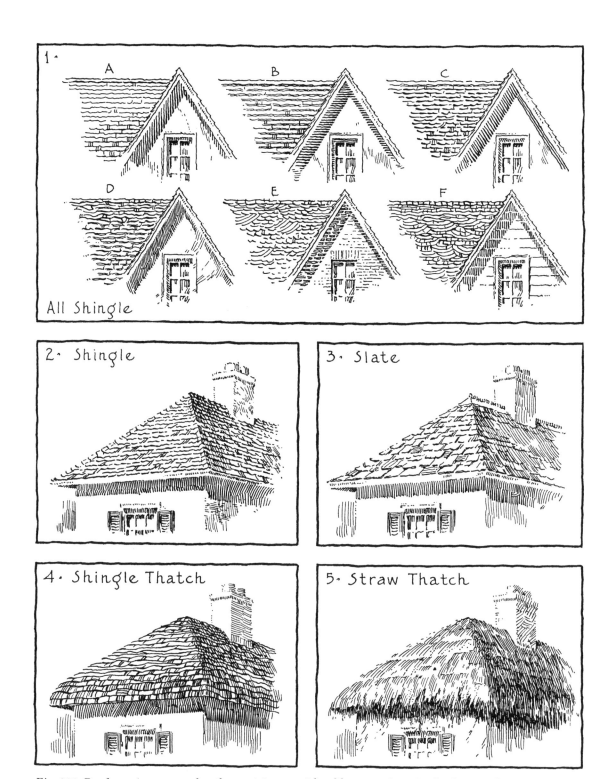

Fig. 208. Roofs are important details requiring considerable versatility. Study these architectural drawings just for the roof indications.

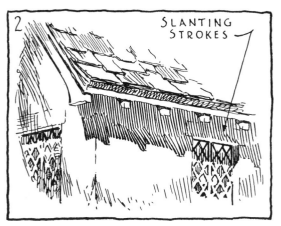

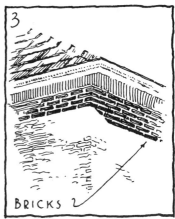

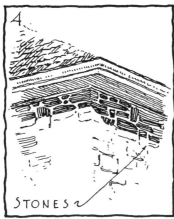

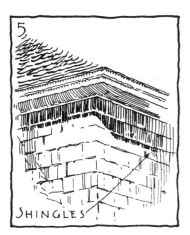

Fig. 209. A number of cornices and their shadows are represented here. Notice that the shadows are expressive of the various building materials.

Fig. 210. A line like A or a black spot like B appears very conspicuous.

Fig. 211. Shadows help in the expression of form.

Shingles

In representing shingles on walls, almost the same indications will do as for clapboards (and this is true, also, for the typical kinds of drop and novelty siding). A few vertical lines as at A in Sketch 4, Fig. 207, will add to their character. Naturally, all these details should be shown at about the proper scale, with the right exposure to the weather.

Roof Indications

When shingles and other similar materials, such as tiles and slates, appear on roofs, their representation is most important; yet it is hard to give anything approaching definite instructions. This is mainly because roof planes are generally foreshortened so greatly in appearance—especially when viewed from the ground —that they vary greatly in effect. Representing every course at its proper scale would be out of the question; it would make the roof too complicated and black in tone. The lines which are most prominently drawn usually represent the butts of the shingles, and just enough of them are employed to look well and to bring the roof tone to the proper value in relation to the building as a whole. This usually means no more than a third or half of the actual courses are indicated. The less the amount of foreshortening on the roof the more lines may be added. The lines that are drawn should suggest the materials in an interesting and a convincing manner.

Fig. 208 illustrates roof indications. Sketch 1 shows six different shingle treatments in elevation. The type of treatment chosen for any building depends on many things, including its nearness, the kind of shingles used, their age, and the method of laying. Old shingles that curl demand a different line from those which are new. Smooth, even slate looks almost the same as shingles, and so must be represented in much the same way. Thick slate, or slate irregularly laid or of variegated color must have appropriate treatment. In Fig. 208, Sketch 2, is a small roof represented as shingle. Sketch 3 shows the same roof covered with rough and unevenly spaced slate. The fourth sketch is of an imitation thatch made of shingles, while Sketch 5 presents a true thatch of straw. For another example of thatch see the roof at Sketch 7, Fig. 131. For an example of slate at large scale, study the sheet of chimneys, Fig. 201. Also look at the various examples of architectural representation scattered through this entire volume.

Cornices and Eaves

Before leaving the subject of roof indication we must consider the treatment of eaves and cornices, and the shadows so many times cast by them, because they play a most important part in the appearance of buildings.

Inasmuch as cornices usually project from the walls, it is necessary to suggest this projection. This is done partly through correct delineation of form in the outline layout, also through the light and shade application. Considering that roof tones are often rather dark and that cornice shadows are practically always so, the most natural treatment is to leave the projecting members of the cornice—such as crown mold and fascia, or gutter, if there is one—light in value in order to create the contrast necessary to achieve the desired effect. As illustration of this it will be seen in Sketch 1, Fig. 208, that the projecting overhang of the roof is left light, while the roof and shadow tones are both darker. In Sketches 2 and 3 the cornice is left even more noticeably white. Fig. 209 shows several other similar examples. Not only do cornice shadows aid in bringing about this effect of projection, but the shadow width suggests the amount of overhang.

There is no fixed rule regarding the methods of building up these shadows. Returning again to Sketch 1, Fig. 208, six methods are shown. In A the shadow lines are vertical, in B horizontal, and in C slanting in a direction parallel to one of the roof pitches. In all three of these, the strokes making up the shadow tones are accented towards the ends to bring about a crisp contrast with the walls as well as a sense of reflected light beneath the cornice, a point which will be more fully covered in a moment. In D the shadow tone is handled with more freedom. Such a tone would be excellent were the shadow falling on a smooth wall, such as one of stucco. On a wall of brick, the shadow tone is often made expressive of the bricks themselves, as in E, while a shadow falling on clapboard may in a similar way be made to suggest that material in F.

We have illustrated some of these points more fully in Fig. 209, feeling that they are of the greatest importance. Here the cornices in all of the sketches except 6 and 7 are in perspective as seen from below. In most of them the soffits are visible, and the shadows are rather dark, especially towards the bottom. Leaving a light soffit is a natural thing to do in many cases, for it is often true that reflected light is thrown under a cornice in this way. Sometimes the thought is even exaggerated a bit, soffits being left pure white. It is, however, no uncommon thing (as you can verify by studying actual buildings) for reflected light to be so strong that it makes soffits light and shadows more transparent in effect and also actually casts reversed shadows within those directly cast. Darkening the lower edge of a shadow tone is also a natural thing to do, for a shadow when seen in contrast with a sunlit wall often seems to grade dark as it comes against it. Because the white of the paper is never light enough to fully express the brilliance of a sunlit surface, the shadow is purposely forced darker in order to make that surface itself seem all the brighter

through contrast.

These sketches in Fig. 209, like those in Fig. 208, show various ways to suggest different materials within the shadows. The only one of these needing additional explanation, perhaps, is in Sketch 7, where the glass of the upper part of the window, though in shadow, has been left white. This illustrates again a common natural condition, for glass within shadow often reflects so much light, acting like a mirror, that it seems white or practically so.

Chimneys

There is perhaps no detail more interesting or worthwhile for early study than the chimney, taken together with the parts of the building adjacent to it, for no other subject offers greater chance to test your skill in representing various materials as they appear side by side. In Fig. 201 we have shown a number of typical examples. Try similar drawings yourself as a preliminary to the later rendering of complete buildings. Your first drawings may be done from photographs or even from other drawings. These should be followed by some from actual buildings.

Shadows

We have previously discussed drawing shadows, but there are few important points which we have not yet touched upon. One of these concerns the *values* of shadows. We have already spoken of forcing or darkening the edge of a shadow tone in order to make the adjacent sunlit surfaces seem relatively brighter by contrast, a point that is further illustrated in Fig. 206.

Although this is a logical thing to do and is done very often — even when the shadow is falling on a light surface such as plaster or clapboards—it is nevertheless true that shadows ordinarily vary to quite an extent in tone because of the local tones of the surfaces on which they fall. Shadows on light surfaces generally look lighter than shadows on darker surfaces, for instance, a fact fully illustrated in Figs. 203 to 205. In this latter sketch note that the shadow is dark on the dark window trim and light on the stucco, a point which has been similarly illustrated in Sketch 6, Fig. 209, at *A*, where the half-timber work has been made darker than the stucco. Introducing some darker areas like this half-timber makes the rest of the tone seem more transparent by contrast. You must be careful of your treatment, however, for a dark line or spot within a shadow tone will often appear more conspicuous than you would think, as evident in Fig. 210. If, on the other hand, a shadow tone seems heavy and overly dark, intelligently introducing a few black touches within it, and placing them logically will make the whole seem lighter and more transparent through contrast.

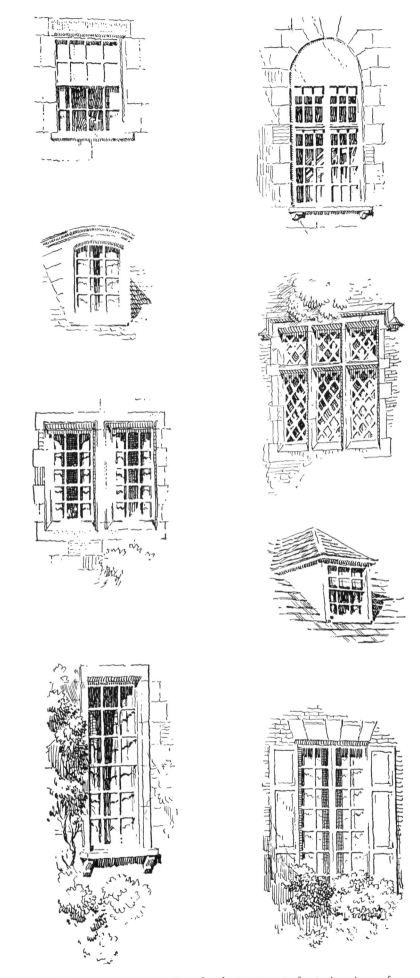

Fig. 212. Here are some suggestions for the treatment of exterior views of windows as they are seen on sunlit walls.

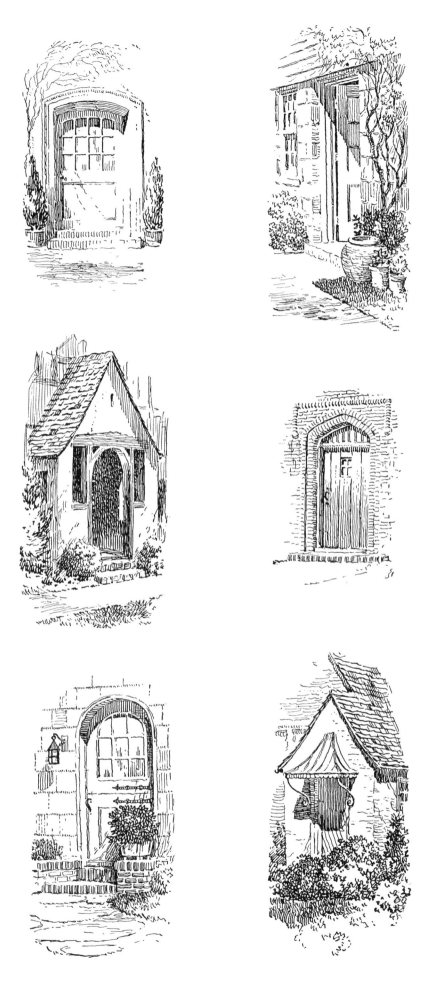

Fig. 213. Residential doorways come in a variety of forms.
Here are some suggestions for their treatment.

In architecture, as in other subjects, shadows help to a great extent in the expression of form. We have already touched on this in connection with drawing clapboards. In Fig. 211 we have another example, for here the arch shadow breaks across the panel of the door in a way that clearly expresses their depth.

Windows

Windows or glass doors or any objects containing large areas of glass are, on the whole, a bit more difficult to draw than most details. Glazed surfaces are so complex in light and shade and so changeable in their appearance that they demand full understanding as well as special care and skill in their delineation. It is not hard, to be sure, to learn to draw a typical window or two, especially if shown at small scale, but if the scale is so large that it requires any considerable amount of detail, windows are no easy task for the beginner. If windows are made too dark or too light, they may, even though good in themselves, attract more than their proper share of attention. If all the windows are drawn in the same way the result will probably prove monotonous. If, instead, too much variety is shown, the effect of the whole drawing is almost sure to be destroyed.

Before attempting finished renderings of windows, acquaint yourself, through observation and study, with the appearance of glass under different circumstances and conditions. Only then will you be able to represent it to the best advantage in any given problem. Walk along the street and study any windows that you see—not only those near at hand but those in the distance as well. Compare those on the sunny side with those in the shade, and those in the upper stories with those in the lower. As you make these comparisons, ask yourself such questions as the following: What is the difference in the appearance of glass in sunlight and in shade? Do windows in the upper stories have the same general effect as those in the lower? How do windows in the distance compare with those near at hand? Can one see the curtains or shades distinctly in all the windows? How much of the interiors of the rooms do I see as I pass? Is the glass always plainly visible? Is it hard to tell if panes have been broken from a sash? Is it easy to distinguish plate glass? If so, why? Do all the lights of glass in one window look the same? Does the glass usually seem lighter or darker than the sashes? Does one see images reflected in the glass? If so, are they sufficiently definite to permit me to tell trees from buildings? Does my own image appear in the windows as I pass? Are images more distinct in glass in shade than in glass in sunlight? Are reflections as clear on a rainy day as when the sun is shining?

A little observation will answer such questions and make it evident that ordinary window glass has two leading characteristics which affect its appear-

ance, and which are, therefore, of the greatest importance to the student. First, its transparency. Under certain conditions, glass seems practically invisible. This is especially true of clean plate glass favorably lighted. We are sometimes able then, in representing windows, to neglect the glazing and treat the sashes just as though the panes were nonexistent, showing distinctly the shades and hangings within. The other characteristic, and the one which causes most trouble for the beginner, is the power that glass has to act as a reflector or mirror. This reflectiveness very often gives a shiny effect to the window, and usually images of objects as well, which in some cases are distinctly recognizable in their reflections. The student usually has great difficulty sketching directly from buildings because of the complex effect created by reflections in windows. Sometimes trees, buildings, skies, clouds, and people are all pictured in the windows, showing so plainly that they confuse the beginner.

What to put in and what to leave out is not an easy decision. Only experience will teach what really is essential and what should be subordinated or omitted. As a rule, the two characteristics of glass that we mentioned appear in combination: glass seems sufficiently transparent to see through it quite easily and yet has enough reflectiveness to give it a shiny appearance.

Sometimes this power to reflect neutralizes the effect of transparency to such an extent that we find it impossible to look through the panes at all. This is especially true in windows near the top of a building where the reflection of sunlight or bright sky is frequently so strong that it makes the curtains invisible or very indistinct. Such windows, and particularly those of the upper stories of very tall buildings, often take on much the same color and tone as the sky, and if the sun itself is reflected, the windows become dazzling. A reflected light cloud may make the glass almost white, while a blue sky may cause a blue reflection of a value similar to that of the sky itself.

If we observe the windows nearer the street level we find as a rule that most of them seem darker than those above, for in place of the sky reflections we now have those of buildings and perhaps trees. Bear in mind, then, that when rendering tall buildings (more fully described in Chapter 18), the general tone of the glass, taken as a whole, may often be correctly shown lighter in the upper than in the lower stories. It is true, too, that glass within shadow, or on the shady side of a building, usually seems much lighter than we would expect (a point which we touched on in referring to Sketch 7, Fig. 209). It is by no means necessary to represent it by a dark tone simply because it is within shade or shadow. Its light appearance generally occurs because it mirrors the brightness of the sky or some nearby building in sunlight.

This may all be rather confusing to the beginner. Surely, this last point about tall

Fig. 214. Buildings contain many possible details that should not be overlooked. They add great interest to the drawing.

buildings seems something of a digression in a chapter devoted to detail representation. However, we are anxious to emphasize that this very complexity in the appearance of windows in different positions and under varying conditions works somewhat to the artist's advantage. Although most other details of buildings, such as chimneys, steps, and doors, are fixed in tone — being either light or dark, and so demanding interpretation in more or less that way — windows may be suggested in almost any value that gives the best effect to the total drawing. If walls are dark, and light accents are needed to break the dark tone, the windows may be left light. If dark accents are needed in light walls, the windows may be made to furnish them. If little contrast is wanted, however, windows may be drawn light in light walls or dark in dark walls.

It is not enough, then, to do simply a few typical windows of customary value. You must learn to draw some light and some dark. You must have skill to handle some in which transparency is prominent, some that act as reflectors, and some that combine these effects. You must know how windows look both closed and open, and in sunlight and in shadow. You cannot, therefore, be content with drawing a few examples of individual windows, but should try many.

The illustrations in Figs. 207 and 212 show some typical window suggestions in sunlit walls. Others may be found in the drawings of buildings in the next few chapters. In this particular group most of the muntins or sash bars have been left white. This, combined with the dark behind them in places and a judicious use of shadow, produced the desired effect of sunlight. In most architectural renderings, buildings are shown in sunlight, so the draftsman usually learns to handle windows in this way first. The artist, however, needs to gain familiarity with the greatest possible variety of effects. Therefore, study many drawings and photographs and, above all, sketch actual windows, both indoors and out, frequently.

In Fig. 207 note especially the drawings of the same window in Sketches 1, 2, and 3. The first of these is a crisp, clean-cut delineation that is quite common to architectural work. The second is less mechanical and more suggestive. The third is much like the first, or perhaps more a combination of the first two. The principal difference between this and the first is in the placing of the largest dark accent, which at Sketch 1 is immediately below the window shade while at Sketch 2 it has been dropped to give contrast with the lower sash. You should sometimes try different suggestions of the same subject in the same way.

Doors

There is really little that need be said about doors. In Fig. 213 we have shown a number of typical examples, two or three of which, incidentally, were based on photographs. Try a number of sketches of this general type, either at this size or larger.

Miscellaneous Details

There are, of course, materials which we have not touched upon in this chapter, including logs and slabs of wood, corrugated iron, plastics, and many others. There are even numerous kinds of roofing materials such as asphalt and asbestos shingles, tin, copper, tar-and-gravel, and tar paper. Aside from such materials taken by themselves there are numerous details which we have no space to include. Not only are there larger things like porches, bay windows, and similar features, but there are also various odds and ends of similar interest. Hardware offers some fine subjects. Then we have weather vanes and the like. As examples of one of these smaller types of detail we show, in Fig. 214, a group of old rain-water leaders and heads from England. These particular sketches were done from photographs. We might add that there is no better way for the architectural student to learn a little architecture than by picking and drawing subjects of this type, arranging sheets of sketches of them for comparison.

Once you have gained a fair degree of skill in doing the kinds of building details shown here, you should be qualified to go on with the representation of complete buildings as discussed in the following chapter.

16. Architectural Rendering Methods

J. MacGilchrist

In the previous chapter we discussed the representation of such parts of buildings as doors, windows, and chimneys. To do even such details well is no small task, as the reader who has tried them is aware. This is particularly true if you work not from nature or from photographs, but—as the architect is so often forced to do — largely from memory. Difficult as this detail representation is, however, it is generally harder still to do an entire building, where many elements must be combined into a unified whole, with each part given just the proper emphasis. Even the architect or draftsman who is trained to make passable sketches of all the component parts of a building is frequently at a loss when facing the problem of rendering a complete structure, especially if the setting of the building with its accessories of trees, lawns, clouds, and people are to be included.

Our primary consideration in this chapter, therefore, is to offer some practical suggestions, addressed mainly to the architect and assistants (though they should prove no less useful to anyone interested in rendering architecture), as an aid in delineating complete buildings. These suggestions are intended to relate mainly to renderings of *proposed* buildings — structures which do not as yet actually exist. Many of them may be utilized equally well, however, in drawing similar subjects from photographs or from nature. We will apply these suggestions, in the next two chapters, to practical problems.

The Function of Architectural Renderings

First of all let us consider, as a starting point, a few of the reasons why drawings of this nature are made, for if we know their purpose we can judge better how to do them.

When the architect starts work on any new project of importance, he usually prepares, once his client's needs are understood, a number of preliminary sketches and studies of the plans and elevations, the sections, and sometimes a few of the details of the proposed structure. Small perspectives, often very crude, are occasionally made at the same time. These first drawings are usually partly freehand and partly instrumental in character.

From these numerous studies, a worthwhile scheme gradually evolves. Final studies are prepared and corrected and, when approved by the client, become the basis of the actual working drawings. These consist of very accurate and comprehensive instrumental plans, elevations, sections, and details. Blueprints of these working drawings — or contract drawings as they are sometimes called — together with the written specifications which accompany them, and occasionally a few additional details, are all that the contractor usually needs for guidance in erecting the building.

The client rarely comprehends these working drawings. They seem to him complicated and confusing. He cannot tell from them how his building will look when completed. Even the architect himself, though no doubt able to visualize the approximate final effect, is occasionally in doubt as to just how some parts of the structure will appear. Therefore, before the working drawings are finished and the contract let, they often agree to have a fully rendered perspective made, showing exactly what the completed effect of the building will be.

In a moment we shall have something definite to say about the actual drawing of this perspective. Just now we wish to make clear that if this drawing serves its intended purpose of clarifying the whole project — not only to the client but to the architect himself — it is really a most important piece of work. This particular use, however, is only one of many to which such drawings are sometimes put. If a building of considerable size — an apartment house or an office building, for example — is to be erected as an investment, bonds are often issued to cover the cost. In attempting to sell these bonds it has been found that the prospective purchasers are anxious to know how the building is to look. For this purpose, a rendered perspective of it is reproduced, usually in leaflet or booklet form, with plans and descriptive matter added (and often a model is made as well). The original perspective is displayed perhaps in some prominent place. These drawings are also frequently published in magazines and newspapers, all of which is not only good salesmanship for the bond house, but sometimes brings valuable publicity to the architect.

Drawings of this nature are not always rendered in pen, to be sure, though the pen is one of the most popular media for this kind of work, because it permits the necessary accuracy and completeness of delineation and makes possible a result which reproduces inexpensively and well. Such perspectives also harmonize nicely, both in original and reproduction, with the instrumentally inked plans which often accompany them.

The Initial Perspective Drawing

Now let us return to the method of making a typical rendered perspective drawing. Such a perspective is usually first laid out very accurately and completely by instrumental means, in exact accordance with the plans and elevations. This naturally demands that the draftsman laying out the perspective (he is not always the one who renders it) have a thorough knowledge of the science of in-

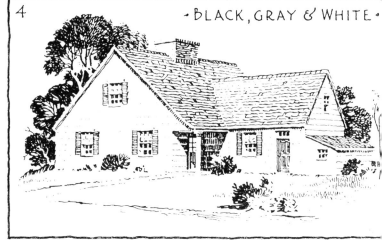

Fig. 215. These are typical methods of arranging values for architectural subjects. As a rule, combinations of black, gray, and white are the best.

strumental perspective and judgment in its practical application. The draftsman chooses a station point and an eye level which he thinks will show the subject in a natural and an advantageous way, and draws the building itself.

If the site has not yet been selected, the draftsman who renders the perspective usually composes one which seems suitable. Some knowledge of landscape architecture is of great help in such work. Often the site is already in mind, however, and if surveys or photographs are available, they assist the draftsman in laying out correctly the appropriate driveways and paths, streets, or sidewalks, as well as in locating the principal trees and other planting. They serve, also, to show what is on the adjacent lots and in the background.

Planning the Rendering

This brings us now to the point where the drawing is ready for rendering. The paper shows a carefully penciled preparatory outline drawing of the building, and an indication of the definitely known facts concerning the surroundings, or a suggestion for an imaginative setting. That is all. A few mistakes in the pen work, and this whole thing may be ruined.

This causes us to offer a word of advice. In rendering you should always be deliberate and thoughtful; the pen should never be touched to the paper until there is a distinct plan for the entire treatment in mind. Too often the draftsman starts the ink work in a rather reckless and haphazard way, trusting to chance that he will pull through all right. The draftsman begins by doing the roof, if this happens to catch his attention first. He copies the treatment, perhaps, from some drawing which strikes his fancy; he borrows his windows from another, his shadows from a third, and so on. When the building itself is finished, the draftsman decides that possibly a tree in back of it would help, so he puts one there, without any real reason for doing so, except that he has seen trees similarly used in other drawings. There seems to be an empty place in the lawn, so he copies a bush to take away the emptiness. With the bush in position another area looks vacant, so in goes another tree or bush or a fence or hedge. Finally he concludes that he has done enough; he calls his drawing finished.

Results obtained in this manner might turn out well, yet it is a faulty method. The experienced draftsman may, to be sure, seem to work more or less in this manner, but he has done many other drawings and knows just what results will be obtained. The beginner, however, will be wise to do much of the planning more definitely. Lay tracing paper over the instrumental layout as soon as it is completed. Thoughtfully work out in pencil, observing the suggestions for composition made below, a reasonable treatment, erasing and changing as often as seems necessary. Study drawings by others, but don't thoughtlessly copy from them. Instead, try to see the reasons for each thing that has been done in them. This pencil preliminary, when finished, will then stand as a guide for the pen rendering.

In doing all this, never lose sight of the fundamental purpose behind the drawing: to express the architecture accurately and pleasingly, and honestly, rather than trickily. Whatever you draw should contribute in some way to this expression. The trees, shrubs, clouds, and flowers common to such renderings do not exist for themselves, for instance, but only to form a setting for the architecture. This is also true of everything entering into the composition.

Determining Direction of Light

With this essential fact in mind, the first thing to do is to decide on the direction of the light, as this decision will control the entire effect. Shall it be brought from the right or the left? If two sides of the building show, will both be in light, or one in light and the other in shade?

No one but the artist can settle this. Owing to the labor involved in covering large paper surfaces with the pen, however, and the unpleasant effect which so often results when this is done, we are inclined to advise the beginner to employ as few shade and shadow tones as possible. This usually means keeping both sides of the building in sunshine. There are exceptions, of course, as in all things.

Once you have decided on this point, the architectural shadows should be bounded on the instrumental layout with rather definite, though not too black, pencil lines. To locate each correct mass is far from easy, and unfortunately even the customary knowledge of architectural shades and shadows is of little help here. Yet the shadow shapes, as we have explained elsewhere, often perform a vital function in expressing the architecture itself, besides determining in a large measure whether or not the appearance of the composition will be pleasing. So you must draw the shadows as well as you can, working thoughtfully and studying actual buildings, or photographs of buildings similarly lighted, as an aid.

Fortunately, people are seldom over-critical of shadow shapes, as they know little about them. Gradually you will acquire a knowledge of the typical forms as they appear with the sun or other sources of illumination in different positions. Even with this knowledge you will still use your judgment, often deliberately doing things in the way which you think will give the best effect even though by so doing you sometimes take liberties with nature so far as some shadow shapes and sizes are concerned. It is seldom that the shadows in an architectural rendering, even when done by an expert, are drawn exactly as they would appear on the subject itself at any one moment; they often compose better if somewhat changed.

Fig. 216. Spots in the abstract are interesting. These were made partly by dropping ink onto the paper and partly by touching the back of the wet pen.

Fig. 217. The possible variety of spots seems endless. These were made by spattering an over-full pen onto a tipped sheet of paper.

Fig. 218. Fingerprints can also form spots.

Fig. 219. Another form of spot is made by rolling an inked stick across the paper.

Fig. 220. Note the individuality in all these spots. These were formed by dragging the side of an inked pen along the paper in a jerky way.

Fig. 221. These spots were made symmetrical by folding the paper over a spot and pressing down.

Determining the Key

Once the direction of light is determined and the shadow forms are outlined, decide on the general pitch or key of values of the entire rendering. Is it to be very light, neutral gray, or rather dark? Generally it is much easier to do extremely light renderings than dark ones, mainly for two reasons. First, a light rendering may be left largely in outline or in outline combined with simple tone. This requires few lines, and to work in few lines means that no time is wasted. Moreover, the fewer the lines the less the chance of showing your lack of skill, as a general thing. Second, poor composition, even if it does exist, is much less conspicuous in light drawings than in drawings where dark values predominate.

In order to play safe, then, the beginner would be better off avoiding dark values at first. A dark drawing, on the other hand, or rather a drawing with strong darks in it, is usually more interesting and convincingly real and the sunlit portions, contrasting against some of the dark tones, will appear more brilliant and natural.

This comparison is made clear by a glance at Fig. 215 which was drawn (and incidentally at the exact size reproduced here) for this very purpose. Here in Sketch 1 is a house in simple outline—all white. In Sketch 3 the same is shown in strong contrast of black and white. In a drawing like the latter one, poor arrangement of the dark values would be noticed at once. These two drawings represent extreme conditions. As a rule more contrast is desired than in Sketch 1 and less than in Sketch 3. This may be brought about by introducing gray, as in Sketches 2 and 4. The drawing in the second sketch is entirely gray and white in effect. It has a richness and solidity which is lacking in Sketches 1 and 3. In many places such a drawing would be entirely satisfactory. As a general rule, however, the most interesting drawings from the architectural standpoint are those which compromise by introducing all three values, black, gray, and white, as in Sketch 4.

Obtaining the Values

When you have decided on the approximate pitch or key for your drawing — whether it is to be kept almost white or gray or very dark, or whether it is to be the more usual combination of black, gray, and white — pause for a moment to consider what such values ordinarily represent in drawings. To put it differently, figure out how these values may be naturally obtained. It makes no sense to add meaningless areas of tone without considering the things they stand for.

Values may be obtained mainly in two ways. First, through the use of the normal local color of material (expressed in tones of black, gray, and white, as the colors cannot be expressed in pen in their natural hues); second, through the employment of tones representing shade and shadow. To state it differently, in some drawings, the values represent merely the natural tones of the materials used in the objects represented. In others they indicate simply the light, the shade, and the shadows—nothing more.

The layman, and not infrequently the beginner, is apt to be more conscious of these inherent tones of the materials themselves than the light and shade values. Knowing that bricks are red, for instance, the novice feels an inclination to draw them that way. Knowing that grass is green, too, it seems awkward to think of leaving it white. But red bricks in bright sunlight often appear more of a warm pink or orange hue, which in terms of pen and ink may be safely left light gray or even white. The tone of grass, when similarly lighted, appears relatively so light that it, too, may often be ignored. The same bricks or grass in shadow, on the other hand, might be correctly represented dark gray, sometimes nearly black.

There are times when it is advisable to take full advantage of the local color — now and then a complete drawing is made which depends entirely on the correct tone of the materials for its effect. Sometimes, on the other hand, it is enough to use only the shade and shadow tones, entirely neglecting the local tones of the materials. Study our example of this method in some of the sketches of little boxes in Fig. 93. For another example, this time of a more architectural nature, see the Neapolitan sketch, Fig. 159. In this sketch the entire effect is gained by rendering the shadow tones alone, except in the figures, where the local color of the clothing produces darker values. Most drawings are a compromise, however. Local colors are suggested in many places but ignored in others, while the tones of light and shade and shadow are also varied to meet the needs of the artist.

Arranging Values

Knowing that we may create our values naturally in one of these two ways, we come to what is the most important, and probably the most difficult question of all: how to compose or arrange these values. For it is not enough, as a rule, simply to give each area of the paper surface a tone which might be a reasonable representation of the thing which that particular area represents. Instead we must adjust the entire composition so that it tells its story directly and pleasingly.

Now a pen drawing, when thought of in the simplest way, is nothing but a spot on a sheet of paper. A complex spot, to be sure, being broken up into many smaller spots of varying size and force — but a spot, nevertheless. If the rendering is carried all the way to a margin line, that spot as a whole takes a rather definite geometric form, within whose boundaries there is variety of shape and tone. If no margin is used and the whole drawing is vignett-

Fig. 222. These are simple designs of spots stamped on a paper in a systematic arrangement with pencil erasers cut to these shapes.

Fig. 223. These spots have been arranged asymmetrically, but arranged nevertheless.

ed, a treatment more typical of pen work, the entire drawing is often simply a spot of irregular rather than geometric shape. Within this, too, there are other smaller spots of varying value.

Spots themselves — even taken in the abstract — vary greatly in interest when considered solely from an esthetic standpoint. Spatter ink on a sheet of paper, for example, and some of the drops will form more interesting spots than others. If a hundred such spots were collected and submitted to a jury, the jury members would most likely agree on a half-dozen or so as being the most interesting in the lot. For further examples illustrating this same point, look at Figs. 216 to 220. Some of the spots in Fig. 216 were obtained by dropping ink onto the paper, and some by touching the back of the wet pen. They are simply blots such as we ordinarily try to avoid. Fig. 217 was made by jarring spatters of ink from an overly full pen onto a tipped sheet of paper. Fig. 218 explains itself. Fig. 219 was obtained by rolling an inked stick along the paper. Fig. 220 was formed with the eyes closed, by dragging the side of an inked pen along in a jerky way.

This entire row of spots is rather interesting, in a sense. It suggests among other things the endless variety that may be obtained by unstudied means. The next group (Fig. 221) is also of interest as a group of symmetrical spots. They were made in an equally unstudied manner, simply by spattering ink onto paper which was immediately folded and pressed flat until the drops were forced into the shapes shown.

Many of the conventional designs which we have are much like these symmetrical spots in general scheme. Most architectural renderings, on the other hand, are like the less regular spots in the first row It is seldom, however, that either a conventional design or a rendering consists of one spot only. Fig. 222, for instance, shows simple designs of spots stamped on paper in systematic arrangement with ordinary pencil erasers cut to the shapes shown. Generally when renderings are made up of more than one spot, the spots—instead of being arranged in some set way like the rows just considered—are arranged according to the practical requirements of making the subject understandable and interesting. As examples to show how renderings may be reduced to a few spots, see Fig. 224. Note that even these black masses — though studied to some extent in shape — are no less spots than those in the previous sketches. They are as informal as Fig. 223 which, though not so obviously arranged as those in Fig. 222, nevertheless, are still arranged. Our last four examples, in Fig. 224, are on the whole fairly interesting spots individually, and well arranged collectively.

Let us now see how you are going to profit from all this in making your tracing paper study, and eventually your final rendering. First try to have your en-

Fig. 224. Rendering of buildings may be reduced to spots. These spots have also been arranged, but in such a way that they take on an additional meaning.

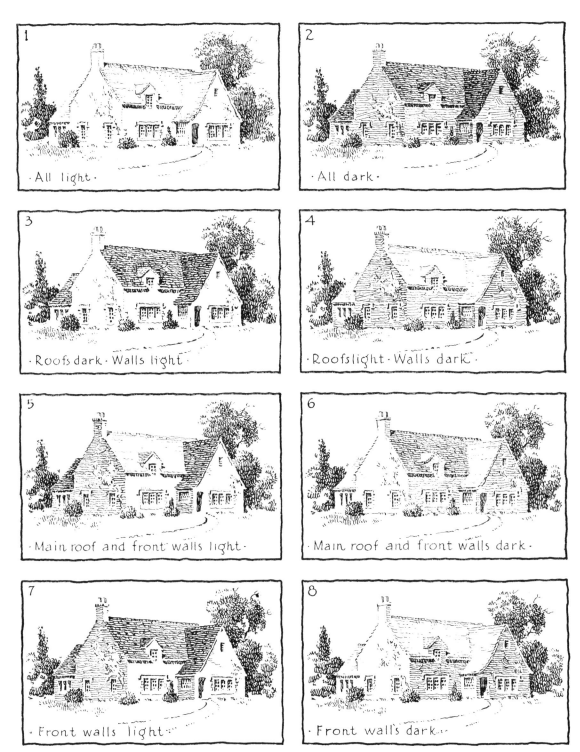

Fig. 225. Here are a few of the possible value arrangements for a single subject. With different surroundings, innumerable schemes would be possible.

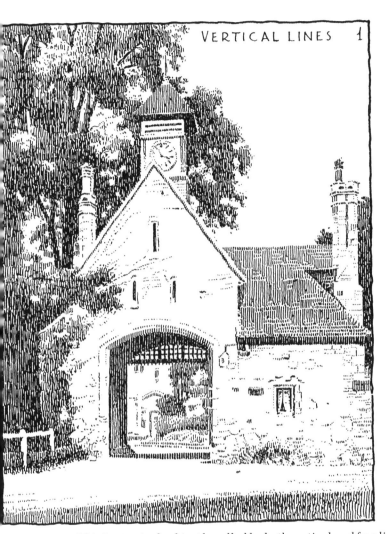
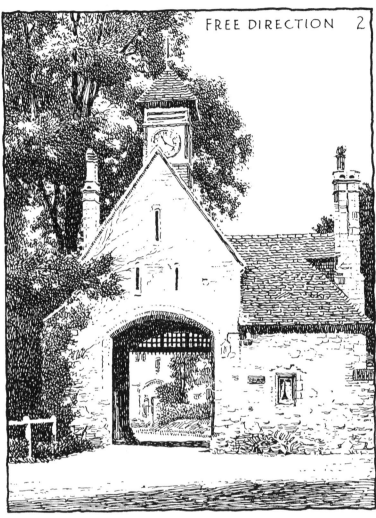

Fig. 226. This is a typical subject handled by both vertical and free line methods. A free method, being more natural, is generally preferable.

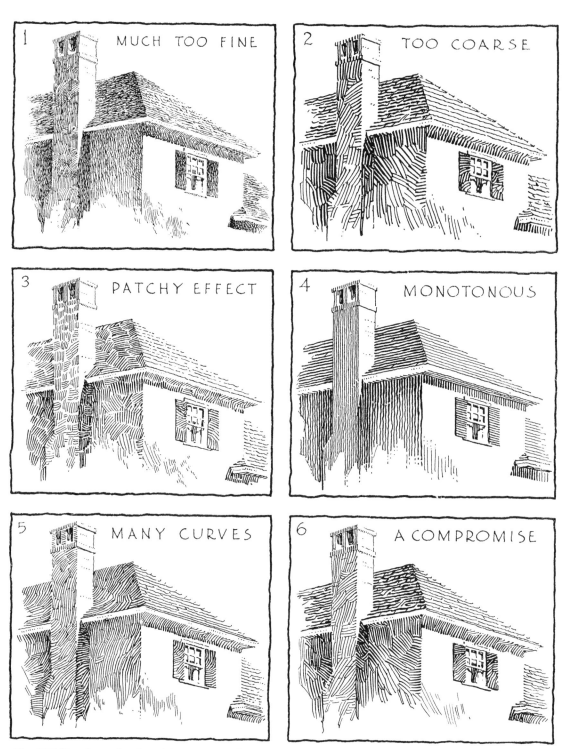

Fig. 227. Render a simple subject in several ways. Here are some sample methods you might try.

tire rendering form a spot or pattern of interesting shape against the background. This will not be a black spot, of course, like those we have observed, but it should be interesting nonetheless. If a subject is architectural and the building itself of irregular contour, its very silhouette may give all that is desired in forming a spot of major interest. A plain, blocky building, on the other hand, may form so uninteresting a spot that it seems very commonplace. Here the addition of pleasingly shaped clouds or trees or adjoining buildings or accessories of some sort may prove helpful in creating a pleasing form. In your preliminary sketch, then, work until you have an interesting (though at the same time not overly complex) general mass. This can be done in soft pencil or even charcoal.

When the sketch as a whole seems to form a pleasing spot, or at least has its elements so arranged that they seem to become one, consider its subdivision into smaller areas or spots, each of which has a certain amount of interest and yet at the same time contributes something to the pattern or design of the whole. The essential thing to keep in mind is that your architecture must be expressed logically, and you must make of your sketch a well-shaped pattern of interesting spots.

Unfortunately we can say little about how you can know when your mass is interesting either as a whole or in its subdivisions. If you make several sketches and compare them you cannot fail to select the best, so this is the ideal way if you are in doubt. Sometimes the whole sketch is recomposed in doing this. Sometimes, on the other hand, the various units are left exactly where they are, but the values are arranged differently.

Look at Fig. 225, for example. This sheet gives some idea of the variety possible in spotting or value arrangement, even when all the masses remain fixed in position. Here are eight sketches, each quite different from the others, yet the spot that the entire mass makes against the paper remains constant in shape in each of them, except for minor and unintentional differences. In fact, the landscape setting was intended to be the same in all. Imagine the unlimited variety which would be possible in this subject if different settings were introduced.

The Final Check

Once the selected preliminary sketch has been pushed to the point where it seems to offer possibilities for satisfactory pen work—with every essential included that is to be shown on the finished work—the actual rendering may be started. As one final test of the preliminary, however, it is advisable to hold it up to a mirror. Seen in a reversed position, the effect will be quite different. If it does not compose well change it until it does, for as a composition it should appear equally well either way, or even upside down, for that matter. While doing the pen work itself, you might reflect the final drawing now and then in the mirror in the same way as it progresses, and again when finished.

Viewing a sketch through a reducing glass is also a help many times. (Too often, however, a sketch looks better through such a glass than without it.) Having made the best possible preliminary, don't wander too far from it in the final.

Concerning Pen Technique

Always use the technique which seems to naturally express the subjects. As a general rule, such freakish methods as carrying all the lines in some one direction are bad. There are sometimes exceptions. Turn to Fig. 159. You will see there that most of the lines of the entire composition (except in the foreground) are vertical in general direction. This was not done intentionally, but resulted from the attempt to render the subject naturally. Fig. 226 shows in Sketch 1 a drawing from a photograph deliberately done with vertical lines. Comparing this with Sketch 2 you will see that in most places it was possible to get a very fair interpretation of the subject. The values tend to run a bit lighter in the absence of crosshatching.

Now and then in outdoor subjects slant lines drawn in the direction of the light rays give good effects, especially where shadow tones are prominent. A rainy day sketch, too, may be done very nicely with all the strokes following the direction of the rainfall. Generally speaking, however, avoid slanting strokes in large areas unless you wish them to seem very restless and conspicuous. If one general direction is used, a vertical line is better as a rule than any other.

Fig. 227 has been drawn to illustrate a few more hints on rendering architecture. In Sketch 1 a commonplace subject has been rendered, at the exact size shown, with a very fine pen. There is nothing very objectionable about this drawing as it stands. To do an original drawing in this way, however, would be foolish; it is too fine. In rendering architecture the draftsman is usually aware that the drawing may be reproduced, and if so it is almost sure to be reduced when published. The technique should be established accordingly. In all pen work a great deal depends on the probable amount of reduction. If Sketch 1 were reduced, the rendered areas would fill with ink and print as almost solid black. Sketch 2, which is marked "too coarse," would not be considered coarse if it were to be considerably reduced in reproduction. For the typical architectural rendering, the second sketch would be preferable to the first. In fact, to do a whole building with as many fine lines as Sketch 1 would be unwise. Sketches 5 and 6 offer reasonable compromises. These are not a bad size as drawn, yet they are sufficiently "open" to stand considerable reduction.

Sketches 3 and 4 explain themselves. The beginner often makes so many detached patches of tone by constantly changing the direction of line, leaving little whites between these patches, that the effect of the whole is restless, as was illustrated in Fig. 40, as well as here in Sketch 3. Total avoidance of little breaks and variations, however, as in Sketch 4, usually gives a monotonous result; a compromise is better. Though Sketch 5 has lines in many directions, some of them curving, the effect is not overly conspicuous, as the lines touch in such a way that they form a comparatively simple tone. Some artists curve their strokes very freely; others make them nearly straight. The danger in the first is overcomplication of tone; in the latter, monotony. The beginner should work for a happy medium in all these matters.

17. Rendering the Complete Building

Olaf Shelgren

In the previous chapter we pointed out some of the reasons why renderings of buildings are necessary, called attention to the customary general method of procedure in making them, and finally offered a number of specific suggestions on composition and technique related to such work.

This chapter is a continuation of that, for here we apply some of those suggestions to a number of definite problems in the rendering of small buildings. Before approaching these, however, we will reconsider some points discussed earlier, adding a few as well, mainly concerning composition. If you have not read Chapters 10, 15, and 16 do so before attempting the work described here.

We have spoken of the fact that some spots on paper, taken either singly or in groups, are much more interesting than other spots. We have explained, too, that a sketch or rendering is, in a sense, nothing but a spot, sometimes simple but more often complex, being made up of several spots grouped to form a whole. We have advised you to try to make of each drawing a spot or mass pleasingly shaped in itself and nicely subdivided or broken up into other interesting and well-arranged spots—well composed, in other words. We have also offered a few pointers to help you accomplish this. We will now take this point a bit further.

Arranging Values

In representing architectural subjects, it is necessary to emphasize the architecture so that it is seen and understood quickly and easily. One of the most common devices of shifting attention or giving emphasis is through contrasting values of light and dark (see Chapter 10). As in other subjects, values in architectural drawings represent the local colors or tones of the materials, or light and shade

and shadow, or a combination of some or all of these. In a rendering of a building, the most important task, once outline construction is completed, is determining or selecting and arranging these values. There are exceptions, of course. Now and then a building is entirely represented in pure outline, as is suggested in Sketch 1, Fig. 215. Barring rather rare exceptions, however, when the draftsman has a building drawn in ruled pencil outline ready for the rendering, his thoughts run something like this: "This building is a light-colored building. It has comparatively few conspicuous windows or other openings to break up this light tone. It has a flat roof which is invisible from where I stand, so the building as a whole counts simply as a light mass or spot. The easiest way of rendering it, along with its surroundings, would be in outline, assuming the entire building is in sunshine (Fig. 228).

"This, however, would not attract much attention to the architecture, which is what I want to emphasize. I must get more contrast. A logical way might be to leave the building as a light silhouette against a dark background (Fig. 229). This background tone could represent anything within reason—trees and grass, sky, and perhaps other buildings. To put in a complete background of tone would take a long time and my time is short. And I am not certain that I could manage it well. Even if I did, the composition might seem rather ordinary and the contrast of light against dark too obvious. Perhaps it would be better all around to darken only the part of the background where contrast seems most needed, still keeping the building light as a mass, adding outline to the portions of the building that seem to require it because they are not in relief against this background tone. I must be careful to shape the trees or whatever areas of dark I use in a natural and pleas-

ing way, because they will count conspicuously as dark notes against the paper. Perhaps I had better try more than one scheme in small sketch form in order to see what arrangement would be effective (Figs. 230 and 231).

"There. I think either of these schemes might be worked up to good advantage, but I am not strong on representing foliage. Perhaps in this case it might be better to change the direction of the light so that this end of the building nearest me would be in shade; the shade tone might then give me almost all the dark needed and I could leave the rest of the building and the trees practically in outline (Fig. 232).

"Another scheme would be to draw the near end of the house in shade but to put a dark tree behind the other end to bring the front of the house out as a white spot against these two dark accents. If I did this, it would be better composition, I suppose, to have one of these darks predominate (Fig. 233)."

For a building as plain as this it is seldom enough to draw merely one light and one dark wall as in Fig. 232. A tree or two or some other dark tone or tones is also needed. But buildings with projections or wings often offer a sufficient variety of planes so that natural shade on some of them not only gives sufficient contrast of light and dark for the entire sketch but affords at the same time a pleasing spotting of it. Fig. 234 offers an illustration of this condition. This sketch, by the way, suggests in a very simple manner the value treatment used by Kates in his sketch heading Chapter 5.

Up to this point we have been dealing with the plainest sort of light-toned blocklike buildings, but most buildings offer in themselves a more interesting variety of values. Windows with shutters usually form contrasting spots, for instance, as do doors, foundation walls,

Fig. 228. A light building of simple block form is much like a white spot. It may be rendered in outline.

Fig. 229. A white building may be left white against a contrasting background.

Fig. 230. A white building also may be done partly in outline and partly in contrast.

Fig. 231. Here is another possibility for handling the white building.

chimneys, etc., while roofs, when visible, are often strong enough in opposing values to provide fine contrast with the walls. Sometimes a simple roof like the one in Fig. 235 will do the trick of providing sufficient contrast of a major kind, though ordinarily a single dark area of this sort is too conspicuous by itself. A much better effect would be obtained if another dark area of a different size and value is added somewhere else to supplement it. In Fig. 236, for instance, the gray tones of the grass and bushes nicely balance the tones of the roof, so the whole does not seem top-heavy. When there are a number of roof planes, however, which happen to be well distributed, the dark of them will often give splendid contrast with the light walls and sky, and well-composed "spotting" besides. Fig. 237 illustrates this point.

In many other instances roofs of this nature look so dark, however, and attract so much attention that, unless they are shown much lighter, some additional tones are needed to balance them. Sometimes it is better to use some wall tone with even very simple roof tones. Fig. 238 illustrates this, the gray end walls of the house and porches keeping the dark tones of the roofs from staring out too strongly against the paper surface. If these end walls had not been darkened, trees or some other dark spots would have been required to provide the proper balance, as in Fig. 239. Even the subject shown in Fig. 234 would compose better with trees added to offer contrast at the right, as suggested by Fig. 240.

So far we have assumed our buildings are constructed of some light material, such as stucco or clapboards. Let us now assume, instead, that dark buildings are to be represented. A dark building is more difficult to do in one respect than a light building: a greater amount of work is needed to suggest a brick wall or any deep-toned or complex material than some lighter or plainer one. On the other hand, once a dark building is rendered, the tonal arrangement is satisfying, even though the surroundings are almost untouched. This means that only a few outline or light tone indications of grass and trees are needed to round out the whole. Whereas the building itself frequently requires more time, the surroundings usually demand less, a thought illustrated by Fig. 241.

Notice that in this last sketch the roof has been left light. As a matter of fact, roofs may be suggested at almost any convenient value without seeming wrong or inconsistent. This is because roofs themselves actually do vary greatly in effect under different lighting conditions and, when seen from various points of view, we all become accustomed to these diversities. If the walls of a building are light, therefore, and dark areas are needed in the drawing, the roof planes offer a natural place for one or more of them. On the other hand, if a building itself is shown dark the roof is frequently left

Fig. 232. Like a cube, a white uuilding can show one end in shadow and the rest mainly in outline.

Fig. 233. One end of the building may be in shadow, and the other against a background.

Fig. 234. Here an end and wing of the building are in shadow, while the rest of it appears in broken outline.

Fig. 235. The roof alone often offers sufficient contrast to the white of the building.

Fig. 236. Here tone is added to the base of the roof for additional contrast.

Fig. 237. Complex roofs offer better contrast than simple ones.

Fig. 238. Roof and shadow tones together are often sufficient.

Fig. 239. The same house all in light tones might need trees behind.

Fig. 240. Here is the same building as shown in Fig. 234, with trees added behind.

Fig. 241. Dark buildings often provide enough contrast.

rather light by way of contrast. These thoughts are still further emphasized by Figs. 242 and 243. Liberties of this nature may be taken not only with roofs, however, but with many tones. Trees, especially, may be made of almost any value from white to black to suit your convenience. It is not uncommon to vary the tones of trees and bushes greatly even in the same drawing (see Fig. 244), and this is natural, for actual trees as seen in nature do show much variation. Not only does one tree vary in value from another, but the tones of a single tree are often seen to grade, for a tree is far from being a flat mass in effect, as was explained in Chapter 14.

Trees are by no means alone in showing gradation of tone, however. Even such things as walls and roofs, and many other surfaces that are actually flat, give a similar impression almost as much as surfaces that are rounded. This means that the draftsman, in working for desired contrasts to bring out the architecture to advantage, and in striving for an interesting arrangement of lights and darks, can often fall back on gradations of tone, thus sharpening or softening his values almost at will. Fig. 245 illustrates this thought, though somewhat inadequately. As a splendid example of the use of graded tones for bringing about contrasts where desired, refer to the drawing by Goodhue (Fig. 247). Here the left side of the building is shown practically white, surrounded by a gray of clouds and foliage and shadows. Towards the right, the building has been gradually darkened, especially along the roof and chimneys, until it counts as a dark tone against a white sky. Notice how contrasts have been skillfully arranged in many other parts of the composition, several of them through gradation of tone. See how the hedge has been handled, for instance, in such a way that light counts against dark and dark against light along its entire length.

The artist who renders architecture often has a decidedly different point of view from the architect. Instead of trying to emphasize the architecture as a center of interest, for instance, the fine artist often subordinates it or in some cases suppresses it almost to the point of extinction (see Fig. 246).

Of course it is sometimes impossible to take some of the liberties we have described, such as putting trees wherever they happen to be wanted. If a definite building is being pictured, for instance, which has existing trees about it—or will have when built—and an accurate drawing is desired, those trees cannot always be moved to meet the spotting requirements of the sketch. On the other hand, after a reasonable amount of practice, you should be able to obtain a pleasing composition for this kind of subject either by carefully selecting your viewpoint or by adjusting the values of these fixed accessories together with those of the building itself.

Fig. 242. With light walls, roofs are often dark for contrast.

Fig. 243. With dark walls, roofs are frequently left light.

Fig. 244. Trees may be made of almost any desired value.

Fig. 245. Roofs and walls are often graded to obtain contrast.

Fig. 246. The artist does not try to "force" his architecture.

Fig. 247. Bertram Grosvenor Goodhue: This drawing of the St. Peter Parish House in Morristown, N.J., is forceful in its contrasts, sunny, extremely simple, yet adequately suggestive of detail.

Fig. 248. Louis C. Rosenberg: Here we have a rendering that excels in its economy of means. Lewis E. Welsh, Architect.

Try It on Your Own

If you have followed this chapter so far, as well as the previous three, and Chapter 10 on composition, you should have the background to compose the simple architectural subject, especially if you have studied the drawings in these chapters as well. Don't forget, however, that you will save time in the end and achieve better results if you make a preliminary sketch as we described in the last chapter.

Once you have made a sketch for rendering, you can turn your thoughts fully to technique, which, until the preliminary sketch is finished, need scarcely be considered at all except in a most general way. We have already discussed technique in other chapters at length. Again we repeat our previous advice that the best technique, after all, is the one that directly and naturally expresses the subject. Of the two things, composition and technique, the former is more important by far.

Learning from the Work of Other Artists

Now let us turn to the accompanying illustrations for a moment and consider a few of the outstanding facts about them. Since we have already said so much of general nature on this subject, our present comments will be rather brief. You are urged to analyze each drawing for yourself, keeping in mind the suggestions already offered in this and recent chapters.

Rosenberg: Economy of Means

First let us look at the drawing by Louis Rosenberg (Fig. 248). The point which we wish to repeat here, and most strongly emphasize, is that this drawing is exceptionally simple in its handling—a highly commendable quality. The building is stucco and this has been sufficiently indicated by a few dots of the pen applied sparingly on one set of parallel planes. Note that throughout the entire drawing little outline has been used, the forms having been cleverly suggested in the most economical way. The treatment is largely a matter of intelligent omission: only enough drawing has been done to make the whole clearly understood.

It takes perhaps broader insight and greater skill to indicate or suggest than to work in any other manner. You should, therefore, study this drawing inch by inch, looking at every detail—the doors, the windows, and the chimneys. See how adequately the tile of the roof has been expressed, yet the means of expression is most simple. And despite the relatively small amount of pen work in the entire drawing, most of the paper remaining white, there is no sense of lack of "color," for the darks which have been used, as in the shadows, are sufficiently strong and crisp to enrich the whole. They are also so well composed that they produce excellent balance. It would be splendid practice for you to copy this drawing in whole or in part. Then try to treat some subject

from a photograph or from nature in a similar way, seeing how much can be omitted without losing the clear expression of the whole.

Yewell: Using Darks for Contrast

It would obviously be impractical and undesirable always to make renderings as light and as simple as the one by Rosenberg. Buildings of dark material, such as brickwork or stonework, usually demand more detailed representation than that required by structures of stucco. Even these materials, however, may sometimes be simply treated. In the drawing by J. Floyd Yewell (Fig. 249), for example, the end wall is apparently brick or brick partially covered with stucco, or stucco with a few bricks showing through, as has been indicated by the chimney technique. Whatever the material, the house is obviously white, the larger surfaces having wisely been left so. Where the wide siding is employed it has been honestly suggested with a few horizontal strokes.

The outstanding difference between this drawing and Rosenberg's is not in any of these details of the house itself, however, but rather in its greater dependence on dark areas, particularly in the trees and hedge. Using these darks, Yewell has made the house as a whole seem very brilliant through contrast. Remember, when dark areas are used you must be most careful of your composition. Regardless of how excellent the technique may be, values must be well arranged if they are conspicuous in contrast, otherwise the results will be poor.

Lewis: Controlling Complex Line Work

Brick buildings which are customarily dark are perhaps less easy to do, as we have just remarked, than those finished in plaster or clapboards or even in light brick. At least they demand more patience, especially if all of the brick areas are covered with line work as they are in Schell Lewis's drawing in Fig. 202. It is only too easy to obtain an effect that is too complex. Despite the number of lines Lewis has used in his brick tones (as well as in his slate areas), however, the tones themselves do not seem complicated. Notice, too, the simplicity in the treatment of the cornice shadow — a tone so evenly graded that you are scarcely conscious of the lines that make it up.

The handling of the trees is also particularly successful. These trees are not simple, yet relatively speaking they are, for little has been done to them in proportion to the excellent effect obtained. Note the large areas left white. The shadow treatment in the foreground is interesting, too: the horizontal lines on the street and sidewalk (expressive of the flatness of the surfaces), the slanting lines on the vertical plane of the curb (following the general direction of the light), the up-and-down lines on the grass, and the slant lines and patches of bricks drawn on the wall.

Notice the skillful way contrasts have been used in this drawing. First the entire house has been shown as a contrasting silhouette against an unbroken white sky, but grading lighter towards the bottom (including vines, bushes and all). This handling permits the fence, together with the darker adjacent foliage, to show in relief against it. The two larger trees are arranged to form a sort of encircling frame (somewhat similar to parentheses) around the whole. Then there are innumerable minor contrasts which are also noteworthy. Study the iron fence, for example. In order to make the gateway important, the gate is drawn in dark contrast against a relatively lighter background, the whole flanked by dark bushes as further accent, the iron work of the fence being left white where it comes against these bushes.

Again, to focus attention on the entrance to the house itself, the fence has been thrown in dark contrast against the light steps, the light area of the steps and the door being flanked by dark bushes the same as the entrance gateway. As you follow the fence itself along you find it constantly changing, first dark against light, then light against dark, and then back again. You will benefit greatly by carefully studying the Lewis rendering.

Powers: Versatility in Handling

We next call attention to the rendering by Richard M. Powers (Fig. 250). In order to show you the exact character of the technique we have also reproduced in Fig. 251 a detail of this drawing at the full size of the original. In this drawing, as in Lewis's example, tone has been carried over practically all of the wall and roof areas. It is not the house itself, however, to which we direct particular attention, but rather to the surroundings, which are given somewhat more than customary care. Note the trees in particular. Observe the "hooked" effect of many of the lines used in representing the bark of the larger tree, these strokes being somewhat like some of those in our early pen exercises in Fig. 32.

In Fig. 252 we show another delightful example by Powers, which, like the first, has been given a very thorough and conscientious treatment. (A portion of this is reproduced at full size in Fig. 253.) In this example we again have a painstaking rendering of nearly every detail, each one handled in a most interesting way. Particularly interesting are the tall trees which form so pleasing a silhouette against the sky; the treatment of the vines and flowers is also worthy of special attention, as is the somewhat unusual use of the slanted lines in the close-knit foliage background.

As you study these drawings you get the impression that an immense amount of labor was involved in producing them. If you assume that Powers always employed this painstaking style, however, look at Fig. 254 by the same artist — an example quite different though no less pleasing.

Fig. 249. John Floyd Yewell: The sketchy suggestiveness of this handling is partly responsible for the delightful atmospheric quality of the whole.

Fig. 250. Richard M. Powers: This is a design for a roadside tavern which was submitted for a competition. Patience, sound judgment, and rare technical skill are blended to produce an effective result.

Fig. 251. Richard M. Powers: This detail of the rendering shown in Fig. 250 is reproduced at the exact size of the original to provide a clear conception of the technique used by the artist.

Fig. 252. Richard M. Powers: Instead of "forcing" his architecture, Powers blended it into the surroundings effectively.

Fig. 253. Richard M. Powers: This detail of the drawing shown in Fig. 252 is reproduced at the exact size of the original drawing, and reveals the studious care used. Notice in particular the slanting lines.

For here we have a treatment completely different from the other examples of Powers' work. Not only does the technique show far greater variety in kind and direction of line, but you find a unique tonal quality—a sort of "painted" quality —due in no small part to the free employment of crosshatch and to the absence of large areas of white paper. As a detail, it is interesting to note that there are almost no long, unbroken lines. The whole thing seems to have been naturally and quickly done, yet without the rigidity and wiry characteristics so often common to quick pen sketches.

When you have carefully compared this drawing with his others, try to retain a mental impression of the outstanding points of difference, for in your own work you will need to develop similar versatility. Some subjects, requirements, or moods demand one treatment, and some another. Unless you can judge which treatments to use under different circumstances, you will be handicapped.

Price: Darks for Brilliance

Chester B. Price is an artist who also handles his pen in a very clever way, as is evidenced by the example of his work in Fig. 255. Notice that in this drawing more dark tone has been introduced than in most of the others so far shown, much of this being confined to a single leading dark area of trees. This use of dark is characteristic of much of Price's work, giving it a strength and brilliance which are often lacking in pen work when lighter values are the only ones employed. Price's rendering, by the way, is in no sense "tricky." He works for a straightforward presentation of his subject. He lets his technique take care of itself with the result that his work is individual and at the same time convincing.

Keally: Technique with a Purpose

Another drawing original in its treatment is that by Francis Keally (see Fig. 256). Here, again, we have considerable use of dark tone, employed in a way that emphasizes the effect of sunshine in the whole. Technically the drawing is interesting, too, for when Keally draws, he concerns himself mainly with the general impression he desires for the final rendering, using techniques that best serve his purpose. He sometimes uses a knife, for instance, scratching through portions of the pen tones. This was done in a number of places in the darker trees at the right of this drawing.

Bearse: Presenting the Architectural Concept

P. E. Bearse was the artist of the architectural subject in Fig. 257. This, like the other examples to which we have referred, is a typical handling of a proposed building, offering sufficient detail to make the architect's design perfectly understood by the client. There is no question here but that the architecture is the center of interest. The values, though dark, are well disposed; there is also a pleasing contrast in the foliage treatment between the trees and shrubs in the distance and those near at hand.

di Nardo and Dise: Emphasis on Architecture

As an excellent example of the rendering of a proposed house of stone, we show in Fig. 258 a drawing submitted by Antonio di Nardo and J. Ivan Dise in a competition. This is a particularly well-composed rendering. The main wall of the house, being left white and surrounded as it is by the grays of the roof, the trees at both ends, and the darker wall below, appears unusually sunny. The stonework itself is handled pleasingly, both in light and shade. The foliage, too, is done with exceptional skill. The simple shadow tone within the nearer porch archway is a detail worthy of consideration. Note, also, the way in which the vine just below it has been kept light along the top, which not only adds to the effect of sunshine in the whole but likewise creates a feeling of detachment, giving the house a sense of actually being behind the wall.

Long: Air and Sunshine

Air and sunshine are expressed to an unusual degree in the rendering by Birch Burdette Long in Fig. 259. Ths is largely the result of the value arrangement, the dark foliage masses at the left and the strong foreground shadow standing in contrast with the light tones of the building and lawn. The rather free pen work, particularly in the foliage, has a vibratory character which contributes to this impression, as do the broken and dotted lines employed in the building itself. Note the consistency with which the direction of the light is suggested.

The student's usual tendency in attempting such subjects, especially when they are laid out at large scale, is to do too much. This drawing, together with many of those on nearby pages, proves that you can simplify in various ways, as by leaving considerable white paper, and yet obtain a fully adequate expression.

Williamson: Decorative Rendering

This thought is again well illustrated in the drawing in Fig. 260 by Russell Barr Williamson. For here, too, large masses of the paper remain white. This drawing differs from most of the others which we show, however. In both composition and technique it has a highly stylized character of decorative nature. As concerns technique, notice the use of unbroken outline, particularly in the representation of the entourage Simple as this expression is, the tile work and stonework, on the other hand, are fully worked out. This concentration of interest on the architecture is of course commendable. The use of stipple in connection with the stone indi-cation is noteworthy. Study also the highly stylized flower forms. The lawn is pure white, the only hint of grass being the dotted line of intersection of house and lawn taken together with the other dotted boundaries.

McSweeney: Using the White Paper

As another example in which the white paper counts strongly, refer to the delightful subject by Angus McSweeney, Fig. 261. Here we have a sketchy technique wholly consistent with the informal character of the architectural design. Though there is no harm in using a sketchy treatment for a formal subject, it is true that such a style seems a particularly appropriate expression of informal architecture like the cottage shown here. In striving for a free treatment, never forget that no matter how sketchy the line may be, good "spotting" of the values is as essential as for the more sophisticated type of rendering. There is seldom excuse for careless composition.

Designing Additional Plans

As a rule, the perspective rendering is only a part of the entire sheet (or sheets) of drawings usually needed to make a proposed scheme clear. Not only is a perspective required, but plans are generally used as well, and sometimes elevations, sections, details, interiors, and even a plot plan, this last showing the relationship of the building to the grounds. Sometimes a part of these and occasionally all of them are rendered to some extent. Two delightful English drawings from the office of R. F. Johnston, architect, provide examples of rendered elevations of some interest (Fig. 262). Some of the lines in these were done instrumentally and some freehand. Notice the treatment of the roof with wavy lines tipped and accented at the hips, the use of right-angle crosshatch in the shadows, and the contrasty method of window suggestion. The indication of brickwork is decidedly simple; the stucco surfaces are shown merely as white paper dotted here and there and broken with vines.

Though these examples beautifully and adequately express the subject, in much elevation drawing it is practically impossible to obtain a proper sense of depth or projection where desired. So when both perspectives and elevations are called for, the rendering is often confined to the perspective where it will count to fullest advantage, the elevations being rendered very simply or left in freehand or instrumental outline.

Whether or not rendering is required on anything but the perspective drawing, always give careful attention to the composition of the entire sheet—or sheets, if more than one is required. Some able designers never fully realize the importance of making each sheet handsome. As one architect remarked, "Why bother so about the spacing of the sheet? The final build-

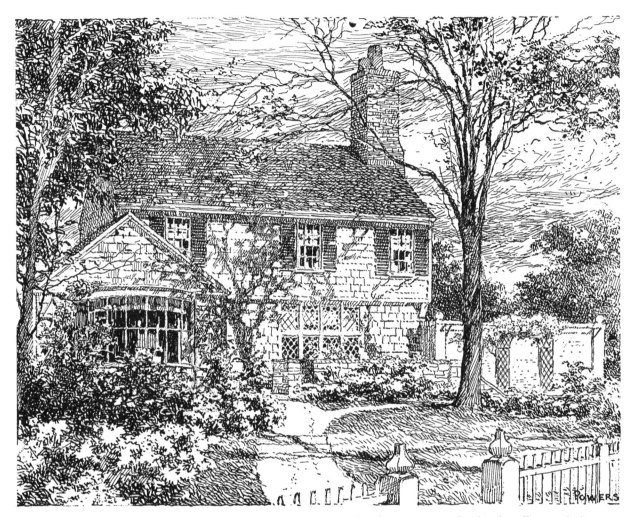

Fig. 254. Richard M. Powers: The artist's versatility is made evident by comparing this free handling with the previous examples.

Fig. 255. Chester B. Price: Tonal contrasts, stronger here than in previous examples in this chapter, gives this drawing brilliance. William A. Delano, Architect.

Fig. 256. Francis Keally: The treatment in this drawing is quite original, particularly in the sky area.

Fig. 257. P. E. Bearse: This is a direct and forceful pictorial statement of the architect's conception.
A. Raymond Ellis, Architect.

Fig. 258. Antonio di Nardo and J. Ivan Dise: This is a well-balanced presentation for a design competition, giving just the proper amount of emphasis on the architecture.

Fig. 259. Birch Burdette Long: This drawing of a stone building suggests the brilliant effect of sunlight by the strong shadows thrown in the foreground. Alfred Fellheimer and Steward Wagner, Architects.

Fig. 260. Russell Barr Williamson: The building here is fully treated, while the environment is simply indicated in a stylized outline, decorative in character.

Fig. 261. Angus McSweeney: Contrasting white paper and brilliant blacks make this drawing of a concrete home most effective. The rendering is in keeping with the informal character of the architecture.

Fig. 262. Combining rule and freehand lines in a pleasing manner, these drawings of typical English country houses are full of suggestions you can apply in your own work. R. F. Johnston, Architect.

SOUTH ELEVATION

EAST ELEVATION

ENTRANCE DOORWAY

SECTION

VEGETABLE GARDEN

HOUSE

GARAGE

PLOT PLAN

DESIGN·FOR·A·SIX·ROOM·SUBURBAN·HOUSE

Fig. 263. Elliott L. Chisling and Allmon Fordyce: Both the interior and the exterior plans are given on these two sheets. This design is well composed and extremely well rendered to provide a pleasing expression of space.

FIRST · FLOOR · PLAN

SECOND · FLOOR · PLAN

CUBAGE

BASEMENT FLOOR TO BOTTOM
OF FIRST FLOOR JOISTS — 3113½ C.F.
BOTTOM OF FIRST FLOOR JOISTS
TO BOTTOM OF SECOND
FLOOR JOISTS — 8668½ C.F.
BOTTOM OF SECOND FLOOR JOISTS
TO MEAN HEIGHT OF ROOF—10952 C.F.
SECOND FLOOR PORTION
OF STAIRHALL — 432 C.F.
PORCH, INCLUDING ROOF OVER 588 C.F.
TOTAL 23754 C.F.

HOUSE TO BE LOCATED IN
NEW ENGLAND

WALLS AND ROOF TO BE STAINED
NATURAL WEATHERED COLOR.

KITCHEN
10'-6" x 9'-4"

RANGE

REF.

PANTRY
8'-6" x 6'-6"

COATS

DN

DINING ROOM
12'-9" x 12'-6"

STAIRHALL

UP

LAVATORY
4'-0" x 4'-6"

LIVING ROOM
21'-6" x 12'-9"

PORCH
12'-0" x 10'-6"

BED ROOM
12'-0" x 9'-4"

CLOSET CLOSET

BED ROOM
12'-6" x 9'-4"

LINEN

DN

STAIRHALL

BATH
5'-0" x 9'-0"

STORAGE

ROOF

BED ROOM
21'-6" x 14'-2"

CLOSET

DESIGN · FOR · A · SIX · ROOM · SUBURBAN · HOUSE

Fig. 264. J. Riegel, Jr.: Consistency between the subject (The John Adams Homestead) and the technical method of rendering it is well illustrated by this delightful sketch.

Fig. 265. Sydney R. Jones: In this drawing of an English manor house, an excellent effect is obtained with comparatively simple means.

Fig. 266. Louis C. Rosenberg: A strong center of interest, pleasing silhouette, and clever indication of detail are characteristic of this study of the Persian Building at the Sesquicentennial Exposition in Philadelphia. C. A. Ziegler, Architect.

Fig. 267. Sydney F. Castle: You should master detail representation before attempting such complex subjects as this.

ing is the thing which counts; these drawings are just temporary things—a means to the end." In a sense this is true. It is equally true, however, that those viewing a drawing are likely to consider that good sheet spacing is almost as much an evidence of good designing ability as the making of good plans or elevations. And even though they give no conscious thought to sheet composition, they are bound to be influenced by the impression given by each entire sheet. Both the layman and the experienced person, viewing a group of architectural drawings, are more likely to select the well-presented design as the best.

When a perspective drawing and plans and perhaps details of a building are grouped on one sheet, the perspective is really the most important thing. Frequently it is the largest single unit of all. It should be placed upon the paper, then, in a commanding position, usually at the top. Sometimes the designer lays it out in this position without much of a definite scheme in mind and then fits the plans and details below it as well as possible. Instead, draw the perspective, or at least block it out, on another sheet of paper, usually tracing paper. This sketch should be shifted to various positions on the final sheet, shifting the sketches of the plans and other required drawings in the same way at the same time, until a logical and interesting arrangement is found for all these larger units. Even the location of the necessary lettering should be carefully studied. Then the final perspective can be drawn exactly where planned, or transferred from another paper.

In Fig. 263 we have reproduced two sheets of a plan presented by Charles W. Cleary and James N. Holden. They are well arranged, providing complete information in a clear fashion.

Drawing Actual Structures

Drawing proposed buildings is not the only thing of interest or value to the architect. It is also valuable to make drawings of existing buildings as well. The draftsman who wishes to learn how to render proposed buildings can do so in no more logical way than through the sketching of actual structures. In Fig. 264 we show a drawing of an old colonial house by J. Riegel, Jr., and, in Fig. 265, one of an English residence by Sydney R. Jones. Both of these drawings have a character lacking in most architectural renderings. There is a feeling here, somehow, that these are real buildings, and not simply things of the imagination. There is a freedom to the handling of both, a simplicity, and a variety of line and tone which are worth attention. In Riegel's, for instance, compare the sort of crosshatch used in the larger trees with the dots of the more distant ones above the roof. Compare, too, the broken line suggestion of the roof and main wall in sunlight with the almost straight line indication within the shadow of the main cornice.

The roof indicated in the drawing by Jones suggests a heavier material than that represented by Riegel. One would never mistake his roof for shingle. Working from actual buildings you are more likely to use a logical suggestion for such details than when drawing from memory or imagination. If, however, you gain enough experience working from the structures themselves, your renderings of proposed buildings will have a more convincing character than most drawings of this nature seem to have.

Nonresidential Buildings

To this point we have shown renderings of residences only, emphasizing this field mainly because it is the one in which the student is usually vitally interested. There are, of course, many other types of small buildings which may be handled in much the same way, to say nothing of the larger subjects we touch on in the next chapter.

For an excellent example of a rendering that is not residential, refer to Fig. 266, a rendering from an original by Louis C. Rosenberg. This, like his other example in Fig. 248, is very simple when you consider the ornate character of the design itself. In this example, however, Rosenberg has used considerable dark tone in the large area within the entrance archway, building a strong center of interest.

If you cover this area with your fingers you will notice that the rest of the work is comparatively light. The ornamental detail is extremely well handled, for it is sufficiently indicated to suggest its richness without being forced into undue prominence. This building as a unit, by the way, forms a very interesting spot against the background, thus exemplifying a point discussed in the last chapter.

In quite a different kind of rendering, Sidney Castle has achieved a remarkable effect in his drawing of Rheims Cathedral in Fig. 267. Though this is so large a subject that our comments on it logically belong in the following chapter, we cannot refrain from presenting it here. The treatment shows a rare understanding of large and intricate subjects. In the upper portion the interest is strong, an effect partly due to silhouetting the architecture against a pure white background. Below, in order to stabilize the whole, a firm foundation has been constructed of tone carried out to a definite rectangular form, the darkened lower corners of which also serve to accentuate the large light area which has been left in front of the entrance doorways. These doorways themselves, almost pure black in value, count the more strongly because of contrast with this light. This helps to create a center of itnerest in this area to which several things, including the figures, contribute. Neither the silhouetted effect against the sky, nor the strength of this center of interest in this area to which phasized so greatly that they detract from the marked pattern of the entire façade. Technically the drawing is freely handled, the textural characteristics of the materials being well expressed and the intricate detail adequately, though somewhat impressionistically, indicated.

This brings us to the end of our chapter. In spite of its length, we have been able to point to only a few of the many interesting characteristics of the drawings represented. Give them again the most careful scrutiny, seeking especially for suggestions that will help to overcome your own weaknesses. In the next chapter we shall continue this discussion, with special reference to rendering of larger structures.

Fig. 268. Robert Lockwood: In this rendering of the Oviatt Building, note how Lockwood freely, yet accurately, drew the structure, displaying his ability to render with lightness and delicacy. Walker and Eisen, Architects.

18. The Larger Architectural Problem

Edward F. Toney

There really is very little that need be said on the subject of rendering large buildings. Much that has been written in the recent chapters applies as directly to handling large subjects as to small ones.

There are a few hints which may be worth offering, however. In addition, we discuss the pen work of the artists shown in this chapter.

Unless the instrumental layout for the rendering of any large structure is satisfactory, the renderer works under a distinct handicap. There are architects and draftsmen—many of them—who seem to assume that if an instrumental perspective is correctly drawn, that is enough. We must reiterate the fallacy of this thinking. It takes a degree of judgment, usually gained only from considerable experience, to select the best station point, the proper height of the horizon line, and the like. This is particularly true if a building is complicated in its masses.

Placing the Station Point

In the typical perspective if you place the station point too close to a building, the principal vanishing points will fall so near each other that the perspective may become unpleasantly acute. Remember that unless you are back some distance from an extremely tall or wide building, you cannot see the whole of it without shifting your eyes.

In instrumental perspective it is assumed that the eyes are looking fixedly in one direction. It follows, therefore, that you should make sure, in laying out your instrumental work, that your station point is far enough back to correspond with an actual point from which the completed structure could be viewed as a unit from one fixed direction. One well-known delineator often takes this point away a distance equal to about two to two and a half times the height of any tall building, or about twice the visible width of a wide

building. Another general rule is to stand away from the nearest corner of a building. This distance should be great enough to permit an imaginary horizontally placed cone — with its tip at the station point and with every element of its conical surface forming an angle of thirty degrees with the horizontal line of sight from this point (or eye) to the building — to completely enclose or contain the building itself. This is based on the assumption that the eye sees things distinctly within a cone of about sixty degrees.

There is, however, no fixed rule. Until you have had considerable experience in laying out these perspectives it is advisable to draw a trial perspective, at small scale, of the main lines of each structure, as explained in the previous chapters. If the station point is taken too close you will notice this as soon as you draw the main lines. The perspective will seem too sharp and unnatural. The top of a tall building will probably appear pointed to an acute angle at the nearer corner. This is always an unpleasant effect.

Another important point in both preliminary sketches and final drawings is that a building in angular perspective will not show to best advantage, particularly if on a corner lot, unless it is turned in a way that can be viewed at unequal angles. One face — the principal one — should be less foreshortened than the other. This not only creates greater unity but gives added interest. It also makes a more natural effect possible.

Eye Level or Horizon Line

The height of the eye level or horizon line on which the main vanishing points are located is important, too. In drawing small buildings this is usually assumed to be only 4 to 6 feet/1.2 to 1.8 meters above the ground. This creates the effect that the building is being viewed by a person from

a normal standing position on a level site. If so low a horizon line is used for an extremely tall building, however, the result is sometimes unfortunate, because the perspective of the top seems too acute, just as when the station point is taken too close to the structure. It is not uncommon, therefore, to fix the horizon line 30 or 40 feet/9 to 12 meters above the ground, the final drawing giving the impression that the building is being viewed from the third or fourth floor of some opposite structure. One delineator makes it a general rule to place his eye level at about one-fifth of the total height of his subject. Another goes higher, placing it at approximately one-third. Study various renderings with this thought in mind. It is easy to discover the horizon on each by locating the level at which none of the horizontal lines of the structure itself appear to slant in perspective.

In making perspectives you can usually best determine your eye level, just as you can your station point location, only by making a small trial perspective sketch. If the eye level is placed high, it will probably result in the top stories showing to better advantage; but the sidewalks and street will be less foreshortened, and hence seem more conspicuous. The spectator will be looking down, too, on the people and the tops of the automobiles. It takes more time and skill, perhaps, to handle these accessories successfully in this position. If the eye level is extremely high, the near angle of intersection of the building and sidewalk may seem too acutely distorted, giving the impression that the building is resting on a point. This condition is further exaggerated if the station point is too close.

Planning Ahead

Once these main problems have been settled by a small trial sketch or two (which may also be used, if you wish, to study the

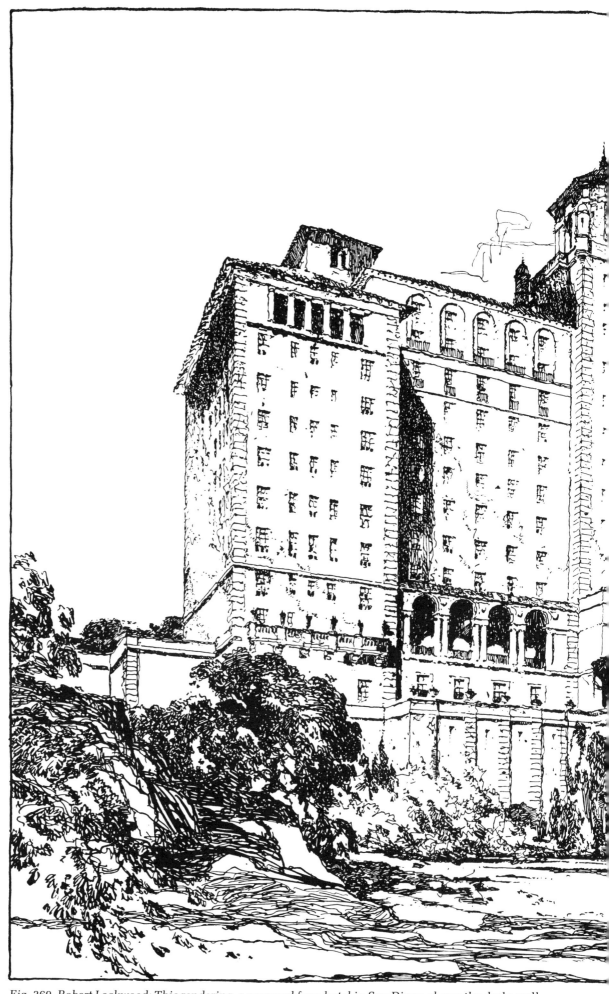

Fig. 269. Robert Lockwood: This rendering, a proposal for a hotel in San Diego, shows the darks well "spotted." The technique, somewhat like that of an etching, is pleasingly free. Postle & Postle, Architects.

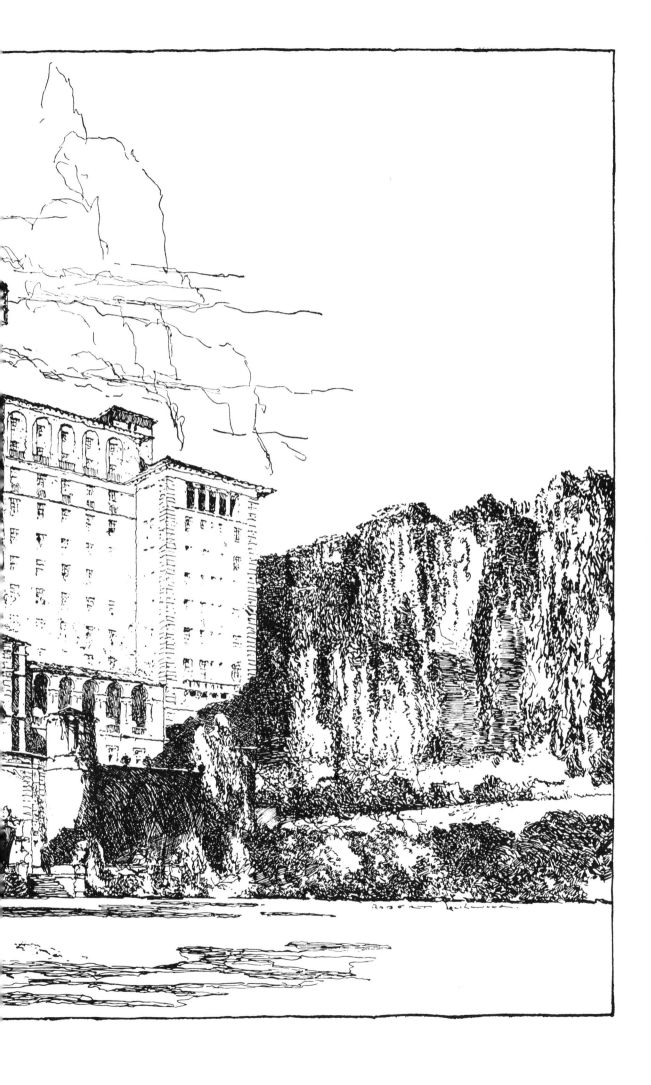

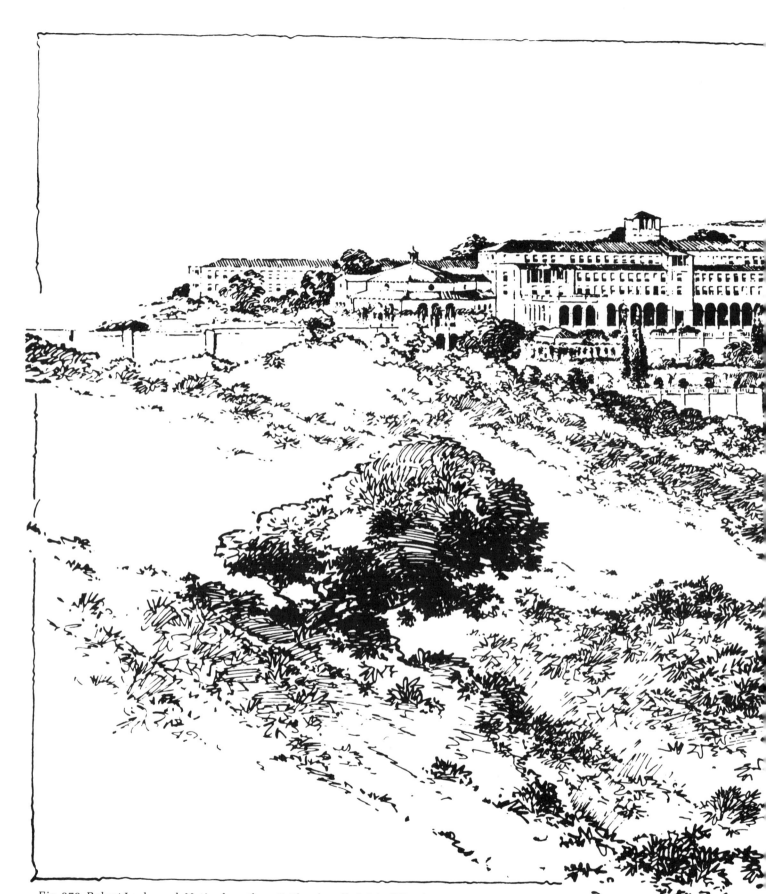

Fig. 270. Robert Lockwood: Notice how the artist has handled this difficult subject convincingly.

Fig. 271. Robert Lockwood: This drawing was originally used as an illustration in a booklet advertising the proposed building. For this purpose, such a daring treatment was particularly appropriate.

values), the large perspective may be safely drawn. Then you can give attention to the rendering.

First we must warn against complication in the rendering. We have repeatedly pointed out that one of the characteristics of excellent pen technique is simplicity. In spite of the fact that the student or draftsman realizes this, he nevertheless often falls into doing much more than is necessary. The rendering then takes longer to do and, when it is done, the whole effect is overworked.

This does not mean that renderings of large or complicated structures can be done hurriedly. Even the expert has to spend a great amount of time on them, every square inch of rendered surface requiring just about so much effort. It does mean, however, that much time can be saved by careful advance planning. The more complex the subject, the more need there is for planning.

The expert often gives little conscious effort to this preparatory work, for experience naturally has taught him how to use his time to advantage. The beginner, however, is strongly urged to make preliminary studies of the sort described and of the values as well, first deciding on the direction of the light, as this is so important in determining the main masses of shade and shadow.

Bear in mind this matter of simplicity. Realize, for instance, that in a tall building having many windows alike it is not essential to draw each one fully and carefully. Spend your time on achieving a satisfactory rendition of the work as a whole, concentrating your effort on details that are unusual or exceptionally important. The entranceway is so essential a part of most large buildings, for example, that it should ordinarily receive its full share of attention. Many times the best method of treating the tall building is to concentrate on the area around the entrance, the lower stories, and the nearby street and immediate surroundings, making that area the center of attention. In this case the upper stories may be slighted—a natural treatment—for when tall buildings are seen from below, the upper stories are usually well out of the direct range of vision.

There are exceptions, of course. Suppose you have a building that starts rather plainly at its base, rising gradually with increased ornateness until it is terminated by a beautiful tower. This tower and the portions of the structure immediately below it may logically become the focal point. In this case the base of the building should not be made too attractive or you will have two leading centers of interest, with a consequent division of attention.

Accessories

In the case of the large building, and particularly the tall building, you have somewhat less opportunity, perhaps, of doing much with your accessories — especially shrubs and trees—than when

dealing with smaller structures. You may, of course, show adjoining buildings. You are almost sure to need people and automobiles, too, for a drawing of a large building looks far more barren without these things than does a rendering of a smaller subject. And all of these accessories must be right in scale or the scale of the building itself will look wrong.

Use care, also, not to scatter the figures so that each becomes too conspicuous. As a rule, figures should be in pairs or groups of three or more. The people must not be standing too stiffly; they should be going somewhere or doing something. If the building is at a street corner, proper traffic regulations of the particular city in mind should be reasonably observed.

As a general rule a client likes to have it appear that his building is a busy place. Consequently the people should in many instances be grouped near it or shown entering it. The turning of figures towards a building seems to add to the importance of the building and also serves to emphasize the center of interest. On the other hand, many figures moving away from a building seem to lead the attention away with them.

Balancing the Lights and Darks

It is often the case that a dark tone at the base of the drawing of a tall building helps to steady the whole drawing. Sometimes this tone simply represents the natural values of the street with its figures and the like. Frequently, however, it is a shadow tone cast by some building or buildings on the opposite side of the street. Such a shadow tone may be shown with a definite upper edge, if this seems best, or it may be graded gradually into the white of the paper. In the former case it must be drawn correctly, or at least consistently, and at an angle that does not introduce unpleasant lines.

Returning to the matter of making either the base or the top of a tall building the center of interest, we may add that a satisfactory composition when rendering a high structure of light material is to form a rather white area at its base, including within this area part of the building itself, the adjacent sidewalk, and possibly a portion of the street. This light area can often be made more conspicuous by adding contrasting darker structures adjoining the building shown. A dark street or shadow tone might also be added at the extreme bottom so the final composition would show a white area or spot surrounded by gray or black. This spot, punctuated by a few strong darks such as in the doorway and lower windows, would provide a strong center of interest.

If for any reason you wanted the center of interest at the top and the building was light in value, you might leave the upper stories as a light mass against a dark sky, creating a similar composition except for shifting the center of interest. Sometimes the opposite appearance would be more natural, however, gained by silhouetting

Fig. 272. J. R. Rowe: It is interesting to compare this washlike drawing of a church in Toulouse with the drawing by Lockwood (Fig. 271). Despite an unusual amount of dark tone in both, including crosshatch, each is highly individual in its treatment throughout.

Fig. 273. Thomas E. King: In these preliminary studies for the Buhl Building in Detroit, both confidence and skill were needed to execute such vigorous work. Both drawings are bold and efficient.

the building rather darkly against a light sky or clouds.

Points such as these should be considered in doing the preliminary planning or sketching. Once you have determined a definite plan, start the rendering and push forward according to it, the most common method being to render around the center of interest first, working out from there.

Rendering Technique

So far as technique is concerned, there is no difference between the large structure and the small, the occasional exception being when a heavier or coarser technique is used for the former. Such a technique is desirable if a drawing is large and is to be reproduced at rather small scale. If a drawing is made with no thought of reproduction, on the other hand, the technique must be fine enough to look well in the original.

Lockwood: Renderings Freely Drawn

Now to turn to the accompanying examples of pen renderings of large buildings, we shall see in what manner these specific problems have been approached. First let us turn to the rendering by Robert Lockwood (Fig. 268). Lockwood's treatment is very charming, for while he has lost none of the accuracy of the instrumental layout, he has brought into his rendering a freedom and looseness which prevents the stiff and uncompromising effect so common to many renderings of similar subjects. Beyond this there is little that need be said. The composition is natural and simple; the lighting selected illuminates the entire building. The angle chosen for the perspective gives a satis-

factory emphasis to the main façade. The sharp, black accents at the bottom — the figures and the like — make that the center of interest. Study the figures for their suggestiveness. There is scarcely one which stands out plainly, yet the impression is satisfactory. The darks throughout are nicely balanced.

Quite different in both subject matter and composition is the second example of Lockwood's work (Fig. 269). Here the whole drawing is keyed to a darker pitch. The building itself is a design which permits a pleasing natural distribution of sharp accents of black, which in contrast with the light wall areas give the whole building an effect of brilliance. As in the previous example, Lockwood has wisely kept his windows quite light in this, a thing which adds greatly to the breadth of the whole effect. Some of the windows, particularly those furthest from the spectator, have been entirely omitted or merely suggested by a dot or two. Observe how the nearer parts of the building have been brought forward through sharper contrast. Notice the nearer windows, for instance, and the dark shadows under the nearer arcaded portion. The surroundings are unusual for this type of building, and full of interest both in composition and technical treatment. Note the decorative character of the foreground shadow tone. See, also, the way in which the cloud shapes contribute to the whole.

Also different in subject and in handling, due in part to the amount of landscape involved, is the third drawing by Lockwood (Fig. 270). Here, as in the others, there is freedom of handling; yet this freedom is in no way carelessness. There is real thought evident in every part of the whole. The way in which the eye is led back gradually from the foreground to the distant buildings is worthy of study;

the "pattern" quality of all this foreground is good.

As a final drawing in this group by Lockwood we have this extremely dark, very impressionistic example (Fig. 271). This is a most unusual sketch, hardly a typical rendering of architecture. It was originally used in a booklet advertising the building shown, and for this purpose was most effective. You should occasionally try a drawing as daring as this. For another approach using bold treatment, compare Lockwood's drawing with Fig. 272. (In Fig. 295, by the way, an interior sketch by Lockwood of this same building is handled in much this same free manner.)

King: Preliminary Studies

We have repeatedly advised you to make preliminary sketches for these kind of renderings. In Fig. 273 we reproduce two drawings which, though made as preliminary studies in design rather than for renderings, show one sort of study that might prove advantageous. Both sketches are done by Thomas E. King with a boldness and daring attesting to the delineator's confidence. The foregrounds are well treated. Some of the windows within the shadow tones have been left light, showing natural reflection. The use of instrumentally drawn verticals here and there gives strength and solidity. The shadows thrown onto the buildings are worth noting, too. Though these drawings are more in the nature of studies than finished renderings, they are just a step away.

Eppinghousen: The Formal Subject

The rendering in Fig. 274 by Charles F. Eppinghousen is a pleasing and restful treatment of a more formal type of large

Fig. 274. Charles F. Eppinghousen: The Crane Technical High School in Chicago. A carefully studied treatment of a formal subject. John C. Christensen, Architect.

Fig. 275. Bertram Grosvenor Goodhue: Church of St. Kavin, Tramburg, Bohemia. An "ideal" composition in which the major structure is most strikingly silhouetted, with the foreground contributing interesting detail to the drawing.

Fig. 276. Bertram Grosvenor Goodhue: Chapel from the Cloister of St. Thomas' College in Washington D.C.
In this rendering Goodhue displays his mastery of clouds, stonework, brickwork, grass — in fact, his ability
to depict every detail. Cram, Goodhue, and Ferguson, Architects.

building than some of the ones we have shown. The nearer portion of the building comes forward in a natural manner, an effect brought about partly through the able way in which the distance has been suppressed. The foliage treatment is good. Notice the difference in scale between the lines used in the foliage in the foreground and distance. Needless to say, it takes a vast amount of patience to do buildings of this sort in pen and ink, to say nothing of the skill required.

Goodhue: The Complex Subject

These kinds of subjects are by no means the only ones that must be considered by the delineator. Aside from these buildings which are usually simple in their masses, including office and loft buildings, hotels and so forth, we have many structures that are more complex in form which are, in a way, more difficult to do.

Churches, in particular, are often broken in mass and ornamented with a wealth of detail. As Bertram G. Goodhue was for years one of the leading delineators of this type of subject we show a few examples by him. First there is the drawing in Fig. 275. This drawing is, however, hardly typical of his work, as it is an early example—an "ideal" composition—done when he was still quite a young man. It shows much of value to the student, however. When considered as a unit, the whole drawing forms a pleasing spot on the paper. The eye rises gradually from the approximately horizontal base to the vertical structure itself, which offers an interesting silhouette against the background. This silhouette is carefully studied. To balance the profile of the building, pointed trees at the left and buildings at the right take forms harmonious with it. Nor were the smaller details neglected, even the least of them receiving their share of attention. The lower portion of the sheet is a beautiful bit of landscape composition, the bridge, trees, and water being charmingly drawn. In this entire rendering the technique is worthy of thorough examination. Some parts might well be copied.

So far as technique is concerned, however, the student can perhaps learn more of Goodhue's manner of working from the larger detail shown in Fig. 276. This is a drawing of an actual building, the architecture very directly expressed. Note the manner in which the various materials are interpreted. Study, too, the several ways in which crosshatch has been employed.

In Fig. 277 we publish a second "ideal" composition by Goodhue. This is of much later date than the first, which makes comparison of the two most interesting. The latter, it will be seen, is more decorative in character than the former. It is also less ethereal in feeling, being rendered with more definiteness.

Wilkinson: The Elaborate Subject

As another rendering of Gothic character, though from a different hand, we show in

Fig. 277. Bertram Grosvenor Goodhue: Though decorative in intent, this "ideal" composition has a structural quality indicative of the architect's sound understanding of the practical.

Fig. 278. Harry C. Wilkinson: Harkness Memorial at Yale University. In this drawing Wilkinson displays a wealth of variety in line and tone, logically expressing an interesting subject. James Gamble Rogers, Architect.

Fig. 279. Detail of the drawing on the opposite page, reproduced at the size of the original. The treatment of the foliage, stonework, and windows shows here very distinctly.

Fig. 280. Harry C. Wilkinson: The Lee Mansion in Arlington, Virginia, with Sheridan Monument in the foreground and the tablelike monument to L'Enfant at the right. The white pedimented entrance, surrounded by darks, becomes the center of interest.

E.C. Peixotto

Fig. 281. Ernest C. Peixotto: *Notice the delightful freedom of handling in this drawing of a fountain at Palazzo Podestor in Genoa, Italy. Study also the variety of line and tone.*

Fig. 282. Ernest C. Peixotto: Chiesa dei Miracoli, Brescia, Italy.
The manner in which the artist has indicated detail by means of
dots and short strokes should be of value to the student.

Fig. 283. (Above) Welles Bosworth: Portion of a drawing reproduced at the actual size of the original. This detail shows the remarkable modeling of the subject, especially evident if the drawing is set away several feet. A small reproduction of the entire drawing is shown on the opposite page.

Fig. 284. (Left) Welles Bosworth: The Sphinx. A painstaking study in which rough and irregular sculpture surfaces are rendered with a rare fidelity.

Fig. 285. Jonathan Ring: The Princeton Club, New York. In this typical architectural rendering, notice the painstaking handling, yet the light and airy effect achieved. Aymar Embury II, Architect.

Figs. 278 and 279 two reproductions of a drawing by H. C. Wilkinson. (The second is merely a detail of the first reproduced at the original scale for purposes of study.) This drawing is particularly interesting in its treatment of the detail, including the stonework. The foliage, too, is unique in handling. Like Goodhue, Wilkinson has used crosshatch quite freely.

Fig. 280 is another drawing by Wilkinson in the form of a composition combining the Lee Mansion at Arlington, Virginia, with the Sheridan monument (shown at the left foreground) and the tablelike monument to L'Enfant (at the right). The pedimented entrance forms a light area which, surrounded by gray as it is, becomes the center of interest.

Peixotto: Simplifying Detail

As an additional drawing showing detail, in Fig. 281 we have a drawing by Ernest Peixotto. This shows a freedom of handling too seldom found in architectural delineation. The draftsman should study the clever suggestion of such bits as the balusters above and the iron rail below. See how much variety there is in the treatment of these balusters. Try to impress this idea of simple yet varied suggestion on your mind by copying parts of this rendering. The foliage, too, is handled with a delightful freedom. In fact, this is a worthwhile sketch in every way. It is not, of course, a drawing of a proposed building, as many of the others have been; but it offers ideas which would be applicable to such work.

Fig. 282 is another charming drawing by Peixotto—one which is perhaps even more architectural in its interest. Among the many things worthy of study, we call attention to the way in which the ornament and many of the moldings are suggested merely by dots, most of which represent the tiny areas of shadow cast by the various projections of the carved embellishments. These dots are placed with sufficient care so that one gets the correct feeling of the ornamental patterns themselves while at the same time gaining an impression of space and light and air. Note the extreme minuteness of some of these dots, particularly on the freestanding columns of the main entrance portico. Note, too, the very delicate yet completely adequate suggestion of the ornament and moldings on the foreshortened end plane of the superstructure which these columns support. Also study the variety of line used in building up the larger shadow tones throughout the sketch.

In all of this work it will be realized that the effect depends as much on what is left out as on what is put in; it is partly because of the suggestiveness or impressionistic quality of much of the detail that the effect of the whole is so convincing and real.

Bosworth and Ring: Two Examples of Detailed Renderings

The drawing of The Sphinx by Welles Bosworth, shown in Figs. 283 and 284, could hardly be called architectural in the usual sense. Yet it is so painstaking an example of pen rendering of sculptured mass that it offers much of value to the student. If these drawings served no purpose other than to show something of the earnest and conscientious study which some of our masters of architecture gave to their subject during their student days, they would still be worth reproducing. They have more to teach us than this, however. Note the way in which the head of the Sphinx as a whole comes forward. Study the features, too: the projection of the lips, the recession of the eyes. It is a matter of wonder that a person could so handle this subject, using the thousands of lines, and yet keep the values so true.

In closing, we once more turn the reader's attention to typical architectural rendering as exemplified by the beautiful drawing by Jonathan Ring in Fig. 285. Clean-cut, light in value, and simple despite its conscientious representation of detail, this stands as an extremely fine drawing of its kind.

So much regarding the treatment of exteriors of buildings. In the next chapter we shall take up the delineation of interiors and furniture.

Fig. 286. A. Thornton Bishop: Armchairs. Notice the treatment of detail and the shadows cast on the floor.

19. Interiors and Their Accessories

Lurelle Guild

In recent chapters we have discussed at length the representation of building exteriors and their settings. Now we turn to interiors and their accessories.

If you have had a fair amount of experience in delineating the former, you should not find the latter particularly difficult. If, on the other hand, you have not drawn exteriors to any extent you will probably discover that it is necessary to do numerous preliminary exercises before attaining any real success in dealing with complete rooms. Many of these essential exercises should be in representing the kind of building and finishing materials used for architectural portions of interiors, including stone, brick, plaster, tile, wood, and so on. Also sketch the movable furnishings and furniture.

Study Interior Items

If you have already done exteriors, you will have had a fair amount of practice in this first direction. But you should join the novice in making studies of items that have not entered into your other work, including particularly all sorts of upholstery materials, hangings, rugs, tapestries, and so forth.

It is truly surprising what a variety of effects we find here. Learn to observe them intelligently. If you select some fabric to draw, for instance, first study it carefully, looking at it close at hand and in the distance, in bright and in subdued light. Then lay it out smoothly and in folds, searching always for its special characteristics under all sorts of conditions, and also attempting to retain mental impressions of these peculiarities for future use. Then compare one fabric with another, or drape several in such a way that they can be easily seen at one time. It is surprising what differences can be discovered, even in plain materials, by an inspection and analysis of this sort. A piece of satin and a piece of cotton cloth of similar color and tone will vary greatly, and even a light piece of cotton and a dark piece of the same material will show marked dissimilarity in effect, in addition to the contrast in value. It is impossible to go into this fully in a single chapter, and at best you could gain little from a more complete discussion. The main thing is to learn that there are such differences and that they must be observed.

To make one or two suggestions, notice that light-colored cloth usually shows more apparent contrast in its values than darker material of a similar kind. The dark color seems to absorb many of the lighter tones of shade and shadow. A smooth material with a sheen will not look at all like some dull fabric of similar tone, as it will have many highlights and reflections. Certain fabrics, such as velours, will sometimes appear dark where we expect to see them light, and light where other materials would be dark, and by rubbing the nap the effect can be changed instantly from light to dark or from dark to light. Many shiny materials grow dull and soft with age, but there are exceptions. Some others—leather, for example—often become smooth and glossy with wear. The smoother the material, the more complicated and changeable its values, as a rule, and the stronger its highlights.

When it comes to draped fabrics, there is great difference in the way they hang, for some are hard and inflexible and others soft and yielding. Heavy materials usually hang quite straight and show fewer small folds and creases than those that are lightweight. Heavy materials, too, are generally opaque, and for this reason are sometimes less difficult to represent than thin nets and scrims and similar fabrics which are so translucent or even transparent that they show light, or occasionally objects, through them.

Exteriors vs. Interiors: Light and Shade

Perhaps we should point out one of the really fundamental differences in the appearance of nearly all interiors and exteriors—a difference in the effects of light and shade. Exteriors, generally speaking —and particularly architectural exteriors — are usually drawn under what we might call normal daylight conditions where the sun is the sole source of direct illumination. For this purpose, the rays of the sun are considered parallel; consequently the shadows cast are definite in shape and have a certain similarity of direction. The observant person can soon learn the shapes most commonly found and can apply them quite successfully when working from memory or from imagination.

Direct sunlight, however, is largely excluded from interiors. What does come through the windows is often softened by curtains. There are exceptions, of course, where sunlight forms areas as definite as those found outside. But if we consider interiors as a whole, it is evident that the illumination is largely reflected. The light is therefore softened and diffused and the shadow shapes are variable and often indefinite. The shadows take many directions, the light generally radiating in a sense from each door and window. This brings about complexity of form and variety in edge and value. If you are now indoors, observe for yourself. You will probably find surprising differences in the value, direction, and character of the different visible shadow tones. Some edges are sharp and some are so soft that they are almost lost. If you place a chair within a few feet of a

Fig. 287. A. Thornton Bishop: Furniture sketches, reproduced here at the size of the original work. These delightfully free and direct sketches suggest rather than fully express the ornamental detail.

window but not actually in sunlight and study the shadows cast on the floor by the four legs, you will notice certain interesting things. You will probably see that the shadows are *radiating* instead of *parallel* in direction. Then if you study each shadow by itself you will see that it is reasonably dark and definite where the leg comes in contact with the floor but grows light and indefinite and is perhaps lost as it spreads from this point of contact. If you touch the lead of your pencil to a sheet of paper, again you will note that the sharpest and darkest shadow appears nearest the point of contact.

This difference between the daytime shadows indoors and out is confusing in the sense that shadow shapes vary so greatly indoors that it is not easy to become acquainted with them. Each source of light, such as each window, causes a new group of shadows. Often in rooms where there are several windows, the shadows cast by the light from each of these cross and re-cross in a highly disturbing manner. Much light within rooms is reflected upward from the brighter parts of the floor and furniture, giving us some shadows in a direction almost opposite to that customary outdoors. The action of reflected light may be noted, for example, in the shadows of ceiling lighting fixtures.

Though more varied, the main contrasts in interiors are seldom as sharp as in exteriors. There is a greater effect of subdued lighting throughout. On the other hand, there are perhaps more small accents of light and dark in interiors, which appear strong in relation to the other relatively subdued tones. These are caused mainly by the large number of smooth or polished surfaces which interiors offer to pick up light and reflect it. There are the shiny floors, for instance, and table tops, and doors, and polished pieces of furniture. There are especially many brilliant small areas of highlight on such places as arms and backs of chairs, dishes, lighting fixtures, and hardware.

Of course artificial illumination changes conditions both within and without. Generally speaking, such light usually seems rather inadequate outdoors. Consequently, it is here that the softest effects are customarily seen at night. Interiors can be quite brilliantly illuminated with no great effort. This means that the night and day conditions in and out are practically reversed. As a rule, however, the shadows cast by brilliant artificial light indoors, though much like those cast by the sun outdoors as far as their definition is concerned, are caused by rays which, instead of being parallel, are radiating from the source of illumination. If there are several sources of artificial light—several different lights —again there may be a crossing and re-crossing of shadows to prove distracting. All this means that in drawing interiors, whether day or night, you may be confused if you try to understand and interpret every shadow. You must learn to

Fig. 288. Russell Patterson: Although these drawings are informal, they are precise. Notice the right-angle cross-hatch and the numerous dashes and dots.

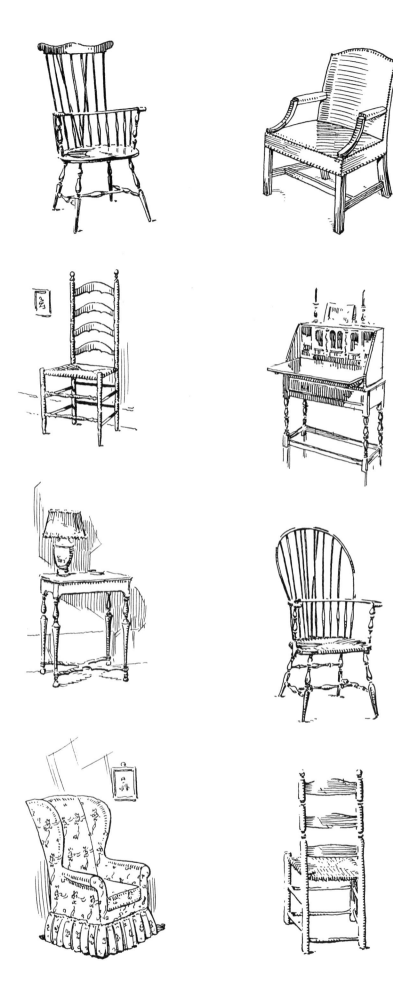

Fig. 289. Practice drawing in this informal manner. It would be better if you worked at a scale larger than that reproduced here.

simplify. It means also, however, that if you do make mistakes, they may be less easily detected than similar mistakes on outdoor subjects in sunlight; so there are advantages and disadvantages in both. The important thing to know is that there is this difference in general effect. Knowing this, you can do your own observing more intelligently.

Exteriors vs. Interiors: Accessories

There is another point of difference between most interior and exterior subjects which affects their handling. Drawing exteriors, even if handicapped at times by being forced to draw more definite shadows, you have as compensation great leeway in using accessories. If the sky seems empty, you can add clouds. If the surroundings seem plain, you can plant trees. If the architecture is bare, you can make use of vines, flower boxes, etc. In a large percentage of interior work, on the other hand, all of the architectural background is quite definitely fixed. You have little opportunity to do more to aid your composition than arrange movable objects such as some of the smaller pieces of furniture, though you sometimes have recourse to potted plants.

Exteriors vs. Interiors: Textures

While comparing interiors and exteriors, we should not fail to mention that ordinarily there is more variety in material textures in the latter than the former, which sometimes gives opportunity for greater variety in technique.

Exteriors vs. Interiors: Perspective

There is still another common difference shown by many drawings of exteriors and interiors: the matter of perspective. Exteriors are usually viewed from a greater distance than interiors, making the perspective somewhat less angular and acute. Aside from this one fact, however, the perspective of both interiors and exteriors is more nearly the same than is sometimes realized. An interior is much like the *inside* of a box, an exterior like the *outside* of it. Keeping this thought in mind may make the relationship between the two more apparent and helpful.

Draw Individual Pieces of Furniture

Ordinarily the greatest difficulty in getting the perspective of interiors correct comes not in the handling of the architectural background — which is usually quite simple — but in placing and representing the furniture. To draw furniture well, correct in itself and at the same time right in relation to the rest of the room, is far from easy. In many drawings the individual pieces look too large or small or seem tipped up or wrongly foreshortened or incorrect in some way. For this reason, therefore, it is often best to start practicing with single pieces of furniture. Fortunately, there are always models available. Chairs are extremely good for first prac-

Fig. 290. Perspective is of great importance in representing furniture. Sketches such as these may be made when speed is essential.

tice. As a rule, they look their best if shown some distance away, so place each one across the room before sketching it.

The various furniture sketches by A. Thornton Bishop in Figs. 286 and 287 were handled crisply and directly and offer many suggestions of value. Note the suggestive treatment of the detail. Note also the shadows cast on the floor by most of these pieces. Such shadows serve to "hold down" furniture, preventing any effect of floating in space. Study these drawings individually. You will discover that there are differences in the treatments used. The sketch in Fig. 286, which shows the light chair against the dark background, is totally unlike the others. This use of light against dark is a less common, but no less effective, value arrangement than the dark against light combination.

The small sketches by Russell Patterson in Fig. 288 are also worthy of careful study. These are distinctively handled, treated in a rather precise and at the same time somewhat decorative manner. The sort of right-angle crosshatch is interesting, too, as is the arrangement of numerous crisp dashes and dots.

The sketches in Fig. 289 also show subjects you can use for your early work, though they were drawn at this exact size, while you should do all your work at a considerably larger scale.

Now Draw Groups of Furniture

After you have practiced for a while on individual pieces, being careful always to get correct perspective and proportion, you might try sketching little groups of several pieces of furniture, or room corners. Figs. 62, 66, and 67 and Sketches 1 and 2 of Fig. 290 offer suggestions for groups of this sort. The grouping itself is as important as the drawing, giving as it does splendid practice in composition. Whether you use outline as in Fig. 62, as well as in Sketches 1 and 2, Fig. 290, or whether you employ outline together with spots of black as in Figs. 66 and 67, or whether you render in more nearly full value as in Fig. 289 depends entirely on your inclination or purpose.

You will probably like to try various methods, perhaps beginning with the more simple outline. Don't confine yourself to furniture alone, however, but practice on rugs, hangings, upholstery materials, etc. In all of these things, you must learn to suggest or indicate pattern, as most of these materials have more complex pattern than can be fully and accurately drawn in reasonable time and at small scale.

The Sketchy Treatment

When you have learned to draw these various details and portions of rooms to fair advantage, you will be qualified to attempt drawing complete rooms or, more strictly speaking, as much of each room as would customarily be viewed from one spot at one instant.

Here again, the method you use will always depend on your purpose or inclination. Plain outline, or outline reinforced by only a bit of shading, is good for many purposes. Or you may prefer a more freely done kind of drawing such as that shown in Fig. 290. This free technique, by the way, generally seems more appropriate for informal sort of architecture than for more formal types. This does not mean that it is never appropriate to represent formal architecture in a sketchy manner. But here, as in other instances, it seems more consistent to use a sketchy style when representing rough materials and where the composition is free, and to use a more highly finished technique for bisymmetric or formal arrangements or smooth, carefully finished materials. The two sketches in Fig. 291 were done at this exact size, and are somewhat less sketchy in treatment than Fig. 290.

Natural Values

Some drawings are made with careful attention to natural values. The one by A. Thornton Bishop in Fig. 292, for instance, is much more convincing in its tonal quality than are those by the author in Fig. 291. this is due in part to the more complete range of tone, considerable black having been introduced. As we have elsewhere pointed out, you get far greater richness of tone — a suggestion of actual color — when black is employed than when you depend completely on gray and white. Gray drawings are almost always inclined to be a bit dull and heavy.

Bishop's drawing in Fig. 292 has a fine sense of depth and distance, too, accomplished largely with the converging lines of the perspective. Much depth is gained also by the way in which contrasts have been arranged. The table top and the two chairs at the left have been kept comparatively light against a darker background, bringing them forward, while the backs of the two opposite chairs have been forced a bit by making them dark against the light pedestal of the pilaster beyond, and light against the shadow of the dropleaf table. Only by working for contrasts of this sort can you bring objects forward or carry them back at will.

Distributing Areas of Interest

As another study of an interior, and this time a very carefully treated one, refer to the drawing by Sydney R. Jones (Fig. 293). This rendering, like Bishop's, makes use of black, though here it is largely confined to a single leading area within the fireplace opening. This one dark accent, seen in relief against the white around it, makes this fireplace a strong center of interest for the entire sketch. The converging perspective lines of the ceiling beams and flagstones help to carry the eye to this center.

Not only has this drawing an easily understood composition, but technically it also has much to teach. Observe, among

other things, the great variety of strokes. There are the long and unbroken lines on the ceiling, for instance, which were of course much longer in the original than here. Then, just below them, minute dots are visible along the cornices. Observe, too, the numerous dots by which the moldings surrounding the coat of arms of the overmantel are formed, some of them so tiny in this reproduction that they are almost lost. Note likewise the speckling of the fireback behind the andirons. Between these small dots and the long lines of the ceiling, you can find great variety in both length and character of stroke. Crosshatch has been used sparingly in some of the shadow tones. Outline has scarcely been used by itself, but has been employed to reinforce many of the edges. Note the vertical boundaries of the chimney breast, for instance.

Quite different from this example both in composition and technique is the interior by Russell Patterson (Fig. 294). Here we have a drawing in which the interest is more generally distributed. It is a drawing, too, which has much less variety of tone, keyed in a sort of gray or neutral pitch, relieved only by the few black accents, as in the chairs, and an equally small number of whites of little area. This very gloom, however, is characteristic of the type and period of room represented here; so this treatment is logical.

Technically the drawing is certainly unlike any of those so far shown — in effect it is complex, though in fact it is simple. Practically every object was first outlined with what seems almost a uniform line. Then the tones were built up mainly of strokes either vertical in direction or converging towards the right-hand or left-hand vanishing points. Some of the strokes, as in the wall planes, are either broken into dashes or dots or are interrupted by slant lines exactly as shown at 5 and 10 in our early exercises in Fig. 33. Many strokes are used in pairs, too. Notice the table top reflections, for instance. These variations, together with the curved lines found in the tapestry and elsewhere, afford relief from the more evenly spaced straight strokes, and result in a most individual drawing.

The Sketch

As a treatment which again is altogether unlike any of the others here, refer to the drawing by Robert Lockwood (Fig. 295). This shows an interior view of the same building pictured by this artist in Fig. 271. This is an impressionistic, though very effective, sketch. In contrast with the gray appearance of the recent example, this seems brilliant in tone, a result obtained by the interplay of crisp blacks against large areas of white. For some purposes, such a sketchy presentation would not do at all, but for others it is ideal. A drawing like this requires real skill, however. There must be intelligent thought behind every bit of it, or it will seem crude and meaningless.

Fig. 291. After rendering single pieces, try larger compositions. Groups of furniture or portions of rooms offer good practice.

Fig. 292. A. Thornton Bishop: Consistency between technique and subject is one characteristic of this pleasing drawing. The contrasting ''spotting'' of the lights and darks produces life and sparkle.

Fig. 293. Sydney R. Jones: Note the strong center of interest, the variety of line, and the clever indication of material in this charming drawing of a plaster chimney in Somerset, England.

Fig. 294. Russell Patterson: The rather decorative quality of the technique gives this drawing a pleasing individuality.

Fig. 295. Robert Lockwood: A most effective treatment of a rather impressionistic nature. The free, sketchy handling is worthy of study.

Fig. 296. Richard M. Powers: Don't neglect your practice in rendering elevations.

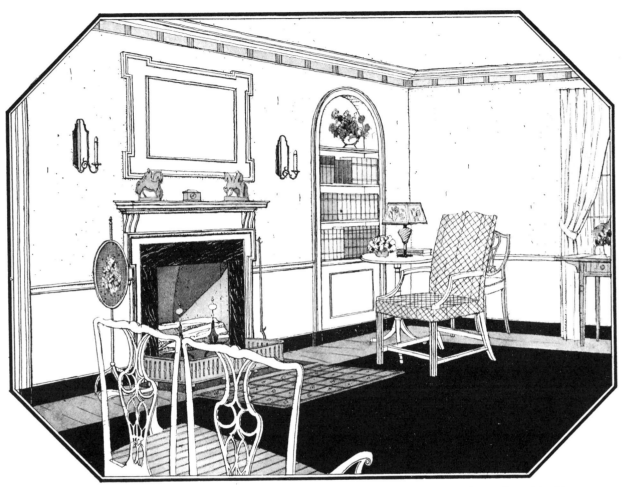

Fig. 297. Verna Salomonsky: Outline, gray wash, and areas of black are effectively combined in this stylized handling. Notice a plan of this room in Fig. 299.

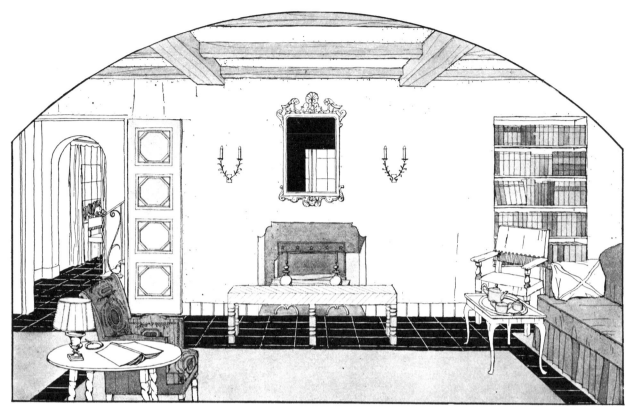

Fig. 298. Verna Salomonsky: The essentials are adequately and pleasingly expressed by simple means.

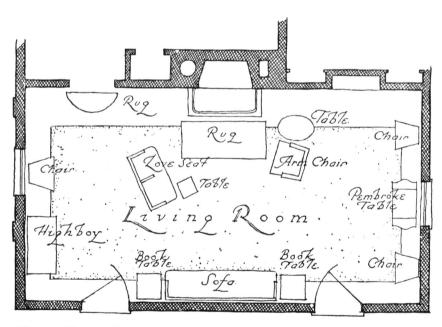

Fig. 299. Verna Salomonsky: Plan for the interior in Fig. 297. This treatment is simple, adequate, and pleasing.

The Elevation

The architect or interior decorator should become acquainted with the methods of representing various types of interiors drawn in perspective as our examples have shown. He should also acquire skill in the delineation of elevations and even plans.

In Fig. 296 we reproduce a rendered elevation of a simple interior by Richard M. Powers. This drawing speaks for itself. In elevation work the most difficult thing, perhaps, is expressing depth, for without traditional perspective aiding the client, it is sometimes difficult to decipher. This fact, therefore, must always be in the mind of the delineator. A plan, on the other hand, is more diagrammatic, as a rule, and may be treated in a more conventional way. The indication by Verna Salomonsky in Fig. 297 is interesting in this respect.

Pen and Wash

Sometimes when a pen drawing is not wholly successful, a wash of some gray watercolor or diluted ink may be applied to it, or to parts of it, with helpful results. Often the artist deliberately combines ink and wash, treating the entire drawing, perhaps, in a somewhat sketchy way. Again, a more conventional combination of the two media is used, as we have shown in the drawings by Verna Salomonsky (Figs. 297, 298, and 299). In most drawings of this type, areas of solid black give the necessary accent. The possible combinations are almost limitless. Be careful where you place these blacks, however. They must be arranged with the greatest care or they will destroy the balance of the composition or attract too much attention to nonessentials.

All of these examples have solved this problem and should be studied with care. As a rule, the objects are first outlined in ink; then the blacks are added with ink applied with either pen or brush; and finally the gray washes are laid in a few simple values. Often these washes are flat or graded in the simplest possible way.

The drawings described in this chapter are used when the interior itself (or the furniture) is the center of interest or the actual subject of the sketch. Such drawings are most commonly employed by architects or decorators, or as illustrations for books or articles relating to home furnishing. Many are made, too, for advertising purposes. Do not assume, however, that this is the only sort of interior delineation done.

Many times rooms or accessories such as furniture are used only as backgrounds, or as settings for people. Here, as a rule, the opportunities for suggestive interpretation are greater. But the artist must be extremely careful that these interiors or accessories do not become so important that they detract from the main thought.

We have now covered in a general way some of the most common kinds of interior drawings, though we recommend that you seek many examples to supplement what we have offered. In this, as in every other field, there is no limit to the variety of treatments possible, to say nothing of the endless numbers and kinds of subjects available.

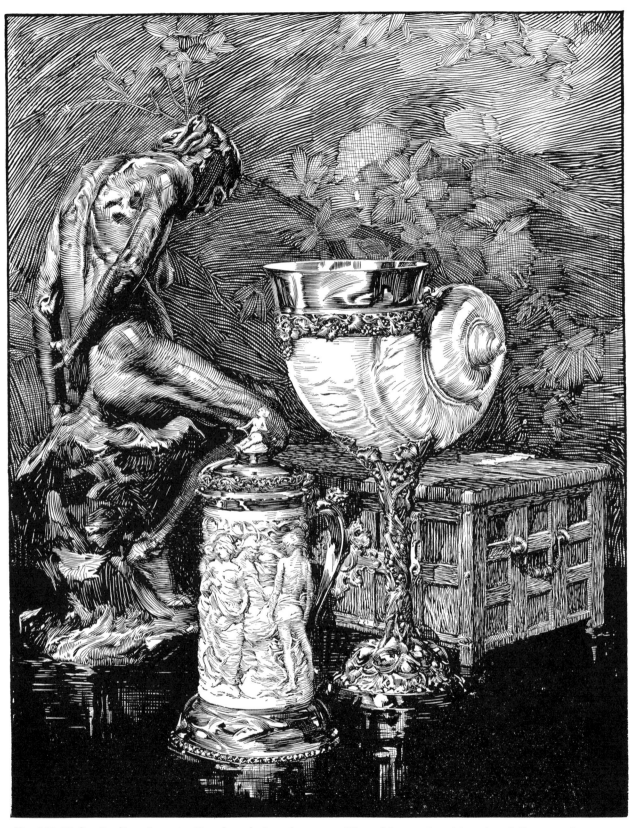

Fig. 300. Walter Jardine: An exceptional rendering of a composition of decorative objects in a full range of values and textures.

20. Special Methods

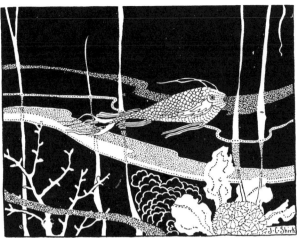

Jeannette C. Shirk

Throughout most of this volume we have shown examples of work done on white paper or board with black ink applied with the pen. This has seemed the logical thing to do, for undoubtedly this type of pen drawing is the most common. Certainly a majority of the pen drawings intended for black and white reproduction are done in this way.

This versatile instrument may also be employed in other equally interesting and even more varied ways. Not only may pen work be done in combination with brush work, but also in conjunction with such different media as pencil, crayon, wash, and color. It is only when you look attentively through illustrated books and magazines that you come to realize what a wealth there is of examples where the pen is combined with one or more other media. In fact, these combinations are so nearly unlimited that we will do little more here than bring your attention to a few of them, illustrating or describing some which are particularly common.

Using the Brush Like the Pen

Working with the brush and ink is a short and easy step to a kind of drawing which, though not strictly pen work, nevertheless has many of its characteristics. In fact, it is not always easy to tell one from the other. This type of work is beautifully illustrated by the drawing by Walter Jardine in Fig. 300. You would scarcely realize that many of the black strokes were done with a brush, yet this is so. Sometimes an artist substitutes the brush for the pen simply because he likes the sensitivity and flexibility of the point. In this particular example, however, Jardine worked on scratchboard rather than ordinary drawing paper, and this largely accounts for his treatment. Scratchboard is a specially prepared board with a chalky surface so soft that the pen has a

tendency to become clogged because of the white dust which it scratches loose. This accumulation causes thicker lines or even blots, while the brush, with its softer and more flexible point, offers no such trouble. Naturally the brush used for such delicate work must be rather fine (not larger than a No. 5, generally speaking) and capable of holding an excellent point. Some practice is necessary before best results can be accomplished.

Though it happens that this particular drawing was done on scratchboard, this use of the brush is by no means confined to that surface. It may be employed on almost any surface, smooth bristol board being an excellent example. Neither is its use limited to this fine type of work shown in Jardine's drawing. Just think of the variety found in Japanese brush drawings and you will realize some of the possibilities of this particular medium.

Brush Combined with Pen

Often pen work and brush work are combined in one drawing. In Jardine's drawing, for example, the pen was used in some places, though it is not easy to tell, however, just which strokes were done with the brush and which with the pen. In the drawing by James Montgomery Flagg in Fig. 301, the combination of pen and brush is used in a manner quite different from Jardine's. In Fig. 301 it is not hard to detect which strokes were made with the pen and which with the brush. You get no sense of lack of harmony between the two, however. Flagg distributes his black brush lines and tones in such a way that they balance nicely and tie in well with the whole.

Other Uses of Black

This use of areas of solid black or almost solid black in connection with line work

is not uncommon. Nearly every pen drawing gives some hint of it. Sometimes the black is applied with the brush and sometimes with the pen. We have outline and pure black used together in Figs. 66 and 67. We have pure black put on with a brush in the drawings by the author in Fig. 118. In fact, all through the book there are many drawings in which areas of black are used, applied in some cases with a brush, and in some with a broad pen. In most instances, these black areas are relatively rather small, though there are exceptions.

The drawing by de Gogorza in Fig. 302 shows a most individual and unusual composition, as well as a great variety of line and tone, and a great contrast of white and black. Almost the entire subject is handled in short, definite strokes; practically the only fine touches are the dots in the surf.

Split-Hair Brush Work

Fig. 303 suggests an interesting type of work. The brush is dipped as for ordinary brush drawing. Then the hairs are made to separate or split, usually by pressing them flat on a piece of trial paper, sometimes employing a match or toothpick to help along the process. The method of spreading the hairs matters little, however. Some brushes will separate almost on their own. This split-hair brush work may be done on almost any paper, rough surfaces being perhaps the most popular.

Dry Brush

The brush is by no means entirely dry for this kind of drawing, as the term might imply. In fact, the brush is only partially dry (Fig. 304). Ordinarily the paper is rather rough so that each brush stroke is broken in an interesting way. Such work has a textural quality—a sort of vibration

Fig. 301. James Montgomery Flagg: This pen and brush drawing is forceful and direct, typical of this artist's approach.

Fig. 302. Maitland de Gogorza: There is nothing commonplace about this drawing; it is imaginative in conception and consistent in execution. The drawing is almost in reverse, white on black carefully placed.

Fig. 303. "Split-hair" brush work provides this kind of effect.

Fig. 304. Dry brush gives this effect.

Fig. 305. Dry brush or split-hair brush may be combined with pen.

—which is most interesting. It can also be combined with pen work to excellent advantage. Dry brush work, by the way, may be also done in colored inks as mentioned later. The author likes a cold-pressed paper or board. Many artists prefer black watercolor to ink when using this and the split-hair methods. It is also popular to combine dry brush with split-hair brush methods as shown in Fig. 305.

The drawing by Samuel V. Chamberlain reproduced in Fig. 306 is an interesting and an unusual example of this brush work. Part of it was drawn with a fine point used much like a pen. A pen might be used, of course, if you wished. The rest, done with a broader and more nearly dry point, has in places much the character of pencil work. The various parts of this one drawing demonstrate the wide range of treatment possible by this means.

Pen and Gray Wash

All of the examples so far discussed have been done partly in pen or have had certain characteristics of pen work, and are therefore closely related to it. All have been done with black ink, regardless of whether pen or brush has been used in its application. If you look at many examples of pen work, however, you will frequently find that the pen and the brush are combined in a different way. Often the pen is employed for drawing black outline and possibly small areas of pure black; then the brush is used to apply areas of neutral gray wash — usually diluted ink or gray watercolor.

The drawings by Verna Salomonsky in Figs. 297 and 298 are all carefully done in a rather conventional manner, primarily combining definite outline, solid black, and simple flat washes. Many times, however, the artist handles this or a similar combination of methods in a more sketchy way, both the pen lines and the washes being applied with much greater freedom. The washes are frequently graded, too, and many values are used. Sometimes the pen work is very prominent, the washes being subordinate, while in other instances there are merely a few touches of the pen to reinforce the edges of some of the washes or to give accents or define detail. Such work as this is, of course, hardly pen work at all, yet you must have a knowledge of pen drawing to handle it to the best advantage.

Pen and Pencil

Not only is pen work combined with black or gray brush work, but combinations of pen and pencil are also quite common. We show a simple example of this in the sketch in Fig. 307. The original drawings of work of this sort sometimes seem to show a lack of harmony between the pen and pencil portions, partly due to the shine of the pencil lines and their silvery gray quality. But when the work is reproduced, the results seem more harmonious. Both the originals and reproductions have something of the softness

and richness common to the pencil, plus the strength and vigor of the pen. Similar to these uses of pen and pencil in combination are the uses of pen and various sorts of crayon, the crayon generally being employed for the larger areas of tone and the pen for accents, boundaries of planes, and so forth.

Spatter and Stipple

In various places, notably in Chapter 4, we have referred to spatter and stipple. We have made the tree in Fig. 308 to suggest that plain areas of spatter or stipple are often used alone as shown. Two or three values of either may be combined, also, each treated in much this same way. In basing a drawing for reproduction on the idea suggested by this sketch, there are several ways of working. In making this particular sketch, for instance, an entire small sheet of paper was covered with spatter. This tree profile was then sketched on the back and cut out with a razor blade, the tree being next mounted on a sheet of bristol board which contained other elements to be used for reproduction.

Another method would have been to spatter the tone directly on the bristol board, first painting out or covering all but the tree, as described in Chapter 4. Or a fairly large area of board might have been spattered, opaque white later used for painting up to the desired silhouette. This would have disfigured the original drawing, but the reproduction would have come out all right.

For more than one value of spatter, the method described in Chapter 4, where friskets are used or certain parts painted out with rubber cement or gum arabic, would be as satisfactory as any.

Fig. 309 offers another suggestion which might have numerous practical applications. Fig. 310, too, shows a combination of pen and spatter which is common. Many pen drawings are improved by a bit of spatter or stippling. Brush and spatter are often combined, also.

Using Color

Now we come to some of the many uses of color that fall naturally within the scope of this volume. We not only have various combinations where black ink is used — such as black ink and washes of watercolor, black ink and colored pencils or crayons, black ink on colored papers, and so forth—but also innumerable uses of colored inks. In fact, colored ink is perhaps the most logical chromatic medium for the student already experienced in pen drawing in black and white, providing also a natural means of transition between black ink and other colored media. We will go directly to colored inks, therefore, later offering a few brief suggestions on other media.

Colored Inks

We have already mentioned in Chapter 13 that many interesting sketches are made

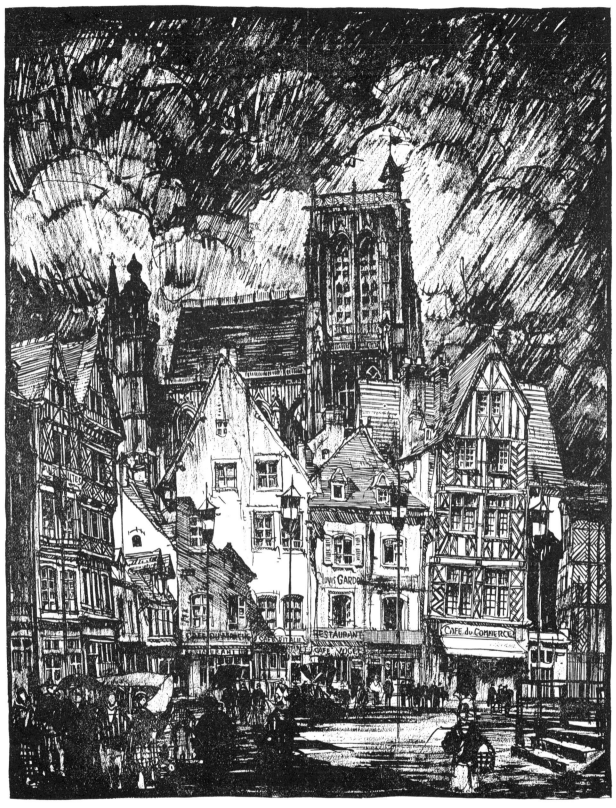

Fig. 306. Samuel V. Chamberlain: In his dry brush drawing called Abbeville, the artist combines ink lines and tones of great variety, both in size and character.

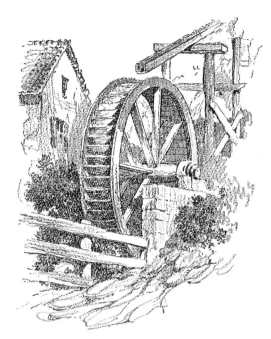

Fig. 307. The brush and pencil may be combined.

Fig. 308. Areas of plain spatter or stipple similar to this are sometimes used alone.

Fig. 309. Sometimes spatter or stipple is used with a simple borderline around, such as this one.

Fig. 310. Spatter tone is often used in conjunction with line work.

with ordinary fountain pen inks. As a rule, however, the inks used by artists are made solely for their purposes. They come in a wide range of colors, customarily packaged in small bottles with stoppers exactly like those containing the black inks. They are extremely brilliant, with few exceptions, but it is not necessary to use them in this form, for they may be freely diluted with water (preferably distilled) to any desired intensity. They may be mixed, too, either in their full strength or as diluted, an almost unlimited variety of shades and tints being obtainable. When dry, these inks are waterproof. The colors are transparent, a feature which is often of great advantage, as we shall explain later. If opacity is desired, however (as for work on tinted papers, particularly when dark), opaque white ink may be mixed with the colored inks.

These inks may be applied either in line or wash, or, because they are waterproof, in combinations of the two, wash over line or line over wash.

All this means that when working on white papers you have a medium offering a full gamut of hue and intensity, applicable either by pen or brush. Even stipple, spatter, and dry brush effects of many kinds are obtainable. If tinted boards are added you have an almost inexhaustible range of possibilities for experimentation in color.

First Attempts in Color

When you want to work in colored ink and have gained as a background a fair proficiency in using black ink, a natural and gradual transition is to try a few drawings with a single color. The subject itself will perhaps determine the color selected. Usually a rather dark ink is preferable. Brown ink is quite a favorite. When a single ink is used, brown is often selected because very attractive sketches are possible with it. It may be used on white paper just as black ink would be used, though results sometimes seem richer and more harmonious if a cream or light gray or brown paper is selected. If the paper is of a quality suitable for wash work, washes of the same ink (usually diluted) may be applied with a brush over the pen work. By combining brown ink in line and wash, or brown ink toned to a warm gray with the addition of black, an endless variety of beautiful effects may be obtained. These effects may have an etching-like quality or a character similar to that of many sketches by the old masters. Other colors may of course be substituted for the brown, or the brown may be modified by mixing with different hues.

You will probably feel inspired to try not only brown or other single colors but also combinations of two or more colors (part of them more brilliant), used with or without the addition of black or white. You can experiment with various surfaces, too, some white and some tinted; some rough and some smooth, using

both brush and pen. Generally speaking, however, unless you have had experience in color harmony you would be better off confining yourself first to only a few colors for any one drawing, using a wider range gradually as broader experience is gained. You can profit greatly by trying washes of gray or brown, or some one or two tints of stronger color, over drawings previously done by pen in black ink in the customary way. In fact, pen drawings in black that have not come out well because of poor composition or technique may often be greatly improved by the addition of a few washes.

At times, however, especially as confidence is gained, you will lean towards a broader range of hue. For first drawings of this sort, select easy subjects.

Setting Up Your Materials

When you use a number of colors in one drawing, arrange the bottles in a convenient and orderly way so that each color may be easily found when needed. If your bottles are not already marked so that they are readily identified, it will take a short time to label them conspicuously. A colored band around each bottle (tinted with the ink itself) serves this purpose very well. For this kind of work it is also convenient to have a separate pen for each color, with a holder of corresponding color. If colored holders are not available, the end of each holder may be scraped and dyed by dipping it into the ink. Sometimes it is more convenient to work with a few pens only. Even one is enough if kept thoroughly clean. Two as a minimum are better, however, one for the lighter and one for the darker inks. Regardless of number, the pens must be kept clean if purity of line is to be obtained.

So far as the number of colors is concerned there is little advantage in having too many separate bottles. Five or ten should ordinarily prove sufficient, because it is easy to mix other colors from them.

Some General Procedures in Color

When you are ready to proceed with your drawing, there are several methods available. It is best, as a general thing, to forget technique for the moment, and strive only for the most direct and logical interpretation of your subject. You may first sketch the subject lightly in pencil, or in some inconspicuously toned or diluted ink. Then build up the lighter values. To save time, all areas of one color should be inked as far as possible while the pen is in the hand. If you have no ink of some desired color, you may mix it from other colors, as we have just said, provided, of course, that you have the essential primaries—pure red, yellow, and blue.

It is not necessary to mix every color needed, however, as a similar effect may be gained directly on the drawing through the crosshatching of lines of one color over those of another. If an open

series of yellow lines, for instance, is crossed by an open series of red lines, the tone resulting will give an impression of orange. Such impressions would correspond very closely to results obtainable by mixing. If you feel that any color seems too strong as it comes from the bottle, dilute it. Once the lighter tones have been obtained, the darker or stronger colors should be added, black, if desired, being reserved for the last.

Although this method of gradually evolving an entire sketch is logical, there is no reason why you can't proceed more directly if you choose. Keep all bottles open before you and, working with several pens, complete or nearly complete one detail at a time, working, perhaps, from the center of interest out.

Still another method (when black is to be used) is to do all the black first, next applying the intense colors and finally the tints, exactly reversing the first method. This method seems natural to many accustomed to doing the usual form of pen work in black ink. Its main disadvantage is that you are sometimes tempted to do too much with black ink, leaving little that is vital to be brought out by the color.

So far we have only discussed line work. Now and then you find a subject which seems to call for a different treatment than is possible or practical if the work is done completely in line. In such a case—or if your mood suggests it—wash may be substituted for a part of the line work or used to enrich it. Such wash may,

of course, be in watercolor, though if the inks are at hand they seem the natural medium. When wash is used, two methods for application are commonly used. In the first, the washes are applied before much pen work is done and the drawing is then completed in line. In the second, the drawing is carried quite far with the pen, either in black or colored inks, and the washes added. Sometimes when one of these methods is used, the pen work is confined mainly to outline.

Watercolor Used Like Ink

We should point out that the use of watercolor is not entirely confined to wash. Most of the pigments may be applied with the pen in much the same way as ink, though when so applied they usually show far less brilliance and are not, of course, waterproof. Because of this latter fact, any watercolor line work done with pen should obviously be done after the washes are on and dry.

Other Colored Media

Don't overlook the many possibilities of getting interesting effects by combining other colored media — such as colored pencils or crayons — with the various media that we have so far discussed. Effective drawings may be made, for instance, where colored inks are used for outlines or some of the smaller areas of tone, and colored pencils or crayons are

employed for quickly covering the larger surfaces.

Tinted Papers

Though much that we have written relates specifically to white papers, remember that tinted papers are often of great value. They may be used to advantage when working with ink of a single color and they may also prove of value when several colors are used or when different media are combined. One very effective combination, for example, is to make a drawing in brown ink (or some other one or two colors) on a warm gray, buff, or light brown board, and then add washes with ink or watercolor, finally picking out a few highlights with a value of opaque ink or watercolor lighter than that of the board itself. Other interesting treatments are obtainable through combining work or tone in colored pencil. Dry brush, wash, and line work in color or black, or both, may be combined on colored papers in innumerable ways.

These last suggestions and some of the other hints offered are perhaps too vague to be of much assistance to you, particularly since we have been unable to illustrate these examples in color. They will serve, at any rate, in helping to make plain that you are by no means confined to work in black and white. In using color, either by itself or in the combinations we have described, you can find no end of opportunities for original exploration and experimentation.

Gallery

Each of the artists presented in this gallery has been noted for a particular approach in pen work. By studying the examples here you will find a full range of subject matter and techniques that should help you broaden your own view of the possibilities offered by this medium. Examine these examples for draftsmanship and handling of pen and ink.

Bob Fink: In this composition, notice that the artist has simply taken a light spot and surrounded it with dark.

Reginald Birch: The Tachypomp. Notice how the artist emphasized the wildly dramatic expression of the leading figure by the way in which he posed the listener, rendered the disorderly setting, and exercised dash and vigor in his technique.

R. F. Heinrich: This pen artist was particularly noted for his ability to draw "in reverse," white ink on black paper, a technique that resembles the old-time woodcuts.

Thomas Fogarty: In this sketch the artist used free handling in his pen work, a seemingly effortless display of skill.

Thomas Fogarty: By drawing this on-the-spot, the artist conveyed a convincing sense of realism. The
original was considerably larger than this reproduction, measuring 17 x 12 inches/43 x 30 cm.

John R. Neill: The complexity of this imaginative drawing was executed with a consistency throughout. The underwater illusion was carefully thought out before the artist placed pen to paper.

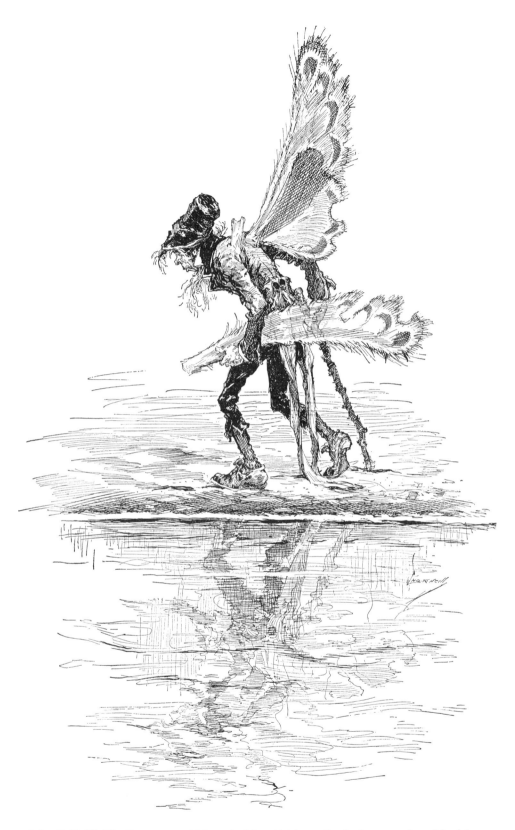

John R. Neill: The Romancer. Although this artist is particularly remembered for his imaginative concepts, his technique, composition, and draftsmanship were equally outstanding.

Willy Pogany: Notice how the artist placed this composition off-center, allowing the white space to act as a dramatic force to the composition and to the imagination.

Willy Pogany: This illustration is naturalistic in many ways, yet it is also highly decorative or stylized in its treatment and arrangement of detail. The drawing was made in the same size as reproduced here.

Willy Pogany: This Pogany illustration also combines naturalistic and decorative treatment in a harmonious way. The touches of black in this and in the previous Pogany drawing are characteristic of this artist.

Willy Pogany: Notice the delicacy of detail and the great variety of line in this drawing.

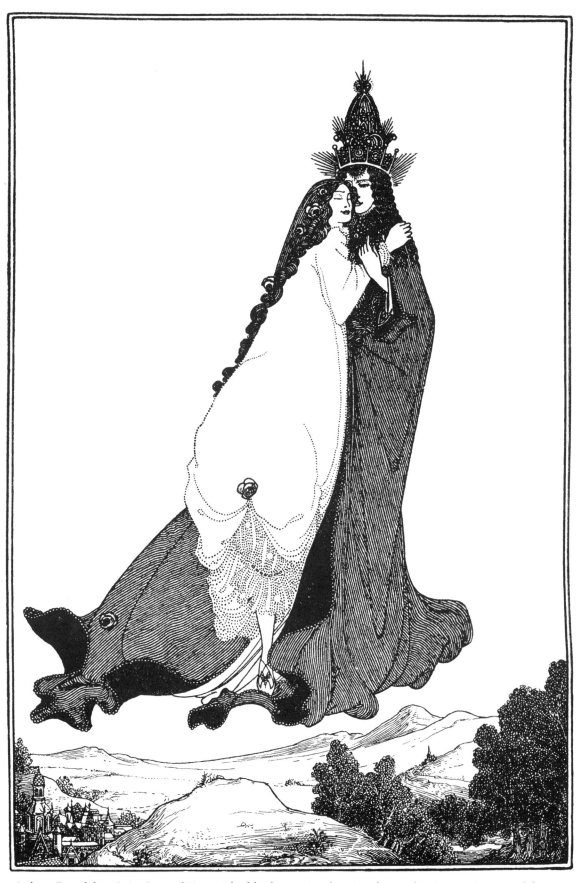

Aubrey Beardsley: Saint Rose of Lima. A highly decorative drawing that makes interesting use of the silhouette.

Rose O'Neill: Kewpies. This amusing illustration has been cleverly thought out and skillfully executed.

Rutherford Boyd: Here is a striking example of the way in which object drawing in several values has been applied to an advertising sketch.

Walter Teague: In this Christmas card design, many elements have been composed to form a most effective decorative treatment.

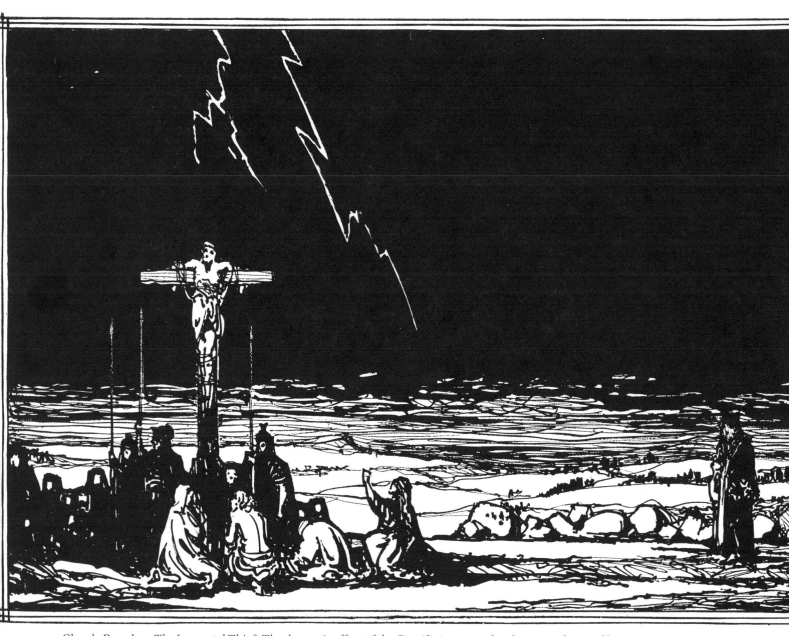

Claude Bragdon: The Immortal Thief. The dramatic effect of the Crucifixion scene has been emphasized by means of strong contrasts of black and white.

Rockwell Kent: Mountain near Lago Fognano. *A strong quality of pattern has been obtained by using a decorative or stylized technique in composing the mountain top.*

Thomas MacLaren: Drawing an existing ornamented structure —such as this detail from Southwell Cathedral —is excellent exercise for the renderer.

David A. Gregg: Madonna and Child on Palazzo Publico, Bologna, Italy. *This is an architectural study of exceptional merit.*

Addison B. Le Boutillier: The original drawing measures 5 x 7 inches / 12 x 18 cm and is reproduced here somewhat larger in order to show clearly the variety of technique often essential to a convincing drawing.

Addison B. Le Boutillier: Notice the conscientious treatment of trees and foreground in this drawing of a ruined shrine at Soissons, France.

T. M. Cleland: This is a border design that was inspired by a 16th century Italian painted ornament, a symmetrical border that combines an intriguing interplay of human, animal, plant, and architectural elements.

Bob Fink: Notice that a central white area has been punctuated by a black accent and surrounded by areas of gray, an effective compositional treatment.

Herbert Railton: Notice the variety of line used for suggesting the characteristics of different surfaces.

Index

Edited by Bonnie Silverstein
Designed by James Craig
Set in 9-point Melior